STRONG WOMEN FOR ART
IN CONVERSATION WITH ANNA LENZ

T0079683

STRONG WOMEN FOR ART

IN CONVERSATION WITH ANNA LENZ

Edited by Anna Lenz
Photographs by Roswitha Pross

HIRMER

Contents

Foreword

At first I didn't have anything to do with art. It was my husband, Gerhard, who began collecting – works by artists of our generation who had dared to usher in a new dawn, a fresh beginning in Europe at the end of the 1950s, celebrating infinitude, reduction, the void, stillness, light, immateriality – artists of the ZERO movement and its fellow-travellers. I remember that at the beginning this mainly caused me worries because my husband's purchases put an extreme strain on our finances.

However, the paintings quickly became our life, and also my life. For our children they were like siblings with whom they grew up. And many of the artists became our friends, so close that you can speak of a large family. That our relatives and some members of our social circle couldn't make anything of the art we loved; that our passion came up against incomprehension and sometimes open rejection, welded us, the art and the artists even more firmly together.

In 1971 we were living in Kronberg im Taunus, where we organised the first ZERO Festival. We exhibited the art works we had collected in the old villa and invited the artists and our friends for the weekend. Almost all of them came, from Italy, France, Austria, the Netherlands and Germany. The next morning we were sitting together at breakfast: the artists (they were all men), their wives and partners, their children, our children. The tension had relaxed and we had the feeling that we'd arrived. It became clear to us that through art, life had gained a new depth, a different content for us.

Later, we also invited guests to festivals and symposia at our estate in Tyrol, and those of the artists who came with their families seldom remained only for the evening, but stayed the night, the weekend, or even longer. The conversations about art and philosophy seemed to continue without interruption. And, not least of all, there were trips that we undertook together.

At the very beginning, the artists' wives and partners weren't important for me; many of them, like myself, didn't come to the fore, but stayed in the background. I began taking photos whenever I was able to visit studios, and it was a feeling of great happiness to be present when setting up our exhibitions. I kept a distance and captured spontaneous situations with my Olympus and my telephoto lens. In this way I produced photos of the artists at work, in conversation, deep in thought. To the degree to which art became a part of our life, the artists' wives and partners did too.

Gradually I got to know some of them better and began to take an interest in their stories. These women participate existentially in the creative work of their

partners; that requires great strength. They maintain social contacts during periods when the artist wants to concentrate solely on his work; they take care of the family when for the artist there is nothing more urgent than his work. Some of them have given up their own professional aims to make room for the artist to complete his work.

The work on the collection and the ever-closer relationships with the women finally gave me the idea of finding out more about them. I wanted to hear their life-stories, to document their view of themselves, their men and the art with which and for which they were living. And so, Roswitha Pross, Ulrike Schmitt and I travelled with our cameras, tripods, lights and recorders all across Europe, to Milan, Venice, Munich, Amsterdam, Antwerp, Paris, Düsseldorf and Prague, to Austria and Switzerland.

We were received with great cordiality everywhere. Even when until then the contact had only been a loose one, even when many of them thought that they were not so important, I sensed that these women were glad to be able to talk about themselves for once. For us they stood centre-stage: their origins, their youth, their dreams, their shared lives with their men and their men's pronounced self-assurance. In the end, the women were often amazed, sometimes even alarmed at how much they had said about their private lives. Not infrequently, it happened that an artist would look around the corner during our conversation and ask when we would be finished, or what, exactly, his wife or partner had said about him.

Unfortunately we were not able to visit Mireille Van Hoeydonck. Because of her illness, a meeting with her was not possible.

The various women's life-stories have touched me greatly, especially when they related their experiences of their childhood and youth. It was moving for me to experience to what degree some of the women, including those who are themselves artists, put themselves and their personal dreams on the back burner, at least partially, to give their men the necessary free space to be able to work creatively. To be sure, this is also a generational question. Often, personal self-fulfilment comes only later in life.

It was equally touching for me to hear the women speak very openly, not only of their falling in love, but also of their great love for their man. More than just a few of the women with whom we spoke are impressively committed, after the artist's death, to promoting his oeuvre, and are leading their lives under new circumstances. Uta Peyrer-Prantl and Marie-Madeleine Opalka lost their husbands

five months after our conversation, Kitty Kemr three months after the German edition of this book was published. In revising their texts, they have modified nothing of their original affirmation of life. I have entitled our book *Strong Women*.

One of our 'strong women', Edith Talman, died in July 2013 during the production of the English edition.

I would like to offer my sincere thanks to my team for enabling my idea to have finally become this publication: Roswitha Pross, who brought the women so empathetically into the picture and who was intensively involved in designing the book; our curator, Ulrike Schmitt, who took on the tedious task of transcribing the recorded conversations, intensive research and project organisation; Ulrike Honisch from Berlin, who has edited the texts with sensitivity and patience, and supported me with her advice; and finally Michael Eldred from Cologne, who has translated the interviews into English with great care. My gratitude is due also to my husband, Gerhard Lenz, who encouraged and motivated me to undertake this project. Above all, however, I express my thanks to the artists' women themselves, who so very openly let us take part in their lives and who now, quite literally, are opening pages of their very personal art history for us.

Anna Lenz

The urge to keep on working,
to write, has always been with me

Antje von Graevenitz

Antje von Graevenitz, art historian and critic,
was married to Gerhard von Graevenitz (1934–1983).
We met in Amsterdam in January 2012.

Anna, before you start asking me questions, I should like to congratulate you on your idea for this publication. I know various books about the life-companions of the Surrealists and the Abstract Expressionists. But for the first time here, the women of my generation are being given the opportunity to express themselves. Of course I've prepared myself a little bit, looked through old calendars and written down a few key-words. It's strange to think about the old days again.

Antje, then let's start really early on, with your childhood: where and how did you grow up?
I was born in Hamburg in 1940 shortly after the beginning of the Second World War. Because of the bombing alarms, we often had to go into the air-raid shelter, sometimes three times a night; I still dream about it today. In my youth there was hardly a word spoken about art. There were pictures at home: a fisherman's wife in oil I have inherited but do not like; a wonderful portrait of my mother as a young girl by the Hamburg painter Stresemann whom she was probably crazy about. On the chests of drawers there were several kitschy ceramic figurines, leaping horses that fortunately have all been broken. And in the living room above the grand piano there was a plaster mask of my father. Only much later, in 2000, did I find out that he played a role as a lawyer in the

10

Nazi district administration (Gauleitung). For me that was a terrible shock and I no longer wanted to see this mask anywhere in my surroundings. My uncle had divulged the matter when my mother went into a retirement home. Suddenly the floodgates opened in the family and it was spoken about. Before that the only thing people had talked about was how utterly charming my father had been. He was a prisoner of war in Russia and died there in 1945. So the relationship to my family is ambivalent.

Did you ever really experience him?
Yes; he was called up in 1943 and came home in the holidays. I can see and feel myself in his arms; I have a vision of going shopping with him and sense a certain masculinity. I can no longer hear his voice. These moments are always very short. During all those years, he was presented to me as a quite enchanting father primarily by my mother, not by my grandparents. That made it all the more terrible when I heard the whole story about him.
After my father died, my mother had to go to work and got a position at the Hamburg Town Hall as a librarian in the primarily legal library that was available to the mayor and senators. My maternal grandparents practically brought me up and left their mark on me. After they were bombed out they lived in our street. My father's parents were not as important for me; my grandfather died when I was little and I saw my grandmother only seldom.

Did you have any brothers and sisters?
No, because my brother had died of meningitis before I was born. He was always held up to me as the great role model. He was supposed to have been so good and laughed so much, whereas I was so naughty. I really hated this invisible brother, even his photo on the desk that my mother looked at so lovingly. To replace him I was really supposed to be a boy, a Jan-Philipp, not an Antje-Maria, which is my full name: Antje, because it was so Aryan, and Maria after my godmother. At the time I found it horrible that I wasn't accepted as a girl. Today I find the name quite funny because it's a Dutch name, although today nobody is called that. It's like being called Erdmute or Sieglinde in Germany.

Tell me a little bit about your grandparents.
My grandfather came from a poor, large mercantile family. He really wanted to study art history, but his father thought that he should learn a vocation that would make him independent. He thought that this wouldn't be possible with art history, and that you had to come from a rich family to do that. And anyway, it would have been difficult to finance his studies. But fortunately my grandfather had a dear friend, the Baron von Goslar, whose father paid for his studies,

but on condition that he studied law. Throughout his life my grandfather continued to be very interested in art, particularly in the Impressionists. He was a member of the Hamburg Kunstverein and the Friends of the Hamburg Kunsthalle, knew almost everybody of any importance in this area, and wrote a book about art and law. I was often allowed to accompany him to the Kunsthalle but scarcely understood anything he was enthusiastic about because I was rather indifferent to how wonderfully a neck or a shoulder had been painted. I still remember this lack of understanding very well. But he made me love Franz Marc with his animals, and Paul Klee. I especially liked Klee's painting *The Revolution of the Viaduct*. Today I regard all these as decisive experiences. Apart from that, my grandfather was an incredibly courageous man full of temperament who, as a divorce judge in 1938, loudly and energetically protested in a huge hall in front of all his colleagues against the application of the new divorce laws for Jews and Aryans. He was dismissed. After the war the British immediately appointed him President of the Senate for the Hanseatic City of Hamburg.

Up until matriculation I went to visit my grandparents every Wednesday. As a young man my grandfather had corresponded with Theodor Fontane, Thomas Mann and others, but all the letters were burned. He knew many poems and passages from novels by heart which, to the annoyance of my grandmother, he recited at lunch. At the time I didn't know how important all this was, but it has left its mark on me. My mother, whom I loved very much, occasionally went on trips with my grandparents and would put me into some kind of children's camp where I was often rather unhappy. When I was thirteen, she sometimes took me along with her on vacation. She went to museums with me, but probably because as an educated person it was something one did, and not because she felt any need to. My grandfather was completely different in this respect. From the age of fourteen I went to exhibition openings regularly on my own. Occasionally I had artists sign autographs, Hans Arp for instance. Unfortunately this collection disappeared at some point; I suspect it was my mother's later lover.

Where did you go to school?
I went to an arts-oriented secondary school in Hamburg, the Helene Lange School, where you couldn't learn Greek, but Latin at least. Music played an important role. The choir teaching was fantastic; we performed madrigals in public. I also sang in the church choir and in a choir for modern music. And we performed many plays. I was often allowed to paint the stage sets. Even at that point I noticed that I really enjoyed fine art.

Religion was also important in my life. On Sundays my mother went with me to the Protestant church. At dancing school I got to know two boys who were very religious and who asked me if I wanted to travel with them to a half-Catholic,

half-Protestant monastery in the northern Black Forest during the summer holidays. I went there three times. We practically lived like monks, getting up at five o'clock, singing Gregorian chants, meditating, remaining silent at meals, walking only along straight paths, never along crooked ones. And when we met someone in the cloisters, we had to greet him or her with the kiss of peace, that is, two light kisses on the cheek. These rituals affected me strongly, even long after I had left the church, along with Gerhard, in 1968. I engaged with rituals not only while studying ethnology, but also in art history. I wrote my dissertation on this topic and also published a fair amount on it after my doctorate.

Did you dream as a young girl of going to the academy?
Yes, because I liked drawing and painting and got very good marks. But when I asked my art teacher if I should apply for the art academy she said that it wouldn't be right for me because I always wanted everybody to react to what I'd done. As an artist you have to be able to 'overwinter' – that's what she called it – even when nobody's interested. You have to continue to follow your inner drive, and for me that probably wouldn't be possible. I was disappointed but I accepted her advice because I sensed that she was right. Later on I experienced with Gerhard and other artists how important that is, this ability to 'overwinter' every now and again. It's a special quality and a strength for which I have great respect. In any case, I followed my mother's example and thought I'd do what she did and first become a librarian, since that was only a three-year course. And if the same happened to me as happened to her, that I became a widow, or if I were divorced, then I'd be able to stand on my own two feet. Perhaps I would suffer the same fate as she did.

In 1961/62 she let me go to Munich for practical work. But already after a fortnight there I noticed that I wasn't in the slightest interested in this career, with those perpetual questions from readers about novels about doctors, travel books, detective stories or whatever; I always had to have these lists of books at my fingertips. Or they wanted to know whether a novel had a happy ending. Or a student needed literature for an essay about Nietzsche, and after I'd gathered everything together, the reader went away with all that wonderful material, and I sat there disappointed because I would have liked to write the essay myself. Happily, with the permission of the chief librarian, I was allowed to attend lectures and seminars in art history, philosophy and German studies at the same time. I liked art history very much more than what I'd been doing. In some courses in German studies I quickly lost interest because we had to count up how many times the word 'and' occurred in a novel. I just wasn't interested in statistics of that kind.

After that year I returned to Hamburg and my mother, and finished my training as a librarian, but then went to university where I wrote my first seminar papers.

And after that, back in Munich again, I studied art history with archaeology and ethnology as minor subjects. I'm so grateful to my mother that she made this all possible for me on her librarian's salary. And there I met Gerhard.

So did you want to get to know an artist?
To be honest, I'd already met one. During my practical work in Munich I often went to concerts or to the theatre in the evenings, as I had done in Hamburg. When, one evening, I tried to get a ticket, a good-looking young man gave me

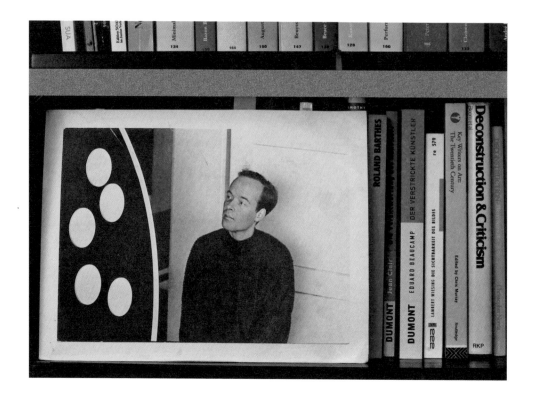

his second ticket and sat next to me. I found him very exciting. He was the artist, Thomas Niggl. I fell in love with him and later on we lived in Munich together for two years, from 1965 to 1966. Sometimes the situation with him wasn't easy; for instance, when I painted something or played the lute and it didn't seem good enough to him. He was probably right. In any case he regarded art history as art hysteria. Once I attended a panel discussion with him in which Gerhard von Graevenitz, Gerhard Baumgärtel, who painted *informell*, and some members of the Spur and Geflecht artists' groups took part. The topic of the discussion was whether the artist – his handwriting, his gestures and his person-ality – had to be visible at all; that is, present in the art work. People were not at all sure in the case of Gerhard's work, and he confirmed this. Yes, he would throw dice and cut up little pieces as similar as possible and press them onto

the still-wet surface using a stick with a ball fastened to it. His hand movements were not to be seen. Many thought Gerhard was a big clown, while others adored him. I didn't know Gerhard and was simply amazed about the way that he found it amusing and unaffected when everybody was laughing at him. This strength impressed me somehow. I sat there gaping and listened.

How did you get to know Gerhard better?
There I'll have to backtrack a bit: Thomas Niggl and I travelled to Prague. There we met Simon Wiesenthal and Miroslav Lamač who, at the time, played a major role in Prague as editor-in-chief of an important art periodical. He advocated above all that Malevich should regain recognition as well as endorsing the work of modern artists. These meetings led to connections to Jiří Kolář and Stanislav Kolíbal. So it was via Niggl that I had connections with the scene in Prague. Miroslav Lamač wrote to me in 1967 that he was coming to Munich and would like to give three lectures. He asked if I could organise that: one lecture on Malevich, one on Russian avant-garde art, and one on contemporary Czech art. But that sort of thing wasn't allowed at the Institute of Art History in Munich. For the professors there, modern art ended in 1930. Under Hans Sedlmayr, with whom I had also studied, fine art had ceased to exist in about 1830. So I knew that I wouldn't be able to find support for such lectures there. So I asked Peter Nestler, the director of the Academy of Fine Arts, whether he was interested, and was lucky. The first lecture was on Malevich. When I entered the lecture theatre, I saw a man who was already sitting there blush and greet me. After Lamač's lecture, Nestler asked me to come along to dinner. At that moment, the man who had blushed came up to me and offered to give me a lift in his car. That was Gerhard. We then sat in some trattoria or other and got into a conversation about the film *Blow Up* that had just started showing.

I recall that. It was a hit at the time.
Yes, I was very enthusiastic about it, but Gerhard wasn't. My view was that it was a great thing to see here how a film reflected on its own medium. He saw it as kitsch, exaggerated, not sufficiently fundamental and strict. That was typical of Gerhard! After dinner he dropped me off close to my house without asking me exactly where I lived and what my telephone number was. Not a word. Before that he'd said to me very casually that he would be pleased if I came to see him in his studio to look at his works. From Hamburg I was used to something completely different. There you don't say, 'Ring me some time', but you give your telephone number and some information about how you could most easily be contacted. Nevertheless I was interested. I waited a fortnight before I rang him and asked if I could visit him in his studio. Oh yes, it would be a good idea to see each other, he said; at the weekend he wanted to travel to Nuremberg

where he had to repair a work in an exhibition and would have to spend the night there. Would I like to come along? That was even better! At first he showed no interest at all, and I hadn't even seen his studio, and now I was supposed to go with him on a trip and spend the night there. That was out of the question. I was a bit prim and proper as Hamburg people are; that is, well brought-up. Nevertheless I agreed on condition that my friend, Sabine Storck, could come along – this was Dr Sabine Fehlemann, the director of the Von der Heydt Museum, who later, as a good friend of us both, held one of the speeches at Gerhard's funeral in 1983. So we drove to Nuremberg with a lot of stuff, rolls of paper and poster tubes everywhere, a terrible muddle, sitting very cramped together. The exhibition in Nuremberg fascinated us. I saw these works of the Nouvelle Tendance group for the first time. Gerhard had installed his enormous light-wall. I was so overwhelmed to have met somebody who made something like that. Back home in Munich things were quiet again for a while. But finally I did visit him in his studio. Gerhard could tell wonderful stories; he was a fantastic person to converse with. We were always able to talk about everything; that was the one side of our marriage. We married the same year and, a few days later, in October 1967, we moved to Amsterdam for six months because of my doctoral scholarship. Gerhard knew a great deal about philosophy and in this respect was far my superior. I've been strongly influenced by him. He was very analytical and critical. This stimulated me to take up my work as an art critic, which is what I became soon after gaining my doctorate. Sometimes people accused me of being arrogant. I hope that today I'm no longer like that. But both of us adopted the stance that you have to apply the highest criteria. You know about that, Anna, because you have a really high quality collection; that particularly impressed Gerhard.

Perhaps I should tell you briefly how my Gerhard met your Gerhard. It happened in 1970 at an exhibition with Rochus Kowallek. We joined him in Frankfurt, at the Galerie Ursula Lichter. There was a back-room there with a radiator. Kowallek said that something especially good would have to hang above this radiator because the collector who was coming soon always bought the work hanging above this radiator. My Gerhard thought that was a terrible restriction. There was a ladder standing in the middle of the room. Before the exhibition opening, a man came into the gallery in a hunting outfit with a tassel on his hat; he was jovial, sat on top of the ladder and then said that he'd buy this and that, and would ring tomorrow from Vienna or Budapest about the three other works. He took no notice at all of the work hanging above the radiator. But when the man left, Gerhard was completely awe-struck because it had never happened before that someone bought so many works at once, and only really the very best. Never had anyone understood so well that he was working on an investigation and wasn't somebody who simply wanted to make beautiful works which, for

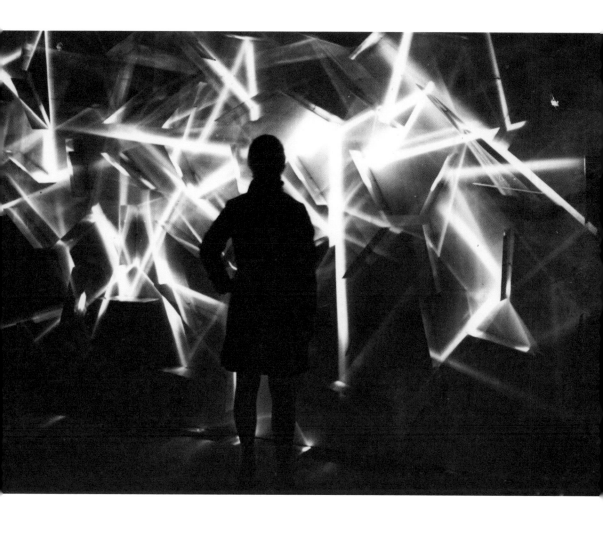

example, you could hang above the radiator, but that he didn't want to make any compromises, and instead research what it would mean for perception if he were to define the basic relations in his works to be somewhat larger or smaller. This man in the hunting outfit had understood that!

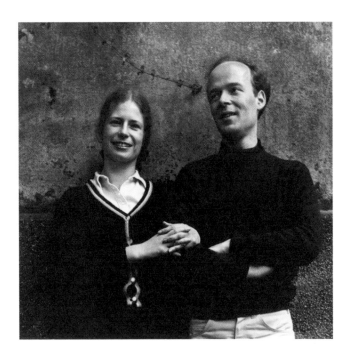

Gerhard was absolutely uncompromising in his art, was he not?

Yes, absolutely. In such moments he couldn't be influenced at all. However, he didn't share the opinion of the art historian, Max Imdahl, who maintained that a viewer must be able to understand everything merely from the art work itself. I recall the controversy that was being fought out in art history at the time. Imdahl represented the side of those for whom everything developed from the artwork itself. The other side was represented by those who, for instance, thought that the date, among other things, was part of a monochrome work, since otherwise it could no longer be recognised as a revolutionary act of creation; art history was in fact also a part of art. Gerhard was very interested in art history and in addition knew a lot more about contemporary art than I did, although I'd gone to exhibitions so often and had seen every *documenta* except the first. However, I found it very difficult to work out what was really important. For me, everything had more or less the same topicality. I simply

didn't yet know which questions I needed to ask. The encounter with Gerhard von Graevenitz was absolutely essential here. Through our intensive discussions I gradually developed my own criteria. At that time, land art, *arte povera* and processual art were emerging. When Gerhard was so critical of artists using grass, earth or water – I'm thinking of Hans Haacke, for instance – I drew his attention to the fact that he, too, was working with nature, with time, contingency and real movement. He couldn't give them a concrete form, but he enabled them to take on a specific appearance through his work. He gave nature an artistic form. He seemed to be remarkably surprised by this. He'd introduced the topic of art and nature into discussions within a wide range of committees in the mid-1970s. During a commission of the Nederlandse Kunststichting he encouraged the chairman, Gijs van Tuyl, to treat this aspect at the 1978 Venice Biennale and was therefore permitted himself to set up the Dutch Pavilion. Two of his exhibitions in 1980, *to do with nature – current art from Holland*, at the Cologne Kunstverein and *Pier + Ocean, Construction in the Art of the Seventies* in London and Otterlo, also engage with this topic. During the course of our continued discussions, my interest was also awakened for body art and performances. Gerhard then increasingly accepted these tendencies, and later became the chairman of the alternative Center Stichting de Appel in Amsterdam. By the way, the organisation was carried out by Wies Smals, who soon became his lover. The two of them died with their baby in 1983 in a plane crash in Switzerland. This event was the worst in my entire life. We're still very much affected by it.

Were you able to support your husband in his work, or were you repulsed?
As soon as I became too critical I was repulsed; he didn't like that much. If, for example, I pointed to an affinity between his work and François Morellet's or some other artist's, he didn't want to hear it. I was also not supposed to help in the studio because I wasn't precise enough. Everything depended on precision to a tenth of a millimetre. By the way, he couldn't bear an assistant either.

How could you help him then?
That wasn't really my job as a wife. Gerhard himself had to be responsible for his art. But as I said, basically we influenced each other through our many discussions. Not only as an artist, but also as a curator, Gerhard engaged with nature and discussed a lot with Richard Paul Lohse, Max Bill and Morellet. I probably inspired him to do this. At that time there was another acute topic about which Gerhard was enthusiastic without my input. The concrete or constructive artists all had the idea of creating models according to which society as a whole could be oriented, improved and reinvented; especially Richard Paul Lohse proposed this ideal of modernity. Around 1979 there wasn't much talk about post-modernity, although there were some publications about it in the

1970s. But it all really only started in the 1980s. Gerhard thought around 1978/79 that all those who were working with nature were very strongly engaged with the aspect of finitude. Therefore he chose for his *Pier + Ocean* exhibition, together with the artist Norman Dilworth, the metaphor of a pier from which you could experience infinity and the ungraspable: the endless ocean, history, time, the immaterial, the limitless, whatever. By the way, the exhibition title originally came from Michel Seuphor for a work cycle by Mondrian, not from Mondrian himself, for then you wouldn't have been allowed to use it without further ado. Implicitly this exhibition *Pier + Ocean* helped introduce post-modernity, for it too was a revision of modernity.

Gerhard's preoccupation with Richard Wagner was probably also triggered by me. I became enthusiastic about Wagner for the first time in 1977; it was as if I had suddenly seen the light. At first Gerhard was completely opposed: you couldn't convince an artist who was against mystification and genius about Wagner. Bach was important for him, and Haydn too. But in 1979 he came along to Bayreuth and had to concede that Wagner had brought a completely new, autonomous vision into art and that there were elements in his oeuvre, especially in *Parsifal*, such as progression or a variable repetition, which he also knew very well.

Did you often have exchanges with other artists?
Gerhard was always open to other artists. Some of them, such as Mack, Piene, Morellet and Mavignier, he had exhibited in the Galerie nota which he ran in Munich in 1960/61 together with Jürgen Morschel. He was close friends with Morellet and especially with Gianni Colombo. The latter was very often at our house, as was Kenneth Martin. The artists often went for long walks and discussions with Gerhard in the nearby park. Representatives of completely different artistic tendencies visited us, including Karl Bohrmann, Ad Dekkers, Henk Peeters, Norman Dilworth, Imi Knoebel, Jürgen Partenheimer, Gilbert & George, Jochen Gerz, Terry Fox, Fred Sandback, Dan Flavin; and Rune Mields and Dietrich Helms, the co-founder of the International Artists' Committee which Gerhard directed for a short time, also belonged to our circle of friends. I, too, had a close relationship with Colombo, Marina Abramovič and Ulay, and also with Rune Mields. Of the ZERO people, Gerhard had contact with Günther Uecker, who also accepted him as an artist. Mack and Piene, by contrast, at first saw him more as an art dealer, because he had exhibited their works. Gerhard began to take off somewhat later than the triumvirate of the ZERO group because he was a bit younger. Sometime after this he travelled together with them through Egypt at the invitation of the Goethe Institute in Cairo.

Did people from the museums and collectors come to you?
Yes; Rudi Oxenaar from the Rijksmuseum Kröller-Müller in Otterlo, who organised the major retrospective just after Gerhard died. Dieter Honisch and Uwe M. Schneede visited us. Frans Haks, who was most recently director of the Groninger Museum, was a very close friend. We already had a quite delightful relationship with Werner Hofmann when he was director of the Museum of the Twentieth Century in Vienna and organised the *kinetica* exhibition. Gerhard also had a good relationship with Ryszard Stanisławski in Łódz; probably for this reason Stanisławski travelled to Amsterdam shortly after Gerhard's death to express his condolences. Jürgen Harten, who at that time was an assistant at *documenta 4*, came to our wedding in 1967 to tell Gerhard that he'd been invited to take part in 1968. For Gerhard that was probably more important than the entire wedding. Jean Leering, the director of the Van Abbemuseum in Eindhoven and likewise a close acquaintance, was preparing this *documenta* at the time. In 1966 he had organised the *Art Light Art* exhibition in Eindhoven and showed Gerhard's large light-wall there in the museum's main hall. He repeatedly asked Gerhard to make a round, white object with a large round yellow disc on it for the museum. Gerhard never did. He always said he wouldn't make a movable fried egg for the Van Abbemuseum.

Of course, collectors also came to us, you two for example, Rolf Becker from Munich, Carel Blotkamp from Utrecht, and Rolf and Erika Hoffmann from Mönchengladbach, later from Berlin. Erika has remained a very dear friend of mine to the present day. Rolf is unfortunately no longer alive. They discussed a lot with Gerhard on long walks along the beach and purchased several works from him.

Antje, which artists or which meetings do you still remember particularly well?
The *documenta*, of course, which we visited in 1968. There Gerhard showed three particularly large objects for the first time. We were there a week in advance to install the works. For nights on end I had to hold the objects, although patience is not exactly my strong point. There I got to know many artists who meant a lot to me, and also Arnold Bode, the founder of *documenta*. During the short breaks I watched the others at work: Rauschenberg, for instance, or Carl Andre. Andre always came in with three 'floor-tiles' that looked like the paving flagstones in front of the hall. He had a long beard, walked at a measured pace like a priest, and laid down his floor-tiles like paths. Gerhard and Morellet made a bit of fun of him, which I didn't like. I fetched a small hand-cart on wheels and asked Andre whether he could use it; I wanted to help him so that he could bring in several floor-tiles at once. He then said something to me that impressed me deeply: for him it was a matter of the weight! He wanted to feel the weight himself, and the visitors too were supposed to sense their gravity when all the elements were finally laid out. For me that was such an important experience that, later on, I reflected a lot on energy and weight and incorporated this in my teaching at the University of Cologne. So if you ask me about a decisive experience, perhaps this was it. Apart from that, in 1976 Brâncuşi's *Endless Column* in his monument in Tîrgu Jiu in Romania especially fascinated me. At the time the Brâncuşi Congress was being held there, which was also attended by Carola Giedion-Welcker and Max Bill. I later wrote about Brâncuşi as well as about this magnificent art critic.

Did living together with Gerhard leave you time for your own work?
You had your own career as well as the children.
I always wanted to have children. Gerhard did too, which very much won me over to him. But at first I had a lot to do with my doctorate. Soon I was no longer certain about whether we could still live together. At that time I was active in the students' movement and in 1968 organised a lot for it as the student speaker from the Institute of Art History in Munich. One day Gerhard said that I should stop doing that because, for example, he had to wait for dinner in the evenings while I was at some meeting or other. He himself, however, had taken part in the revolt in the streets for a time, even at the railway station,

where he and others had blocked trains. That was a difficult time for us. For that reason I went back to Amsterdam for three months to do my research. There I received a magical letter from him, stuck together out of letters cut out from somewhere about how very much he missed me. I found it incredible to think about how long he'd taken to do it. So early in 1969 I travelled home again. There I gave birth to Julia. For health reasons I could only resume work on my dissertation after a ten months' maternity break, at first in Munich and then after our move to Amsterdam in 1970. The urge to keep on working, to write, has always been with me. Of course I've gradually learned to become more purposeful, not to take on certain things, so that I could cope with all the various activities. Half of the money, or even more, that I earned from my critic's reviews was passed on to a girl who looked after the baby for three hours a day. During this time I wrote. When I had to go to editors' meetings in the evenings, I was very unpopular. And when I wanted to go to the university because there was trouble at one of the various editor's offices in Holland, Gerhard said that I should remain a freelance author; he said he wouldn't approve if I received a fixed salary from the university at the end of the month. He said he would feel dependent on it; but he really wanted to remain free of a civil servant's salary. Apart from that, he wanted to move to Berlin. But then I would have had to give up my recently acquired lecturer's position at the university and also my editorial work for various periodicals. At that time in Berlin, socially committed art was *en vogue* and I hadn't engaged with it for good reasons. I was simply against the idea that now stated, with some exaggeration, that a Gothic cathedral as a whole had been created by the community of human beings. There are only a few who are capable of giving something a new form, perhaps a team, a collective or a stonemasons' lodge, but not a mass of people, or all the residents of a town. But such supposedly 'élitist' ideas were impossible at that time in Berlin; I'd never have got a position at the university. Gerhard had to decide between Amsterdam and Berlin. That was certainly difficult for him. And so I worked as a lecturer at the university in Amsterdam – fortunately, because when a period of overwintering came for Gerhard in which he didn't sell anything, this occupation was a blessing for all four of us. And when he died, I wouldn't have been able to support the family otherwise.

How old were the children when he died?
They were nine and twelve-and-a-half; I was 43 years old. When I was at the university, the short-term writing decreased. I was still working for the *Süddeutsche Zeitung*, but less than before, and more for journals instead. Doris Schmidt, my main editor, retired. And I also wanted to write longer essays and be active in scholarship. That was a slow process.

Which trip do you remember particularly well?
I could only really travel with my children after Gerhard died. In 1985 we travelled together to Egypt and in 1986 we travelled with a camper-van through the United States. Before that such things weren't possible because of the lack of money. Most of the trips with Gerhard were associated with setting up an

exhibition. We only rarely had real vacations; he didn't want that. I remember very clearly the first trip with the baby to Venice to set up the light-wall in the International Pavilion. Julia was only two-and-a-half months old and lay on a thick piece of foam next to all the technical equipment. When Moritz was born in 1973, I was working on a film for Südwestfunk and took my new-born baby along with me. That worked out; it became routine.

What excited you especially about living together with Gerhard?
In contrast to friendship with others, it was this very, very strong exchange, and also a freedom and responsibility which I hadn't experienced before. That really revolutionised my thoughts and my actions. Before that I'd experienced another kind of freedom, more a freedom of action, because I was living in a tiny garden-house way outside Munich for only fifteen marks a month. Even there, I had many visitors with whom I could talk, but it was not of the same calibre of independent thinking as was the case with Gerhard. And of course, I found his kinetic art was overwhelming. Gerhard's work contained a lot of humour, a kind of intellectual wit. That was surprising for me because as a native of Hamburg I tend to be rather lacking in humour. And despite all the aggression that sometimes resulted from his criticisms of other artists, there was an enormous need to have an exchange with them.

Would you let yourself in so intensively for a life with an artist again?
For me, Gerhard was at the very heart of my family of four, my mission and my aim in life. Today I see it the same way, even though I've moved on considerably during the past 29 years, probably because I'm still working for him, and I talk a lot about him and his art. After Gerhard died, I lived together with a painter again for four years who was completely different. Gerhard had met him. I've never had the feeling of having replaced him with this man. I didn't want to. He was a 'wild' painter, much younger, another generation of artists with which I engaged as an art critic who was already well-known. Thomas Niggl, Gerhard von Graevenitz, Floor van Keulen – each time it was a new gateway. That some-one spoke about something that Gerhard had rejected: wild, primitive painting, once again the gesture, the enormous urge to narrate something in art; for me that was a new spiritual adventure. But primarily I was concerned of course with the human beings, just as with Gerhard, whom I didn't marry simply because I esteemed his art. My present husband, Martin Adrichem, by the way, isn't an artist.

What dreams and desires do you have for the future?
Gerhard always said that you shouldn't disturb pilots when they're flying. But I'll tell you nevertheless: at the moment I'm very interested in Nam June Paik.

Shortly before his stroke, after which he could scarcely speak, I had a discussion with him because I'd written about him and Heidegger. People assume that Paik had been interested only in Buddhism, Confucianism, Cage or Schoenberg. But when he was studying composition at the College of Music in Freiburg, he also engaged with Heidegger and even bought the recording of his talk on the *Principle of Identity* in 1957. During our meeting he confirmed this; for this reason he'd adopted the corresponding passage from my published essay at the last minute before his catalogue for the Venice Biennale went to press in 1993. I now want to expand on this. I don't think very much about my afterlife; in this respect I'm probably not a typical art historian. With advancing age, in contrast to earlier on, I no longer know so precisely from where the wind is blowing, what artists who are still unknown today are engaged with, what their key concepts are. It wasn't easy to recognise this lack. There's also a generational time, and therefore I'd prefer to work through what happened before and during my time. I publish on Sigmar Polke and Marcel Duchamp, and repeatedly on Beuys. At present Paik is my topic.

From the kind of rustling, Holweck always knew very well whether I was in good form

Christiane Mewes-Holweck

Christiane Mewes-Holweck, artist and art teacher, was for three decades the professional and private partner of Oskar Holweck (1924–2007), whom she married in 2006. We met in April 2012 in Bechhofen in Rhineland-Palatinate.

Mrs Mewes-Holweck, your husband, Oskar Holweck, was born in Saarland and lived and worked only there. Where do you come from?
I was born in Magdeburg, but I spent only two years there. My parents moved to Berlin in 1951 with my sister and me. There we lived for a year in a refugee camp because at that time you could only move to the territory of West Germany if you could show you had employment. In the meantime one of my father's colleagues at the theatre in Magdeburg had gained a foothold in Kaiserslautern and managed to get him a job at the Pfalztheater. So we came to Kaiserslautern, where I attended primary school and then the grammar school at the Institute of the Franciscan Nuns, where I teach today.

So your father worked in the theatre?
Yes; he was an actor and a director. He had staged plays in Magdeburg, Naumburg and Halle an der Saale. He also wrote radio plays, including for Saarland Radio.

Do you still visit your birthplace sometimes?
Not any longer, but earlier on, when we still had acquaintances there and my grandparents were still alive, we visited there for a week – during a period of 'thaw' between West and East Germany. I was only nine years old when my

grandmother died; only my mother was allowed to go to the funeral, and no one else. A school friend of my mother's came regularly each year to visit us after she had retired and told us about Magdeburg. But now there's nobody with whom I still have contact.

Did your mother work too?
Yes; she was a bookkeeper, but not really by choice. She really wanted to work in fashion. In Magdeburg there was a college that would have been suitable, but her parents thought that it wasn't a proper career. And when they finally agreed, the college was closed down by the Nazis. So then she went off to do her compulsory year as a farm worker, after which she completed her training as a bookkeeper. The training was not efficient, however, because the trainees constantly had to take refuge in the air-raid shelter when the sirens sounded.
By the way, my mother will soon be 86 years old. To mark the occasion, my sister will visit us again, together with my brother-in-law. They both studied English and French and worked as translators in the Federal Language Bureau in Hürth. My sister is now retired.

With whom did you have the more intensive relationship, with your father or your mother?
That's hard to say. As far as the things that interested me were concerned, it was really my father; and with regard to practical things, my mother.
For me and also for my sister, shared experiences with my parents were important. At first my father still worked at the theatre in Kaiserslautern, but when he had to go on tour with the ensemble, he refused. He said he couldn't do that with two small children. That meant that his prospects of continuing to work there faded. He then had various jobs and finally got a position with the American forces as a translator. But at least we were together.
We frequently went into the forest on weekends, to the Großer and Kleiner Humberg. Later on, when my parents had a small car – a Lloyd 400, the 'Band-Aid Bomber', made of plywood covered with artificial leather that had to be waxed and polished, which we children were allowed to do – we drove into the lovely environs of Kaiserslautern which we hadn't yet discovered at all.
We heard a lot of radio; there was still no television, and a visit to the cinema was something special. When the radio programme wasn't good, our father read to us on weekends and winter evenings, or we painted and made things with our hands. In this way we got a very good impression of literature early on. Our parents also liked classical music, especially operas, and we children did too. In the car we sang operas, or rather bellowed them, you could say. We knew a lot that other children didn't know.

Did you also go to the opera?

Yes, sometimes. But we mostly heard operas on the radio. Later on, when I was already attending grammar school, we got a record player. At that time you still had to pay school fees. Since my elder sister attended the same school as I did, the amount was reduced for me as the second child. On the basis of my achievements and conduct, I also received a couple of hundred marks' additional support. One year my mother purchased mattresses for us with this money. But we begged so much that she finally bought this record player with the big needle on which you could play 78 r.p.m. records. By the way, I still have it today.

We also saved up our small amount of pocket money, five marks a month, to buy opera records. Every now and again, our 'nominal relatives' also gave us some money. We liked Callas very much, and I still do. On one of the first records given to me, the soprano, Erna Sack, sang, and then I bought one with Jussi Björling, the Swedish tenor. On that one I liked the aria from the *Pearl Fishers* by Bizet, in French, most of all. I had just started my first year of French and found the record just great. When, on the last day of school before the vacation, we were supposed to bring something along for the lesson, I brought this record to class. All my fellow pupils laughed, and the teacher then got very angry.

I'm very grateful to my parents for introducing us to music and also, as I have mentioned, to literature. When one of us children was sick, we got books which at the time cost 95 pfennig or 1.95 marks. As soon as we began to read we became members of the town library, like my parents. We could always talk to them when we couldn't get into a book.

What dreams did you have as a young girl?

Dreams like everybody else's: I wanted to become an actress. My father didn't have any sympathy at all with this idea because he knew about all the difficulties with the theatre. But these dreams faded with time.

What career did you then choose?

I was very much interested in architecture, painting and graphic art, in everything to do with fine art and shaping things. Most of all I would have liked to move to Berlin to study, but my parents were against this. There I would've been totally cut off. I would have always had to fly when I wanted to visit them or if something happened. To travel by train was too risky. I couldn't decide for myself because as an eighteen-year-old matriculated student I was still a minor. Instead, I was supposed to go to Mainz, but I didn't want to because I didn't know anybody or anything there. Finally we agreed on Saarbrücken as a compromise, where my sister was already studying. So I travelled with my mother to the Werkkunstschule (art and craft school), as it was still called at the time, and introduced myself. The director, Professor Robert Sessler, looked at my portfolio,

found it very good and said I should apply. First of all, however, I had to do one year's compulsory commercial practical training. I worked at a big, very fine book-store in Kaiserslautern that was run like a family business by a pair of siblings, which I liked very much. When the year was over, they didn't want me to go, and if I hadn't believed so doggedly in studying in Saarbrücken, perhaps I would even have stayed.

In the vacations and after my studies, I still helped out there occasionally. The contact remained until the owners died.

And after this year at the bookstore, you went to the Werkkunstschule?
Yes, for a total of four years. Before you specialised during the three-year training, you had to pass the one-year *Grundlehre*, the basic training course, comparable with the *Grundkurs* (basic course) at the Bauhaus. Independently of what specialisation they planned to take later, every student took part in the basic training in brightness, colour and materials. The artistic means were first investigated in isolation, separately from any context, and only then within well-structured tasks. Then they were employed in combination in freely applied exercises. This initial reduction to the craft basics meant that we got to know the materials very intensively.

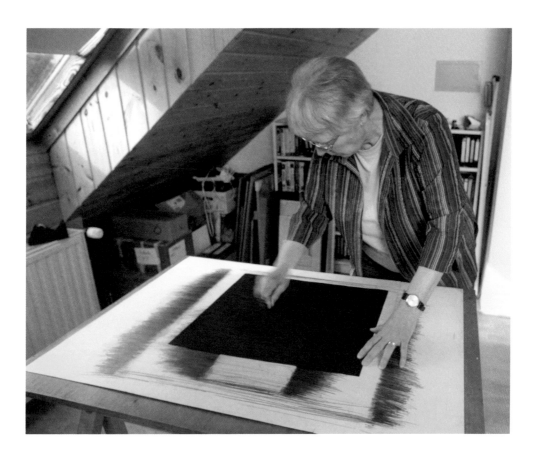

Running parallel to the *Grundlehre*, there were courses in art history, woodworking and metalworking, in visual and auditive perception as well as in representational geometry and algebra.

I did this basic course in 1968 with Oskar. I was very interested in the method of working, and it appealed to me very much that we 42 pupils had a fixed time-table. We didn't have a choice about which classes to attend, but I was quite satisfied with this tight, but not strict, organisation. After all, it was a basic training course. In an artistic career you have the freedom to set tasks and rules for yourself, but you also have to discipline yourself.

Which specialisation did you choose after the Grundlehre?
After this first year in which we all acquired the same foundation, you could choose between graphic design, communication design, industrial design, the textile class or interior architecture. Before my time, there was also a class in painting. I decided in favour of the three-year training in graphic art, or communication design, as it was called at the time. To a certain extent I already wanted to go into advertising, but my attitude was thoroughly ambivalent. Director Sessler and his wife were very much engaged with Amnesty International; by the way, he designed its letter logo, 'ai'. One of our set tasks was to design a poster for an Amnesty fair stand. This kind of advertising – for a town, for museums, for an idea, for something I was persuaded of – interested and attracted me. Later on, apart from teaching, I did illustrations for a French textbook for the publisher, Moritz Diesterweg, to earn some extra money. This enabled me to realise my ideas to some extent.

Did you also have contact with other artists at the school?
Yes, particularly when artists had been invited to give talks or to show small-scale exhibitions. Oskar in particular encouraged us to address them without shyness. And at the Saarbrücken Music College, which also had a department for theatre and acting, there was an initiative by young people who performed experimental plays and made music in a basement theatre, the 'So-called Theatre'. We often went there, also with our teachers.

Oskar was your teacher. How did you get to know him more closely?

We got on very well and worked very well together. We were on the same wavelength and had the same aims. I admired and esteemed him. At that time it was nothing more. He was married and thus out of bounds as far as I was concerned. His wife was very ill and died in 1974.

When the Werkkunstschule was incorporated into the Technical University in 1971 as the Faculty of Design, there was no longer a separate secretary. I took on part of this work for the *Grundlehre*; after I completed my diploma, this also included preparations for the examinations and other tasks.

Before that, my class had been given the task of working on revising and supplementing an exhibition about the *Grundlehre* which went on tour through Britain for a year. After that it was supposed to be shown in Saarbrücken. Oskar made the matter attractive for us. We would have light in the evenings, it would be warm, we would be given information, and he would look in every now and again. To be sure, in this way we got enormous insight into things that we hadn't known before.

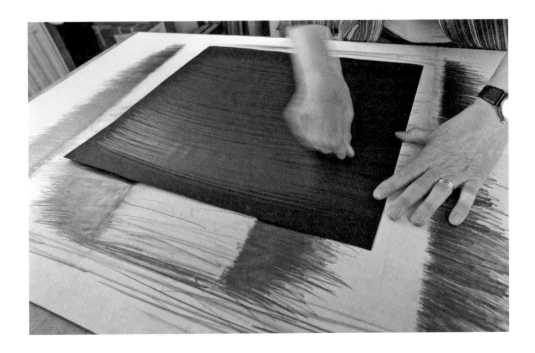

I took care of all the correspondence and written stuff. I'm very good at organising. Study and work gave way seamlessly to each other. Since it would not have been possible to complete the curriculum in colour, form, rhythm and movement because of these preparations for the exhibition, Oskar offered the missing lessons in basic training the following year outside the usual teaching times. In this way there was constant and also very close contact.

Students and lecturers in the *Grundlehre* and the specialised courses also undertook projects together outside the school. With 240 students over four years, the school was small.

When did things get really serious with Oskar?

Here we're jumping ahead. That was not until the end of the 1970s when we'd already known each other for more than ten years. At first, in October 1972, three months after my diploma examinations, there was a phone call from Oskar in Saarbrücken – I was already in Kaiserslautern at that time – to say that he had a part-time teaching job for me. Earlier on he had already advised me to go into teaching; he said I had patience and also a pedagogical streak. Of course I accepted this offer immediately.

Only the lessons that were actually given were paid for. You got your fee only at the end of the semester, but Oskar negotiated with the administration that I'd get my money each month, since this was my only income, and a very meagre one at that. Since I decorated the display window at my old bookstore on the weekends, and assisted on Saturdays, I was able to get by. In addition I was still teaching in adult education. And then my former school asked whether I could substitute temporarily for a teacher. I accepted under the condition that I'd be able to keep my part-time teaching. So I was working in Saarbrücken from Monday to Wednesday, and from Thursday to Saturday at the school in Kaiserslautern.

During the period of part-time teaching I also worked a lot privately for Oskar, preparing exhibitions, taking care of correspondence and such things. In this way it came about that we became closer and closer.

Were you able to help Oskar with his artistic work?

I did support him, but to what degree only became clear to me much later on. I did my own artistic work initially at home, separately from him, for good reason. I didn't want to be influenced by him too much, and I also didn't want people to say perhaps that there was a little bit too much 'Oskar' in what I did.

At the end of my studies I gave him a work that I'd just finished because I didn't know that I would get the part-time teaching and return to Saarbrücken. I'm sure you remember the children's clothes in which the upper part was smocked. These works with which I began early on looked something like that. If you

press firmly with the pencil on the relatively soft paper of a drawing pad, it expands and becomes even softer, like textile. For the work I gave Oskar, however, I took another white paper that became hard and began to shine. He found it great and said I should stick with it. In principle, I did that, but I changed something decisive. I wanted to expand the material through pressure, but I couldn't find any utensil that wouldn't colour the white paper; even metal left behind streaks and everything looked smeared. Then the idea came to me to use black cardboard. It expanded, you heard not only the hatching, but also the material at work, similar to how the carbon paper in the typewriter used to 'work' and rustle. And that was how it was here, too: when the surface began to rustle, the uppermost layer had separated through rubbing and expanding, and I only had to lift off the layers from one another from the side. I always found that fascinating, to follow what I heard, because I didn't look directly at the paper, but closed my eyes or looked somewhere else. By the way, from the kind of rustling, Holweck always knew very well whether I was in good form, or whether I'd lost my rhythm. With one of his last works he said he had to think of my way of working, and that I'd given him the idea. But we didn't talk much about it.

In the State Gallery at the Saarland Museum in Saarbrücken there's a wonderful work by Holweck made in 1988, at about the same time when the Faculty of Design at the Technical University was destroyed, in our estimation, and the Academy of Fine Arts was established. At that time, strangely enough, we had the same ideas about working with the material, lifting, 'getting under the skin'. And the business about the abolition of the *Grundlehre* went very much under his skin: his life's work was pretty much destroyed. It was at this time that he became ill and suffered a heart attack. That was the only time we had an exchange on a linguistic plane about this knowledge, this separating-off, this feeling-beneath and seeing-beneath. Otherwise I noticed only from his look whether he was simply amused by my works, or found the path I had taken to be right. However, he never influenced me directly as he had during my studies. And conversely, I, too, would never have presumed to do so with regard to his either.

You inspired each other! Did you also have exchanges with other artists?
We didn't constantly seek contact, but we went to exhibitions and met other people. With Ernst-Gerhard Güse as director of the Saarland Museum, Saarbrücken was fantastic at that time. Of course there were exchanges there.

Did other artists or museum people come to your place?
No, not into our home. Oskar didn't want that. He always said that no one should come into his private domain. And so this was moved exclusively to his, or rather, our studio in Saarbrücken.

Do you recall who they were?

We were visited by museum directors from all over the country, by art dealers such as Gudrun Spielvogel, Franz Swetec, Edith Wahlandt, and earlier on also by Adelheid Hoffmann and Hubertus Schoeller. Since at the time almost three-quarters of the young Saarland artists had studied with Oskar or with us, there was close contact with them, but mostly restricted to official occasions. One exception was Till Neu, who did his doctorate on *Grundlehren*. Many artists who exhibited in Saarbrücken also came to the studio, including Raimer Jochims, Raimund Girke, Arnulf Letto, Seiji Kimoto, Gotthard Graubner, Georg Karl Pfahler, and of course Heinz Mack and Günther Uecker. I only got to know Otto Piene personally after Oskar's death. There was correspondence with Italian, Spanish and Dutch artists or museums, primarily in connection with exhibitions, especially ZERO activities, but also with the United States and Australia when it was a matter of questions concerning teaching. And I recall that you as private collectors often had contact with my husband.

Do you have records on this?

Records would be exaggerated, but Oskar kept a kind of diary in small calendars. What he recorded there is already quite incredible: who visited him when, as well as short notes on events that happened. These entries helped me also in inheritance matters because I could prove what had been sold when and via whom, and that many works were simply no longer here.

Which encounters have remained in your recollection as particularly interesting?

I like to recall the conversations with Arnulf Letto and the photographer, Kilian Breier. One conversation especially has stuck in my memory: at the Josef Albers Museum in Bottrop we discussed the art market and the way art is dealt with with the director, Ulrich Schumacher, the son of Emil Schumacher. It was a very fundamental conversation: how dicey the art market was because, through its actions, things can also be destroyed. I know of a sculptor, for instance, whose large steel sculptures were very good. Nobody was interested in him and he hadn't found anybody to manage him, to put it that way. He no longer saw any options for himself in Europe and went to America. Before that he destroyed his sculptures and sold the material at scrap prices. In America you now pay hundreds of thousands for his works.

On the other hand, today the term 'artist' is used in an inflationary way. What I am going to say now sounds malicious, but I don't intend it to be so malicious:

many of those who call themselves artists today should perhaps first learn their craft. In any case, I think it's very important that artists get a solid training. Therefore we were so disappointed when, with the founding of the Academy of Fine Arts, the Faculty of Design was completely reshaped and the basic course of studies disappeared. Oskar thought that this had been a unique course on offer in Germany.

At that time I made a video recording: *Training to Be a Dilettante*. Apart from professors such as Graubner, KP Brehmer and Fritz Seitz, who was downright enthusiastic about the basic training at the beginning of studies, students also had their say. Many of them said rather derogatory things about lecturers who only looked in very occasionally and didn't give any proper instructions. Oskar had experienced that earlier on in Paris: the professor didn't explain to the students why a work was bad or even good. He left them to their own devices.

How do you deal with your pupils at school?
When I do corrections for my pupils, I write on the back, on the edge or mostly on another sheet of paper, but never on the drawing itself. That shows a lack of respect because at that moment they've given their best. I try to explain how it could perhaps work differently and better, and then they also go along with me. When I am teaching drawing in the senior class, we speak about theory, that is, the pupils learn styles, techniques and similar things, and we work practically. Art itself can't be taught, only how to handle the means – that was the way Oskar described it. And you can awaken slumbering abilities, or a sensibility.

Let's come back to living with Oskar: did you travel around together?
Only to exhibitions, and that only for brief periods, for one or two days. Oskar didn't want to travel. He was very much a home-loving man rooted to his native soil, like all Saarland people. We travelled around privately, mostly in southern Germany, for example, to Maulbronn, Aalen and Neresheim with its impressive, not too heavily decorated Baroque church. I recall how a monk was practising on the organ and how the regular evening service took place – in a wonderful atmosphere and with amazing acoustics. We also travelled frequently to Alsace. But I was working at the school, and the school holidays didn't coincide with the semester vacations, so that only short trips to the environs close by or further away were possible.

A very personal question: would you let yourself in for such a life again?
Yes, any time. You also knew Oskar. He was a man with charisma. He could arouse people's enthusiasm incredibly, not just girls who simply melted away, but also the boys. Apart from that I don't know any other life. I imagine everyday life in another form as perhaps more boring, which may be false. My life was very varied. That didn't have to do with Oskar as an artist, but as a human being. He had an incredible, mischievous sense of humour and did things about which I still laugh even today when I think of them. Nobody could resist it. When the mood was bad, Oskar always made people laugh and think of other things. That was always interesting, always full of surprises. And he was a very warm-hearted

person who treated others with respect. He formulated and argued in favour of even harsh criticism in such a way that the person concerned could accept it.

What do you dream of now?
I want to see that Oskar's works are safe. That's a very great dream I'm working on. I want to bring his works, inasmuch as they are available, into a foundation and hope to get the right contact persons and advice. It would be a sad thing if they were dispersed to the winds in all directions. If they had to be divided up, then surely his hometown of St. Ingbert would have rights, or Saarbrücken or the ZERO foundation, which already has some works.
Also Oskar's applied works, which hardly anyone knows, must be better protected. He painted 32 square metres of ceiling in the chapel at Überroth. When the roof started leaking and the ceiling was stained, the entire painting was chipped off without Oskar's knowledge. Even the sculpture on the roof of the mathematics faculty at the University of the Saarland was removed at some point and stored in the basement.
I want to make contact with the pastor in Fechingen and exert my influence so that the church there, on which Oskar had also worked, is not torn down. But I fear that my life will not be long enough.

A short time ago we looked at photos in the other room and saw works by Oskar on the wall. Is that now your studio?
Yes – or no, properly speaking not *my* studio. You know, after Oskar died, someone said to me that I must have loved my husband very much. I didn't like this use of the past tense. When a person is no longer here, that doesn't mean that you no longer love him. It remains. And in this sense it's not *my* studio, but *our* studio.
By the way, I haven't worked as an artist for ten years, but now I'm itching to do something. In the drawers I've found many of my trial works. I'll get stuck into it in the summer holidays.

We're like a family business

Christine Uecker

Christine Uecker has been living for decades with
Günther Uecker. We met in Düsseldorf in June 2010.

*Christine, we've known each other for a long time, but I don't know much
about your childhood and youth. Where were you born?*
Now I'm surprised. I thought you'd first want to hear from me how I met Günther.
Well, I was born in a small town in Westphalia, in Lemgo, but I won't say when,
if that was going to be your next question.

Has your birthplace had any influence on your life?
No, not really. Lemgo is a little medieval town that's famous or notorious because
the last witch was burnt there... For that reason, perhaps, the place has had an
influence on me after all. I had a wonderful childhood. I taught myself to swim in
the river at the age of four. My childhood lasted a long time.

How important were art, music and culture in your parents' home?
At home literature in particular was important; my father read a lot. I remember
a glass cabinet with 'forbidden literature', that is, literature which my father
thought I was still too young for. It stood in the second row behind the other
books. When my parents were away from home, I took a chair, reached behind
the first row of books and found the really interesting things to read, such as
Dostoyevsky's *The Brothers Karamazov*. In this way my curiosity for literature
was awakened.

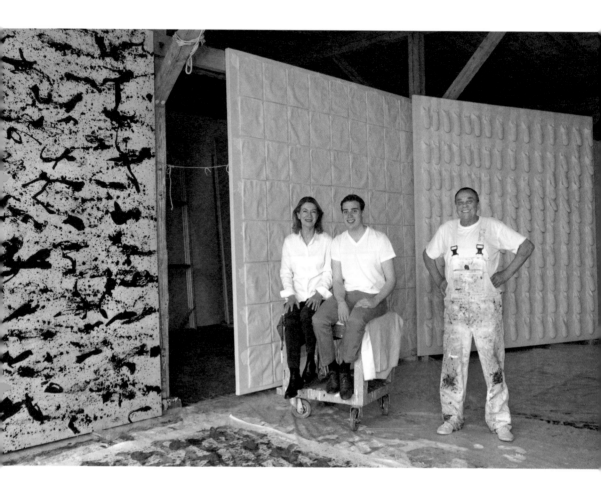

What did your father do for a living?
My father was a civil servant at the Ministry of Finance, so I'm a civil servant's child from a middle-class family. Through my father's job we moved from Lemgo to Detmold, and finally to Düsseldorf-Rath. The Aaper Forest there was the continuation of my childhood, a wild, magnificent, adventure playground. We played Indians; my big sister was the chief, and we ate sorrel on the railway bank. When we moved to the zoo and had to leave our forest, we cried. My mother worked, too: she was the mother of three children and a housewife.

Did you have a career wish for after school?

My elder brother had a very pretty girlfriend, a bookseller. She was my model: I wanted to become a bookseller and to live and work with literature. Even during my apprenticeship, Werner Höfer, the television director at Westdeutscher Rundfunk, came to an autograph-signing of his first book. As an apprentice I had to hand him the books for signing. While autographing he suddenly asked me whether I wanted to become a television announcer. For him I was the nice, well-behaved girl from next door, and viewers liked that.

I then started working in television in parallel, even during my three-year apprenticeship. In the mornings I went to the Schrobsdorff'sche Buchhandlung and in the afternoons to WDR. At the same time I was taught elocution by an elocution teacher.

Later on I gave up the bookstore. For Uecker it meant getting up too early, because I had to get to work in good time. After that I worked only for television as a regular freelancer.

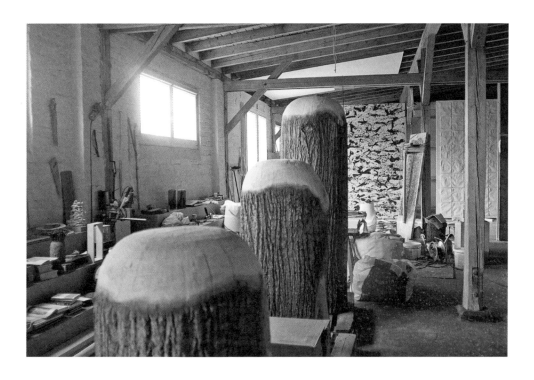

What did you do in television?

I was an announcer, a news-reader and also introduced a magazine on adult education. The third WDR station was different from the rest of television. It was regarded as an education channel, and we were proud of it. There were five cultural programmes each week. The writer, Jürgen Becker, wrote the script for the film, *Schreiben und Filmen* (Writing and Filming). I ran through the film as a young bookseller and was also able to speak my own lines which finished, 'Then I'd rather be literature myself'. That described my world of emotions at the time.

Dealing with literature – was that your dream?

As a young bookseller I had the dream of living with or supporting an important writer. My dream was to take part in a creative life. Then Uecker stepped into my life, and so it became an important artist instead.

Where and when was that?

I was nineteen years old and already in television. I got to know Günther at a party at the home of an editor who made programmes about art. For that reason many artists were there, I believe, including Jef Verheyen. The art dealer Hans Strelow was also there. I came together with a friend from my youth who had majored in German studies and who was leaving the next day for Wisconsin to take up a professorship. It was really our leave-taking. And then someone was standing there who looked so strange. He was simply standing there by the wall looking at me. Somehow that was uncanny. It had something of a wild animal, the way he simply stood there and concentrated on me and cast a spell over me with his gaze. That was Günther Uecker. The German studies professor-to-be and I left the party. Günther then went to a lot of trouble to get to know me; he made inquiries about me. One evening he was standing in front of the Schrobsdorff'sche Buchhandlung on Königsallee. I was so shocked that I disappeared through the back door. Strangely enough I met him the same evening in Restaurant Spoerri, and later we went out. He was so strange that for a long time I rejected him. The spell was broken with our first lengthy discussion when he said that he could move mountains. He had just come back from New York where he'd spent several weeks making a sculpture for the *Earth Art* exhibition in Ithaca in which sand is moved through the air. What he was now saying about being able to move mountains had me spellbound. At that moment it hit me. Günther said that it had fascinated him that he'd seen something in me that evening, something that was related to himself, and he had thought even then that I was the woman with whom he wanted to live. And he was also fascinated by the fact that for the first time he had to make an effort to win over a woman. Otherwise, it had always been the women who had made the effort to win him

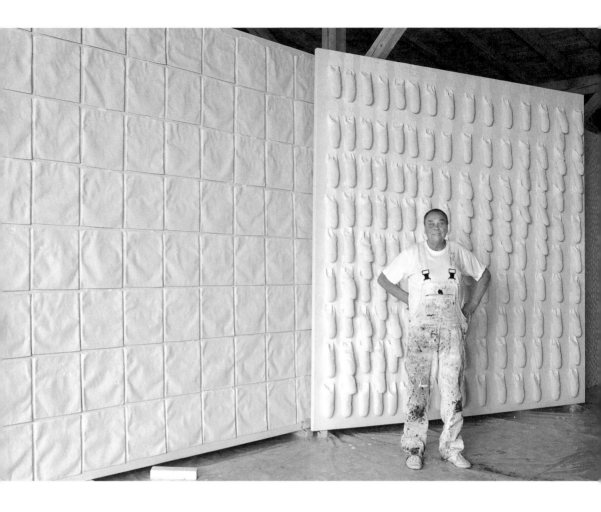

over. But now here was a woman who didn't approach him, but *he* had to... That attracted him. He found that very unusual and found me special. That in turn moved me. He had really made an effort to win me over. The next morning I received in the mail a copy of all his *Uecker Zeitungen*. So he had really made strenuous efforts. Then came wonderful letters from Ibiza where he travelled frequently to see his sister, Rotraut. Of course I still have all his letters. And then it happened that I fell so much in love with him that I forgot everything else. It

was really such a grand love affair. I also had family, my parents, my siblings, but only he still mattered. This being-in-love has borne us along to the present day – a long time when you reflect on the fact that earlier on Günther only wanted to tie himself down for two years. With his previous lovers that had become a principle. He always had to have the feeling of freedom, which sometimes wasn't easy for me. But I also had my independence and found recognition in my work in television. That played an important role for me. And to the present day we have continued to extend this 'two-year contract'.

Do you take part in Günther's artistic work?
Yes, but not in the concrete sense that he would let me draft a concept for him. That is his very own thing. Of course he creates his works alone. But we speak about them. Later on, our son, Jacob, arrived and from then on we undertook all the big trips to the exhibitions abroad together. Earlier on, we often took Jacob out of school so that he could be there. When he was studying in Bremen, at least I also went along. That's where family takes place, that's work, and with us they can't be separated; everything is part of everything else. In the mornings I sit with the telephone; that's also a part of my job. There are enquiries and projects that have to be discussed. But my role is rather a supportive one, that's quite clear.

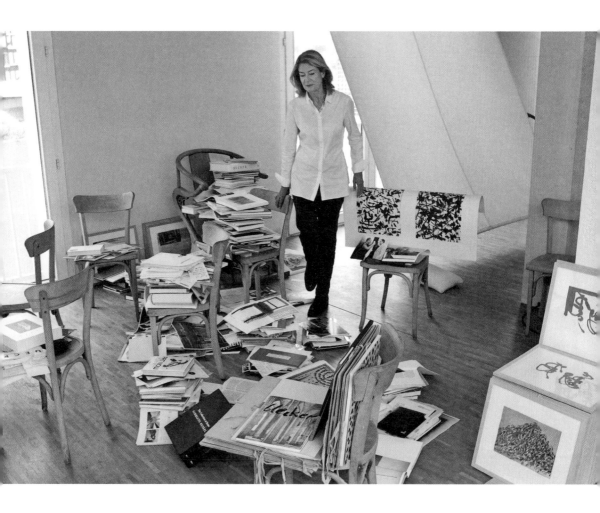

Were there encounters or exchanges with other artists from the very start?
I was so young that I absorbed everything very openly. That always meant a lot
to me. We met wonderful artists, in Japan for instance, with Noriyuki Haraguchi.
I think about that because we were there a short while ago. The first person I
met in New York was Carl Andre. The ZERO group was already history or had
just become history when I met Günther in 1968/69. Everybody followed their
own path, and so we didn't really have much contact with Mack and Piene.
That's only happening again today.

And did you have many visitors?

Yes indeed. I got to know Jef Verheyen right at the beginning. Günther and I lived together for ten years in a single room. That was really the best time, both of us say, because it was so intensive. You couldn't avoid each other. When there were arguments you couldn't simply withdraw into another room. You had to see it through. I can recommend to everybody that they live together in a single room during the first years of being in love. Many people were surprised at the time that Günther as a 38-year-old was prepared to commit himself to living with someone in a single room. But our relationship finally persuaded them.

Back to your question: Jef often stayed overnight at our place. Then we pulled out a bed from the cupboard; he always said that the 'white woman' was lying there waiting for him. Through the many friendly conversations with Jef a very close relationship came about. We had parties there, even the golden wedding of Günther's parents with many guests and relatives. Hans Magnus Enzensberger visited us too. It was with him and Nikolaus Lehnhoff that Günther made his first musical theatre, *Fidelio – Leonore*. The discussions went on into the wee hours and we danced in the garden. It was such an intensive time then, this concentration in a single room as if in a cell; you can't compare it with anything else. I travelled to Cologne and came back at night. At that time Günther worked especially in Fürstenwall, mostly for long hours until late in the evening, and I often came by on my way back from Cologne. Already at that time I'd begun to assist him.

Doing what? With correspondence and making telephone calls?

It was rather the humdrum tasks in the studio of preparing working boards, glueing canvases, things like that. During the course of the years, the tasks of course have increased.

How large was this room you mentioned?

It was a small apartment of about forty square metres with a large bed, a built-in kitchen, a wonderful garden and a small terrace – quite a dream.

At the golden wedding of Günther's parents, people were sitting everywhere and were eating even in the bathroom – it was magnificent. And we didn't think anything of it. That was simply the way it was. Gerhard Richter occasionally came to our parties; I remember that well. And frequently we rang someone up spontaneously, Georg Jappe or Gerhard Richter. Gerhard always went out by the front door and came back via the garden. Either way, he was one of the first artists whom I got to know because he had his studio in Fürstenwall, so that came automatically. Günther and he were together a lot at that time until at some stage Gerhard left the studio and moved to Cologne.

Did other artists also have their studios there?
No, only Gerhard Richter at the front on the left, and then you went over the roof to Uecker. But then Blinky Palermo arrived! My encounter with him was very warm. I think that Gerhard Richter left and Palermo came. Such artists, of course, leave a lasting impression on a young girl.

And there are no photos of this, no records?
Hardly any at all because we didn't even think of it. There are a few photos. At the Edinburgh Festival before the exhibition in Edinburgh, the artists got together in the studio and were all sitting on the roof. There are some good shots from this period.

How did Jacob change your life, individually and together?
It was a great piece of luck! Günther's greatest worry was that I'd become simply a mother and housewife. But I tried to defuse this worry, and six months after the birth I began to work in television again. I spent the money I earned in Cologne on baby-sitters. Jacob always had to come along; that's the way Günther wanted it. When Jacob was six months old, I followed Günther with Jacob to Arizona where he was working on an exhibition for the museum in Scottsdale. We stayed with his sister, Rotraut. In the plane a man almost wanted to award me an Order of Merit for good childcare because the baby made such a calm and satisfied impression. I followed the instructions of the nurse who taught me everything in the first weeks exactly. She had brought up three hundred children in Germany and, after a few weeks, they all slept through the night. We spent some time in America and from there went on trips together. Jacob was 'a good traveller'.
But he was also always with us in Düsseldorf. Often Günther called in the evening to say that he had guests and was sitting in a restaurant. We were supposed to come and join them. So I dressed Jacob again and we drove to Günther. Jacob fell asleep at the table. He had to get used to this life in a family with an artist early on. Günther always wanted him to be there. That became more difficult when Jacob attended the kindergarten at the International School. He was supposed to be there by 9 a.m., but Günther often delayed the leave-taking just so that Jacob would stay. For our family that was good, but it was not so good for school. Normally there is a separation of worlds for a child when school life begins. Günther didn't accept this; the nuclear family was supposed to be together.

And did you always travel as a threesome through the world?
When Jacob got a bit older and went to school I sometimes stayed at home with him. But that was really only for a short time. After that we tried to take him with us. At the International School it was possible to free him from classes; he

could attend school in America, which is one reason why we chose this school, but also because Rotraut lived in Arizona with her family, so that the children could communicate with one another.

How long in general do your stays abroad last?
Normally we arrive and go straight to the exhibition. Günther has such energy and discipline; it's incredible. So, we disembark, go straight to the museum, and set up over a week or ten days. And we try to add on an extra one or two weeks to see the country. Of course it's wonderful that we always get together with locals who take us to unusual places. After that Günther normally has lectures with the students. Our trips are very concentrated. In January next year Uecker has an exhibition in Cape Town where we were invited by the ambassador whom we met at Günther's exhibitions in New Delhi, Mumbai and Kolkata.
So our life as a threesome runs in such a way that Jacob and I support him; we're like a family business. Our everyday life is defined by the work; we've adapted ourselves to him.

Which artists have made a special impression on you?
I got to know Barnett Newman, but only through the stories told by his wife, Annalee, I must add. In her home she explained precisely where Barney had sat, stood or read. She spoke in such a lively way that he was physically there, and to the present day I still think that I had really met him. Günther, too, has told me so much about him. They met when Barnett Newman came to his exhibition in New York. Which other artists? Serra, Richter, Palermo, especially Palermo.

They are great personalities...
Yes, Palermo was so unusual. He was shrill, an extraordinary artist, never smooth, never conformist. He liked to dress up. At Carnival I danced with him. He came as a woman and it took some time before I recognised him! For me, from a middle-class family, he was so different, attractive and enclosed in his own world. We also met him on the street shortly before he flew to the Maldives, where he died. And his works! In his studio he left behind a triangle painted on the wall above the door.
My life changed so completely and opened up through Günther. That was precisely what I liked. I didn't want to leave this life again.

What do literature and music mean to you today?
Music! Through the wonderful concerts in Salzburg to which you invite us, you share a large part of our passion. Günther became deeply engaged even early on with musical theatre. The period in Bayreuth from 1978 to 1982 before Jacob's birth were great years. Wagner had grabbed me. For four years every

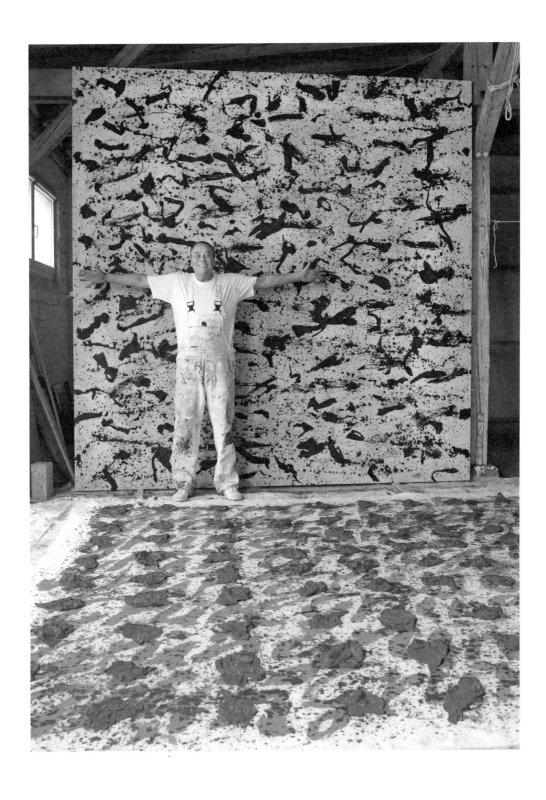

summer we were in Bayreuth at the rehearsals and performances. We were still able to experience Patrice Chéreau with his unforgettable *Ring*.

On the topic of literature I want to add: Günther says that he writes so much just for my sake, because I've always had this quiet yearning for literature. He's a member of the order Pour le Mérite – the encounters there are always highlights for me.

In Bayreuth you've got to know many celebrities from the world of opera. Tell us a bit about that.

The first person with whom Günther collaborated in this area was the opera director, Nikolaus Lehnhoff. One day he was standing there in our one-room apartment and asked Günther whether he'd do *Fidelio – Leonore* together with him. At the time it was still unusual for an artist in the fine arts to work in musical theatre. Günther ignored that. He was completely open and was simply fascinated. And so the performance of *Leonore* in Bremen came about. Hans Magnus Enzensberger revised the libretto and gave it another form at the end. So Enzensberger was involved as a writer, as well as Nikolaus Lehnhoff and Uecker. Later on he also worked a lot with Götz Friedrich. *Lohengrin* in Bayreuth, *Tristan and Isolde, Parsifal* in Stuttgart, *The Bassarids* by Werner Henze in Stuttgart and Bach's *St Matthew Passion* in Berlin. To meet the singers in Bayreuth, to take part in the rehearsals, to help in the workshop – they were simply four incredible years! Günther always said, 'If you have a child, you'll put him in lederhosen and walk around with him in the Festival Theatre'. It's a music with such a magnetic pull. You spend five hours under a spell in the Festival Theatre. I was even there for the rehearsal of 'Elsa' on stage, played her part, mimed. Götz Friedrich demanded bodily nimbleness of his singers. I burst into a sweat even as an extra. His wife, Karan Armstrong, was so supple; she could do it. A few weeks ago we were at Wolfgang Wagner's birthday shortly before he died.

Christine, a completely different question: what kind of dreams and wishes do you have?

That Günther lives for a long time; that's really my most important wish. Otherwise everything would be completely different. My aim is to achieve a balance, to find a personal balance. I have wishes of my very own, not so much visions. I want to have harmony within me and be an equable person. I want to develop in that direction, without fears. Life with an artist also involves strong emotions, and so I wish for myself that I may come to rest within myself more and take everything with composure. On the other hand, excitement is also important. Recently at the meeting of Pour le Mérite, Albrecht Schöne, who held the celebratory speech, said that he didn't want to live without adrenaline. That's right. I don't want that either. That's what fills life with vitality.

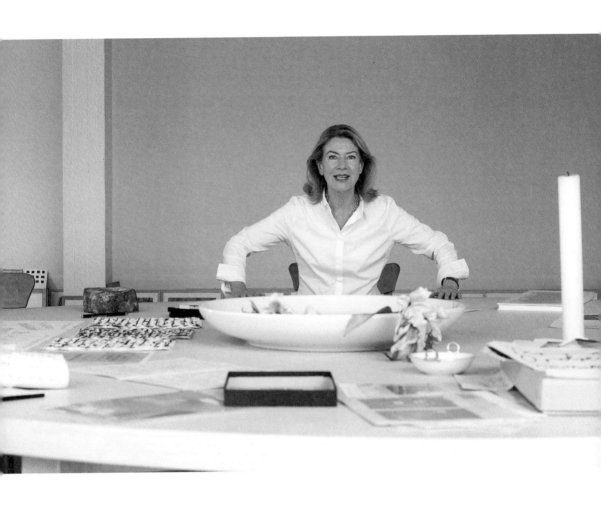

But then don't you also need times without adrenaline?
Yes, of course, I also need phases of calm. I go everywhere by bicycle, go swimming. That's my relaxation. You need a moment each day when you return into yourself. You can't always simply be there and available. What has driven me was to take part in a creative process, to bear some responsibility for the person and his work. This process is our life.

It's great good fortune
to live together for so long

Danielle Morellet

Danielle Morellet has been married to François Morellet
since 1946. We met in April 2011 in Cholet, France.

*Dani, your husband François was born in Cholet and you've been living here
for a long time. Where do you come from?*
I was born in Nantes, which is sixty kilometres from Cholet. Nantes is an historic
town with a somewhat oppressive history because in the eighteenth century its
harbour was the centre of the slave trade in France. In Nantes there is a very
beautiful castle, the Castle of the Dukes of Brittany, where, from the thirteenth
century on, the Breton dukes resided and which was later the seat of the French
kings in Brittany. Today Nantes is the sixth largest city in France. In particular the
climate there has always suited me well. The weather is temperate, neither really
cold nor really hot, and there's always a light breeze blowing from the sea.

Did you grow up alone?
No; I had two brothers who have died in the meantime. They were six and eight
years older than I was. Unfortunately I didn't have any sisters. Almost all my life
I've been surrounded by men: a father, two brothers, two male cousins, no sisters,
no female cousins, a mother, of course, no daughter, three sons, a granddaughter,
at least, a grandson and two great-grandsons. I'm encircled by boys.

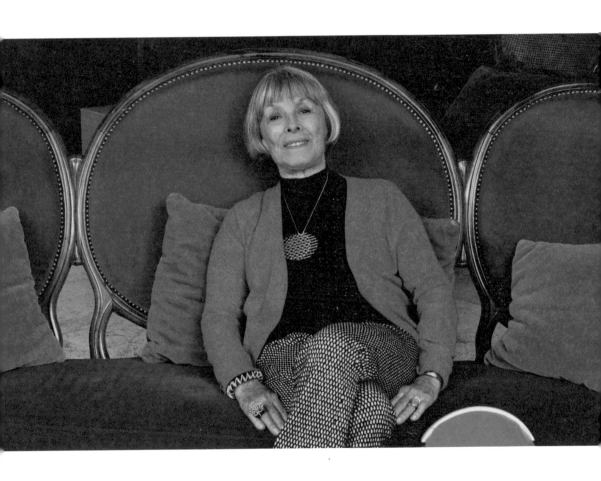

Was your family interested in culture?
Yes, but to a normal degree, nothing exaggerated. Classical, bourgeois culture has played a role, as one would expect in a city like Nantes. My father loved music. He had a mechanical piano with pedals and piano rolls. This way I already knew all the operas by the age of six.

Would you say your mother or your father left the greater impression on you?
Well, as a travelling sales representative, my father was always on the road and at home only at the weekends. My mother didn't work; she was a housewife and looked after us the entire day. For me she was an amazing mother. We were very close. When she died at the age of 94, when I was 50, it was terrible for me. We'd spent our entire lives together. She was simply wonderful. And she made sure that I worked, which went well.

Where did you work? In the household?
No; I attended a chic private school in Nantes called Cours Paviot, a good school, although I didn't like the nuns very much. From the age of six, I had piano and music lessons. I quickly made progress and was already a good pianist at a young age. When I turned eight, for my birthday I absolutely wanted pointe shoes for ballet. My parents agreed, and I had dancing lessons for five years until everything was interrupted by the war and post-war troubles. I just loved it! I was doing so much at once: I attended school, had private tuition in music, piano and dance, and was completely absorbed by this musical and artistic environment.

Did you have dreams as a young girl?
Just like any other small girl: romance, Chopin, Liszt, and I dreamed of charming princes.

What did you want to become?
My career was more or less predetermined because I was a good pianist. At the age of fifteen I won the Prix de solfège in the highest grade awarded in France. One year later I won a prestigious prize for piano with high distinction from the jury, then the prize of the City of Nantes. In 1943 I had to leave Nantes because it was being heavily bombed by the Americans and British; many people were killed and the houses were set on fire. Along with many other residents we fled from Nantes into the countryside to Clisson, a small place thirty kilometres from Nantes and Cholet. There we found a place to live. I continued to play the piano, but not as intensively as before. At that time all my friends had taken refuge in the countryside as we had done. Often we made an arrangement to meet on a certain day at a certain hour at a certain place. Everyone came by

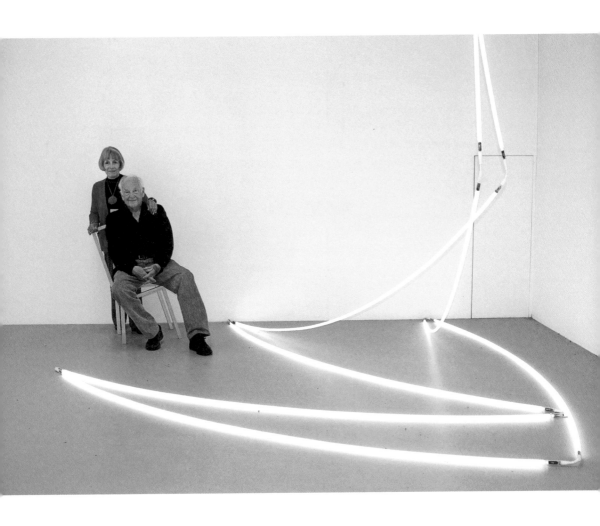

bicycle and brought picnic things; one brought a record player, another records. We ate together and danced. And then, early in 1944, I met François; I had turned seventeen just a few days previously, and François had turned eighteen in April. He had come together with an older, not exactly shy friend from Paris to spend holidays in Clisson. He approached one of my girlfriends from Nantes, for he had noticed that in the small town there were a few young girls who were obviously not from the country. That made him curious. This older boy then arranged a picnic on the following Sunday with my girlfriend. There I saw François for the first time, and it was love at first sight.

You were seventeen and he was eighteen?

Yes. François was very good-looking, like a Greek shepherd. But that was not the only thing. What mainly attracted me to him was that he acted in a slightly scandalous way. In comparison with the very nice, but rather conventional, perhaps bourgeois boys from Nantes, he was completely different. He used coarse words, told stories about sex; his trousers were shorter than those of the others, he went barefoot while the others wore sandals. I said to myself, with this fellow you'll learn things you won't learn from the others. That was my first impression.

Did you continue with your training as a pianist?

Yes; I wanted to continue studies at the Conservatoire in Paris but it turned out to be simply too difficult for me to live there, so young and completely alone. And of course, after getting to know François, I was completely confused because from that moment on I was in love. I did continue working with my teacher in Nantes. But I didn't embark on the career I had aimed for and which, under other circumstances, I perhaps would have attained. In 1945 we became engaged; we married in 1946, and a year later Frédéric arrived. Then, of course, I was occupied with other things and no longer had time to practise the piano regularly and to play. By the way, at this time François already called himself an artist. When we got engaged, he was studying Russian at the Institute for Eastern Languages in Paris, but he was already painting and drawing and said that one day he would be only an artist. I was convinced of that. Since, however, we had married young and the small family had to be supported, after studying Russian for three years, he entered his father's firm at the age of 21. Morellet-Guérineau was the largest factory for toys and prams in the whole of France. There he became commercial director and remained in that post until he was fifty. For the first ten years we lived in Clisson in the country house of my parents, where our children were born. In 1957 we moved here to Cholet.

After Frédéric s birth I was overcome by the longing to play the piano again, and again worked intensively. I had very good teachers, Marguerite Long and Yves Nat, to whom I travelled in Paris for my lessons. Particularly important for me was an artist who was not a pianist but a violinist, a very famous avant-gardist and professor for musical phrasing at the famous music academy in Paris: Joseph Calvet. With him I worked out many of the sonatas by Mozart and Beethoven. And thanks to him I gave concerts. We appeared in Nantes in the theatre with success; we played Mozart concertos; he conducted and directed the Engineers' Orchestra at the Conservatoire in Paris. That was a wonderful time.

Then Christoph and Florent were born. At that time François was concentrating more intensively on his artistic activities. And I said to myself, either you're a good pianist or a good mother and wife. So I completely gave up playing

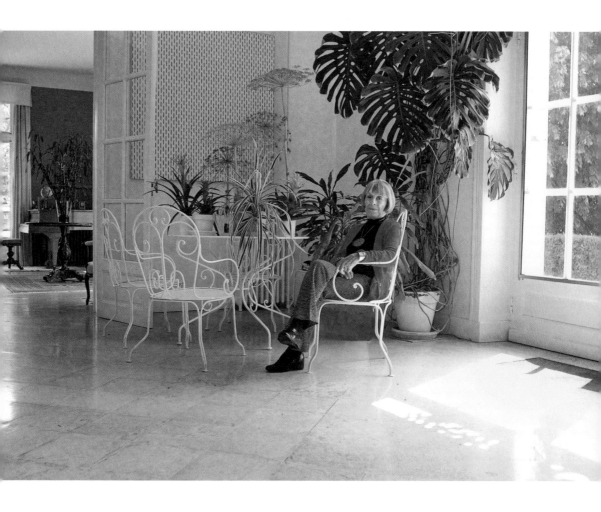

piano. I never played it again! In this profession it has to be all or nothing. That's the way it is when you've reached a certain professional level, a certain quality. Once you notice that you suddenly have to play more slowly or that you make mistakes, you have to stop and listen to others playing instead. I didn't regret it. I always said to myself that my work surely has its limits and François' work would be more interesting than mine. So I accompanied him and his work from the outset in every respect and didn't feel this to be a sacrifice.

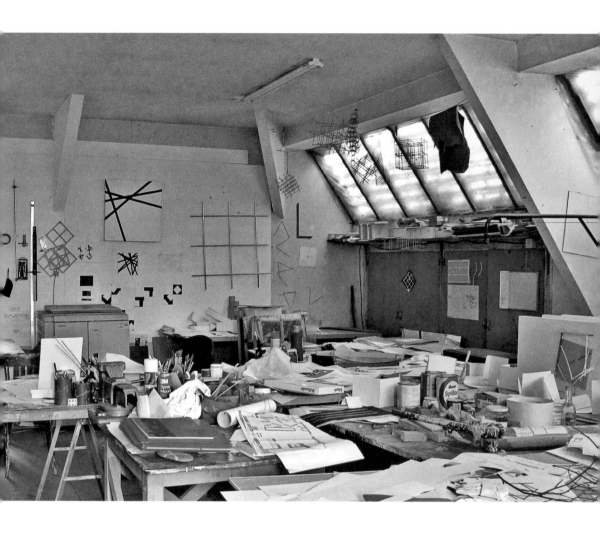

Once you were living together, you surely had many guests from the art business at your place?

Yes, artists, museum directors and collectors had always come to us, just as they do today. When François was still working at his company, of course, a lot of business people also visited us. We were leading a double life, so to speak. That was quite funny. In Cholet no one was supposed to know that the company's director was also an artist. It simply wouldn't have made a respectable impression. So we tried to hide it. Accordingly, I had two wardrobes, a very conservative

one for here, and an unconventional one for the occasions when François exhibited as, for example, in Paris with the Groupe de Recherche d'Art Visuel or in Zagreb with the group Nouvelle Tendance or in Milan or London, where I bought mini-skirts in Carnaby Street when they were *en vogue*. At that time my friends and I found this game of hide-and-seek very amusing.

Do you have notes or photos from this time?
Photos, of course. And I made daily notes in a little exercise book, not a proper diary, on where we had been and with whom. That proved to be very useful. Sometimes museum directors came and wanted to know on what day and on what occasion we had met so-and-so. Then I got out my little notebook and was able to give them precise information.

Which encounters with artists have particularly stuck in your memory?
Of the artists with whom we were close friends, particularly Joël Stein from the Groupe de Recherche d'Art Visuel, Almir Mavignier, Ellsworth Kelly, Jack Youngerman and of course Vera and François Molnár must be mentioned. And Yvaral, the charming son of Vasarely, who has already died. Vasarely himself was also a close friend of ours. And Gianni Colombo and Gerhard von Graevenitz, both of whom are no longer alive. Many are dead, unfortunately. We also knew Piero Manzoni well, and Jean Tinguely visited us in Cholet. There were so many. But they're the ones who occur to me spontaneously.

Did time and space remain for your own interests?
Yes, I devoted myself even more passionately to art than did François. I liked visiting museums and galleries frequently. I tried to take in as much as possible. And after 1949, when it was allowed again, we undertook many trips abroad. To Italy of course, then to Germany, Holland, Belgium, Denmark, Sweden, Norway, and to what was then Yugoslavia, to Greece, Turkey, Syria, Lebanon, Jordan, Iraq and Iran. They were journeys not associated with exhibitions. Rather we wanted to get to know the cultures, museums, castles, mosques, and the tourist attractions in general. But also – and now you'll be surprised – in order to discover the water or, more precisely, the waters: the rivers, especially clear seas in order to be able to fish. François is a passionate angler and a first-class under-water angler. He goes snorkelling and fishes with a spear-gun. From the age of three, our three children also went along and fished underwater together with their father. All of us were either in the water or, with a snorkel, under it. Wherever you can imagine, we have fished: in the Red Sea, the Mediterranean, in Cambodia before the civil war began there, in Brazil, Venezuela, in the Pacific and the Caribbean. Art and culture were on the one side, and the enjoyment of fishing in the sun and water was on the other.

Which trip did you find the most interesting?

The journey to Iran, to Shiraz, Persepolis and Isfahan around 1955. There were only four of us, with François' sister and her husband. We slept in caravanserais, something unimaginable today. We had wonderful experiences, constantly in search of attractions. We were in Ardabil, at that time a small town in the north-west of Iran; there we discovered a caravanserai with nine or ten bunks and made the best of it. The toilets consisted simply of a hole, directly next to which were the showers, if you could call them that. The toilets stank so much that you couldn't really take a shower. But I developed a technique. I took cotton wool, drenched it in perfume and stuck it in my nose. It worked. At the time of Nasser we were in Egypt. And then in Cambodia, in Angkor Wat. They were journeys sometimes under difficult conditions, often the purest adventure. In 1960 we visited New York for the first time. In 1967 we travelled through the United States, a new continent for us. We drove with the boys to a jazz festival in New Orleans, saw the Indian reservations in Santa Fe, then Las Vegas and finally San Francisco. To experience these huge dimensions was impressive. Corn fields as far as the eye could see! My sister-in-law was also crazy about new things. We wanted to travel from Moscow to China, not by train, but by car with supplies on board to be independent, but that was prohibited.

Nevertheless, four of us crossed the desert from Damascus to Baghdad by car – likewise a great experience! We left Damascus in the evening and toward midnight we had a picnic in the headlights of our car, in the middle of the desert with its extraordinary stillness. Early in the morning we set off in the direction of Iraq. At six in the morning the sun rose and we had a quick breakfast, for otherwise it would have become too hot. The heat was incredible, for it was summer. My brother-in-law said once that it looked like rain. At first we thought he was crazy. But in a certain way he was right because a cloud of sand was approaching like a torpedo. Luckily there was a building nearby, a tea-house for drivers who were able to go in there. They had a bus and we made it clear to them that we had to go to Baghdad. The conditions could not have been worse because you couldn't see further than twenty metres. The bus-driver admonished us to drive directly behind him, which we did. We couldn't see anything. The entire car was full of sand and it was terribly hot. But we arrived safely in Baghdad. That was a really amazing existential experience.

When was that?

That was in the mid-1950s. The journey to Yugoslavia was also an adventure because at that time there were no tourists there. In 1961 we exhibited in Zagreb with the group Nouvelle Tendance; we met Julije Knifer, an excellent Croatian artist (he called me Miss Nouvelle Tendance), Ivan Picelj and Vlado Kristl, a very charming person. We got to know Uecker, Piene, Mack – all of them looked

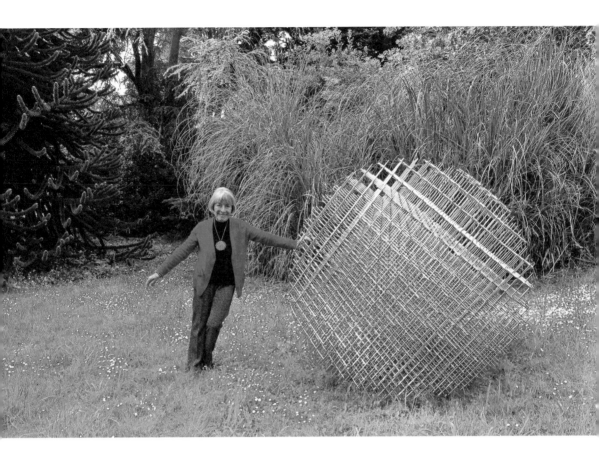

absolutely wonderful at that time. And of course the Americans who had come to Paris at the beginning of the 1950s. We had very good relations, as I said, with the Hungarian, Vera Molnár, and her husband, both great artists who lived in Paris and were friends with Vasarely. And with Gianni Colombo and Almir Mavignier who was both a good and important artist. He had left Brazil in 1951 to continue art studies in Paris. Later he went to the Hochschule für Gestaltung in Ulm. Through him we got to know Max Bill. We also knew Mack well. The entire generation at that time had close relationships. At the last ZERO event in Düsseldorf we met once again. That was a great joy. When I think about it, what was particularly valuable for me and also for François was the contact with Vera and Feri Molnár and with Almir Mavignier.

Would you want to lead such an intensive life once again?

That would be a fantastic thing! But I fear that another life would perhaps be less interesting than the one that I've lived. Destiny was always so well-intentioned towards me! That I'm able to live with François! It's still so beautiful! Artists can be very difficult; they like to make a monument of themselves, which is unbearable for the wife and children. But with him that was never the case. I always had an involvement with his work. He draws all of us in.

What does your work for François look like?

Here I have to make a detour. Thanks to Alexander von Berswordt-Wallrabe from Gallery m, who has really done an incredible lot for François, he became well-known in Germany and Holland, starting in 1970. And after François' first large retrospective in 1971 at the Van Abbemuseum in Eindhoven, his success grew. Because François was also working in the firm, I had to become active. I looked after everything that had to be done in the background, first of all, the archive, then the correspondence, telephone calls, appointments. The work grew along with the success. Now I'm supported by a very nice young woman

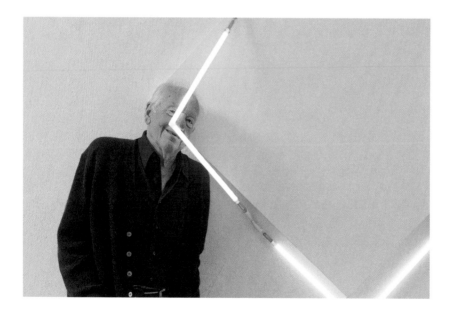

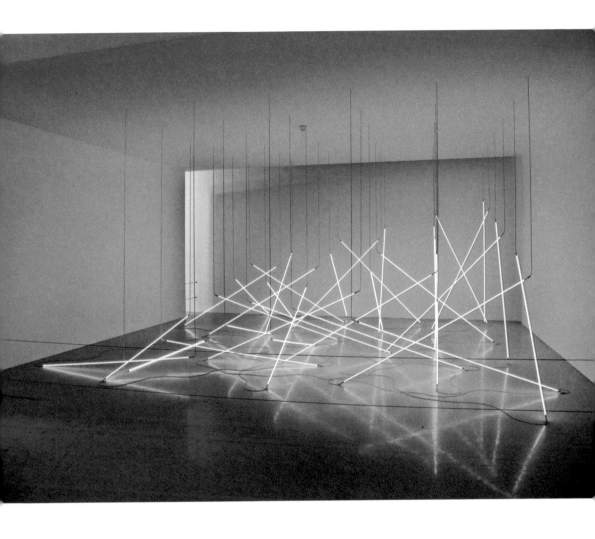

regularly, and previously only now and then, because it simply became too much for me. But it's a great joy. Through the work on the archive I'm up-to-date concerning François' work; it's a continual collaboration. We always have something to say to each other; we discuss everything; we exchange thoughts, it's very lively. We have the same friends. François' friends are also mine and conversely; that's also important. We have known each other now for 67 years and have been married for 65 years. We share everything together.

It's great good fortune to live together for so long. Other couples who likewise have worked together well are already separated from one another by death. I have to emphasise that now because tomorrow perhaps everything will be over. That's a very important point. Already when we were young and then had one, two, three children, I'd try to give François room to move, that is, I respected his desire to work. When he returned home from the firm, he often worked in the evenings and at the weekends in his small studio upstairs in Clisson. Downstairs I practised piano, and meanwhile the children were in the garden. At that time you didn't have television and each person could take care of his or her own field, painting, music. Being considerate was simply necessary. If you're the wife of an artist, you have to know one thing so as not to be disappointed: art always occupies first place. In François' mind there is first of all his artistic work, then the children and after that me. That's a completely matter-of-fact assessment. You simply have to accept the fact, and then you can't be disappointed.

Yes, I think that's the secret of your happiness.
Yes, to be sure. And so, on the other hand, François cannot be disappointed by me either. I'm interested in his art, even today. I was not an artist and I don't have a diploma in art history. We've learned a lot together. We have a lot in common: a life together, the same interests, the same encounters, the same experiences. Of course there are problems sometimes, and we go through crises. You can't have one without the other. We know how to treasure everything and speak about it. We hope that life will continue this way.

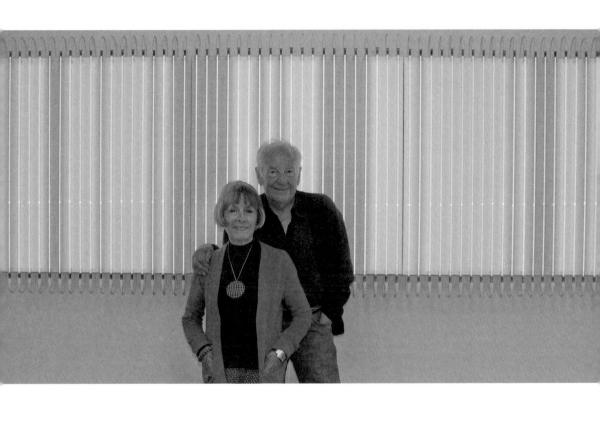

I never get bored

Edith Talman

.

Edith Talman was married to Paul Talman (1932-1987).
We met in March 2011 in Ueberstorf in Switzerland.
Edith Talman died in July 2013.

Mrs Talman, you used to live with your husband in Ueberstorf Castle.
Today you live in one of the beautifully renovated former stables.
How did you come to Ueberstorf?
That's a long story, but I'll make it short. Bernhard Luginbühl's first wife drew our attention to Ueberstorf Castle. Paul Talman, however, wasn't looking for a castle, but for an old factory or a schoolhouse where he could work. But I was so enthusiastic about the building that nobody wanted to have that I was able to persuade Talman to take it on at a price we could afford.

It certainly took some time until the castle was put in order again?
Yes! The castle was in a terrible state. At first we had to make it liveable. Lots of things, including the heating, didn't work. Everything was associated with a great deal of effort, and everybody had to do their bit. Our aim was to convert the building back into its original state, and so 24 rooms were made into eighteen again.
We grew our own vegetables in the garden. That was very useful for us because that way we could feed all our many guests and have them stay with us. Many of them were in Ueberstorf on business.

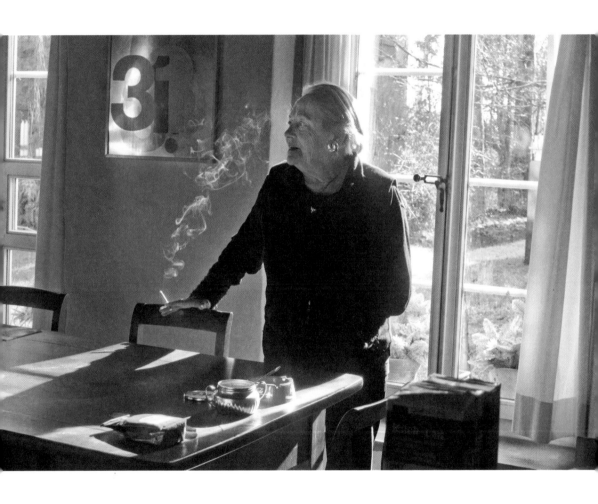

Next door was the chapel which adjoins the castle and in which there were regular church services, weddings and baptisms. It was a real family business: one of my sons was a server, the other son rang the bells, and I played the organ while my husband took part in the weekly church services.

Did all your friends also live here in the area?
Some of them did. Jean Tinguely and Bernhard Luginbühl lived only a few minutes by car from Ueberstorf, and Daniel Spoerri lived for seven years in the adjoining schoolhouse in Ueberstorf, which also belonged to the estate. On

Sundays we all met at our place to watch the car races. This was always a big event.

At the beginning of the 1960s I would have very much liked to buy a Spoerri. I found his tableaux pièges so insane, but they simply didn't fit well into our collection.
To be sure, Spoerri's tableaux pièges, some of them with stuck-on bits of food, are not to everyone's taste, but the way in which they came about was cheerful and also peculiar.

Yes, the story of a long feast became visible. At least that was what it was like at the beginning. Later on everything became more like a composition.
Yes, that was a shame. Spoerri made a lot of his tableaux pièges here, including the ones for the Expo in Seville. My eldest son, Paul, assisted Spoerri for many years and glued, nailed, screwed and installed innumerable curiosities onto the tableaux pièges. I remember when Paul was at the army training school and Spoerri had arranged a dinner in Ueberstorf for the top brass of the Swiss Army.

Unfortunately, a colonel had placed his hat and Swatch watch, which was a rarity at the time, on a tableau piège, and so these relics were immortalised on Daniel's assemblage. Spoerri was delighted, and the colonel ecstatic.

Is Spoerri still active in the kitchen today, cooking every day?
Certainly not like he was earlier on. He now has a large affair near Krems with lots of assistants, and directs them. A short time ago, Daniel was homesick for Ueberstorf and visited me. He wanted above all to go to Schlüssel, the local pub, where we ate fried potato cake with sausage. It's always nice to see him every now and again.

The house you're living in now and where we're sitting used to be the cowshed?
That's right. Cows, pigs and horses were housed in this former stall. After the farmer decided to build something at his place and to take the animals with him, this dilapidated building was also left vacant. The sight of the stables was really depressing. An architect whom we consulted at the time was of the opinion that everything should be torn down and built up again anew. The costs, however, were beyond what we could imagine, and so I decided to renovate and restore the building myself. My aim was to make it liveable.

And what did your husband think of that?
When Talman saw the end-product, he was delighted. To be sure, he hadn't quite believed I could do it because I wasn't an architect, but I'd always had faith in this project. The Basel art dealer, Klaus Littmann, was also the first co-resident of the stable after it was ready, and shortly thereafter, my daughter moved into the upper storey with her husband. Suddenly everybody wanted to live in the stable. This constellation resulting from the gathering together of Littmann, Spoerri and Talman resulted in the legendary 'Kuddelmuddel-Fest' (Huggermugger Party) in the courtyard. Almost 350 people from politics, business and culture, anybody who was somebody, came to this happening.
In 1989, two years after Paul Talman died, I decided to live in the stable myself. With the furniture that didn't fit I furnished a place in Tuscany.

How did you end up having a place in Italy?
Ingeborg Lüscher, who was married to Harald Szeemann, told me of a com-poser friend, Thomas Fortmann. At that time Thomas was in Berne, and so we got to know each other straight away. This way I got a flat on the top floor of a castello near Stribugliano which I also renovated. By this time I think that this had become a passion of mine.

Today my daughter lives there in Tuscany with her husband. They keep the place going with newly erected adjacent buildings so as to offer painters, artists and those working in culture a place to stay.

Are your daughter and son-in-law artists, too?
My daughter plays the piano and is very busy with the new challenges in Italy. This is an enormous effort that she tries to cope with together with her husband. I find it magnificent when young people want to build up something without knowing what will come of it.

Where's Stribugliano?
Not where there's mass tourism, but situated remotely in the mountains where sometimes there's a rough wind – utterly divine!

Do you still travel there today every now and again?
No, I don't have the urge to do so any more. The journey is tiring and I can't stand the heat these days.

We've now heard a lot about Ueberstorf and Italy. Tell me, where were you born?
I was born in Basel and lived there for forty years, very happily. I like Basel; it's one of the most open and interesting cities in Switzerland.

Do you have any brothers and sisters?
No.

Do you come from a musical or artistic family?
Yes; my father attended almost all the concerts in Europe. Music was his life. For instance, he was friends with Arthur Rubinstein. He was also very interested in the fine arts. Gauguin sent him paintings from Haiti so that he could bring them to Lucas Lichtenhan, the director of the Kunsthalle Basel.

What was your father's profession?
He had to follow in his father's footsteps. My grandfather was the co-designer of the North-South Tangential Route, and so my father had to continue this tradition.

With whom did you have the closer ties, with your father or your mother?
Really with my mother, because my father was often away on trips.

You attended school in Basel?
Yes, I spent my school years in Basel. After that I went to a boarding school in Bulle, not far from Ueberstorf.

What dreams did you have as a young girl?
I always wanted to skate. My parents made this possible for me, and so I became a professional and would have been able to go to *Holiday on Ice*, but my boyfriend at the time was too jealous and wouldn't let me go. Ice-skating was my great passion.

And what kind of professional training did you do?
Apart from ice-skating and playing the piano, I did a course in Basel as a restorer.

Did you have the desire at that time to be together with an artist?
No, not at all.

Where and when did you meet your husband?
In Basel. At that time Talman lived in Berne, as did his friends including Daniel Spoerri, Meret Oppenheim, Jean Tinguely and Bernhard Luginbühl. Many artists were in Berne at the beginning of the 1950s. When Talman was introduced to me by a friend, it didn't click for me immediately, but when one evening he said something special to me, I knew that he was the right one, and everything else fell into place.

Were you able to help your husband with his work?
Certainly, and I ruined my bronchi by spraying the 'ping-pong balls' for his sphere works in our flat in Basel. They were for the forthcoming exhibition at the Byron Gallery in New York.

Many artists damaged their lungs in this way. Rotraut Klein reports that about Yves Klein, and we also know it happened to Gotthard Graubner and Niki de Saint Phalle.
Yes, art has ruined quite a few people.

Did Talman have a proper studio, or did he work at home?
Talman had a small studio in Basel, but he couldn't really get going there because at the time he was employed as art director by the GGK advertising agency. I knew about Talman's artistic potential, and so I resolved to find a suitable place where he'd be able to devote himself fully to his work. Ueberstorf was more than suited for this purpose.

Which encounters and discussions do you still remember today?
You'll understand that it wouldn't be appropriate here to list all of my memories and encounters with interesting people. But Jean Tinguely and also Bernhard Luginbühl often dropped by unexpectedly, and we had mostly illustrious and cheerful dinner parties because during the course of the evening a few more people would come in, since word spread quickly. It's probably the spontaneous encounters with charismatic people that I've kept in my memory.

Is there an artist who especially impressed you?
So specifically I can't say. Each in their own way. I lived with them, went to exhibition openings. I very much liked what Meret Oppenheim made. She often came to dinner and the discussions we had were very valuable.

I can understand that well because, also for us as collectors, the conversations with the artists are very important. Did living together with Talman leave any room at all for your own interests?
Living with Talman in Ueberstorf was also in my interest, so everything was good as it was.

Do you have records from this time?
Yes; I've recorded everything in my diaries, just as I do today. And there are many photographs from this period. The first photos are my own, and they're rather amateurish. Later on, my eldest son, Paul, continued; he's a photographer.

You have three children?
Yes, Michèle, Paul and Niklaus.

Have your children changed your life?
Of course. Each of them was an enrichment. Michèle established her own family early on and lives today in the middle of Switzerland and in Tuscany. Paul is a freelance photographer and graphic designer. He has his studio in Ueberstorf. And Niklaus is an actor, director and leader of the Talman Ensemble. He, too, lives with his wife and two children in Ueberstorf.

Did you go on a lot of trips?
Yes. Mostly the trips had some connection with Talman's exhibitions. Talman was Professor for Design at MIT in Boston. Every weekend we flew to New York where he later showed his works at the Byron Gallery. But we visited also many European cities where Talman had exhibitions.

The trip to America was surely something special for you.
We made our first voyage there by ship, on the *United States*. One of the passengers was the writer, Alain Robbe-Grillet, who'd written the script for the film *Last Year at Marienbad*. During the voyage we played the match-game that's also in the film.

What did you especially like about living together with Talman or with the other artists?
With Talman it was love. And with all the friends it was not only interesting, but mostly also cheerful, light-hearted.
I experience that today with Niklaus. We often talk about his theatre productions that are performed in German-speaking countries and also elsewhere, including New York. Often he comes by with young people and wonderful encounters take place; that's valuable. Things keep going; many creative people from all areas find their way to Ueberstorf. Recently the artist, Jim Whiting, visited and there was a lot of talking and laughter. I never get bored.

To have dealings with people is wonderful. But didn't it get burdensome at some stage, always having to cook and look after guests?
Not at all, because I always liked doing it, even though it was associated with a lot of work.

Would you like to lead such an intensive life once again?
Yes, of course – immediately!

What wishes or dreams do you have for the future?
Things are good the way they are. I don't need to dream any more. I'm surrounded by a host of angels, and those who're no longer here are here nonetheless! In their art they live on. And since I'm surrounded by art, they're here the moment I think of them.

You've given so much earlier on, and now everything is coming back to you.
No. Everyone gives, always. And we never expect anything in return. And that's the way it ought to be! Everything continues, also with the children of Niklaus and his wife, Alexandra. Their daughters, Laila and Sofia, are very much attached to Ueberstorf.

Some days Otto and I think that together we SEE it all!

Elizabeth Goldring-Piene

Elizabeth Goldring-Piene, artist, poet and scientist, is married to Otto Piene. We met in November 2010 in Munich.

Elizabeth, I know that because you became ill with diabetes when you were younger, your sight is often greatly impaired. Sometimes you see better, sometimes worse. How is it today?
Yes, my sight varies. I don't see anything at all with my right eye. In daylight I can vaguely see things that are close up. Right now, however, I cannot really recognise you. I can imagine what you look like, but my vision is not sufficient to see you clearly. If someone entered the room, sat down and didn't speak, I couldn't say who it was. Often my eyes grow worse; then, if I'm lucky, I can distinguish light and dark. Sometimes everything is completely milky. This condition can last a long time, and then I have to use my white stick. In the evenings I must do so anyway.

Are computers a help for you?
Yes, I use a computer for my work, a Mac, because the 'close view' settings are very good. If I make the letters large I can recognise them, so I can read short e-mails which is, of course, wonderful for me. I also use the 'voice over' program on the Mac and, when my vision is very poor, I can have everything read out electronically. This Mac program is better than it was, but it's still not really good. The best technology for blind people is offered by the PC, I suppose, but unfortunately I don't like the PC at all. The problem is that if you go blind, the

PC is not always suitable, but if you're born blind, it is currently the sole device that's right. My blind friend, Paul Parravano, who works on the President's staff at the Massachusetts Institute of Technology (MIT), really knows his way around with respect to appropriate computer technology and the latest innovations. I, on the other hand, am not as tied to the technology for people who are blind as I might be. I am in that intermediate state of seeing and not seeing, and I always hope to be able to see. By the way, at MIT there are almost no blind persons, less than one per cent. On the other hand, because of all the technology available there, it's the best place for people who are blind. It's a strange thing that the people who work with the Commission for the Blind in Boston and in the area around Groton do not know more about what is currently out there for people who are visually challenged. For instance, they brought me a 'reader' on which, among other things, many books may be stored, but it's difficult to distinguish and use all the functions. In any case, they couldn't fully explain to me how everything works. I gave the 'reader' to a highly qualified student at MIT; she took a look at it and got very angry. Even for her as an engineering student and with good sight it was not intuitive and extremely complicated. I asked the Commission representative how many people had been given this machine – and he said four in all! That's a great pity because if it were redesigned, it could really enrich the lives of blind persons.

You mentioned Groton, the town where you now live. Were you born there?
No, I was born in Forest City, Iowa. I spent most of my childhood in Nebraska where I went to school. So I grew up in the Midwest of the United States. Characteristic for this entire region is the big sky and the relatively flat land-scape. Most of Nebraska is completely flat; when you fly over the country it looks as if it had been squashed flat. By contrast, Iowa is a little more hilly. Now we live in Groton, Massachusetts, which is part of New England. There the land-scape doesn't seem to be as free because of the many trees and hills, but over our farm the sky is wide and big, too, and that's what attracts me, probably because it reminds me of my childhood.

Do you have any brothers and sisters?
I have a sister who's four years younger. She's the director of the Roosevelt-Vanderbilt National Park in the Hudson River Valley, the favourite park of Bill and Hillary Clinton. For that reason she has spent some time with them.

What did your father do for a living?
My father, James Olson, was a frontier historian at the University of Nebraska. He specialised in westward expansion and Native American tribes. He was particularly interested in the Oglala Sioux and, during my childhood, I spent

some time on Sioux reservations. Already early on, he wrote a book about the problem of the Sioux in which Native Americans were given a human face for the first time and were not, as was usual at the time, treated disparagingly. He was strongly criticised for this book; if he had published it twenty years later, his views and work would have been applauded.

Do you come from an artistic family?
Yes, our family had constant visits from writers, poets, musicians and artists. So I grew up in a thoroughly academic, intellectual and artistic environment, which I liked a lot. Many of the writers wrote frontier poetry and stories; they are perhaps not so well known in Europe, but in the American West they were big names. I'm thinking, for instance, of Willa Cather, a really famous woman writer and poet, and her quasi-disciple, Mari Sandoz, who once wrote in my autograph album the verse: 'Remember me when far, far off, and wood-chucks all have whooping-cough.' Later, when my father was president of the University of Missouri, a multi-campus state university, lots of artists also came to our home, including Thomas Hart Benton, Jackson Pollock's teacher, who later suggested to my father that he would like him to write his [Benton's] biography. My mother, too, was immersed in art and culture. She was originally a teacher. When I was small, she didn't work, but she pursued masters degrees in English literature and art history at the university. By the way, there is a series of concerts named for my parents because they were also enthusiastic supporters of classical music and performance.
In my teens we often travelled to Europe, especially when my father had a sabbatical. For us that was always a purely cultural trip because, as my sister says, our mother made sure that we visited really *every* single museum. I recall that, as a little girl, Sarah once sat in the foyer of the Louvre and said that she didn't want to see another Jesus picture in her entire life.
By the way, in the 1950s, it was extremely unusual for Americans from the Midwest to travel to Europe and even to live there, as we did in Rome and Paris, while my father was writing books.

What do you think: which of your parents influenced you more strongly?
My father had a very strong influence on me, but my mother asserted something which was even more unusual for a Midwest American than for you Europeans: for extended periods of time, my sister and I were required to speak French at the dinner table. It's a pity that it wasn't German.

You mentioned that you first went to school in Nebraska.
Yes, after the public high school in Lincoln, Nebraska, I attended the International School in Rome. After that I graduated from Smith College in Northampton,

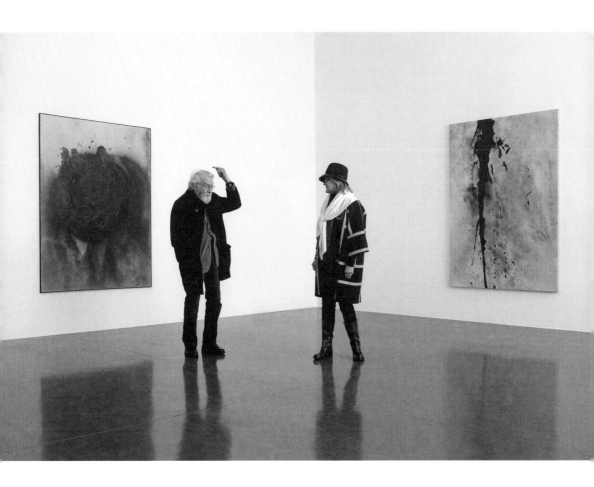

Massachusetts and received a masters' degree from Harvard University in Cambridge, Massachusetts.

What dreams did you have as a young girl?
As a very young girl, of course, I had those princess dreams. But then I thought a lot about what I wanted to become. My greatest wish was to join the Peace Corps, an independent American agency that has taken on the task of pro- moting mutual understanding between Americans and non-Americans in other countries. That was my life-plan. But I had a rude awakening from this dream because, in my first year at Smith College, I got diabetes. I fell into a coma and

could only just barely continue with school that year, but I got through some-how. With a chronic illness it was impossible to join the Peace Corps, so I first tried to hide the illness, but that couldn't be kept up in the long run. This threw me into a deep depression, because diabetes is bad enough as an illness, but it also destroyed my hopes for a career.

What did you study?
I took honours in French medieval history and I studied initially in Paris with Georges Duby, who later published several illustrated volumes on the Middle Ages, although at that time he was not yet as well known as he is today. I wrote my first thesis on the portals of Saint-Gilles-du-Garde. My second thesis, at Smith College, treated the question as to whether we can speak of a cult of the Virgin in the writings and sermons of Bernard of Clairvaux, admittedly a rather unconventional topic. And I have always written poems, even during my child-hood and up to the present day. Sometimes Otto and I spend hours writing what we call 'dialogue poems' together.

Did you have the desire to get to know an artist and even marry him?
I didn't think much about that. From my childhood I was used to being together with artists, but I didn't think much about marrying at all. I thought that when you grew up, you simply got married. My first husband was a medical doctor. When I first met him, however, he was planning to become an English professor. I have always been more attracted to the humanities than to medicine.

And how did you meet Otto?
I was a graduate student at Harvard University. I wanted to study further with the art historian and critic, Rudolf Arnheim, but my daughter, Jessica, was born, and it was only two years later that I was able to resume university studies. Arnheim had already left Harvard by then. I attended many classes at Harvard, and also at MIT. Otto was teaching the Art and Environment class that he estab-lished at MIT. He was my teacher. Later on I taught this class together with him. Before I came to Boston, I had worked at the Smithsonian's National Collection of Fine Arts in Washington, D.C. where I had followed my first husband, who was working for the National Institutes of Health. At the Smithsonian I organised exhibitions and initiated a special programme for children. When we moved to Boston – my husband had been appointed to a position at Harvard Medical School – I was given responsibility for the temporary exhibitions at the Children's Museum there. That was a good fit, because I had a small child myself. The Children's Museum played a pioneering role in developing participatory, inter-active art for children. It was via the kind of communication in this museum that I became enthusiastic about Otto's art, which is oriented toward participation, or

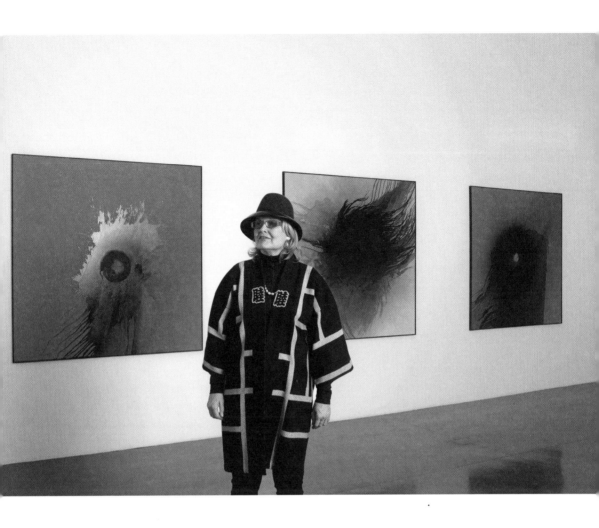

as he calls it, 'energy transfer'; it is not purely museum art to be hung on walls. Everyone could understand what art is on seeing Otto's *Inflatables*, these inflatable air sculptures, fly. I found that fantastic.

Were you able to support Otto with his artistic work, or did you have to hold back?
That's really not easy to answer. In a certain respect it is true that I helped him and he helped me. But restrain myself? I don't know. I find it difficult to answer

that, since I'm so deeply immersed in my own work. From the outside it some-times may seem as if I kept in the background, especially as far as the ZERO period is concerned, but I've always done my own thing parallel to Otto. I could say very different things in answer to your question. In a certain way, Otto casts a long shadow. For instance, and at a certain time, if I had applied for a tenured professorship at MIT, I wouldn't have gotten it because I was married to Otto who himself already had a position as a full-tenured professor. In the meantime the rules have changed with regard to spouses, but at that time that's the way they were. And there was not a single woman in the School of Architecture and Planning. That, too, has changed dramatically. At MIT, my motivation was the work itself – in the research, in opening up areas close to my heart. And in poetry.

What was it like with visitors? Did collectors or museum people
come to you?
Yes, indeed. After all, we know a lot of museum directors and curators. But Otto also loves to lead a free, private life in Groton in order to pursue his work in peace and quiet. It's funny – when we bought the farm he was so happy because we didn't know anybody in the small town of Groton and he would be able to work undisturbed. However, gradually it became apparent that there's a really interesting community of artists in Groton; it's really wonderful. For in-stance, the artist, Paul Matisse, lives in the centre of town; he was also a former fellow at the Center for Advanced Visual Studies (CAVS) at MIT. I knew that he'd moved away from Cambridge. After we'd been living in Groton for just one week and were walking down the street, we suddenly bumped into Paul. The same thing happened with others as well, so that we're really surrounded by artists.

Did you make notes or photos or keep a guest-book?
Sometimes we took photos. We don't have a guest-book, and I also didn't keep a proper diary. Otto has his black books.

Yes, these black books are impressive. Once I was able to cast a glance in
one of them. There he's noted down precisely, among other things, with red
and yellow markings, when you had appointments and when he did.
Presumably only Otto had an overview over time. [Laughter]
Yes, they're really amazing. Otto keeps these sketch books meticulously; I think they're very beautiful. They tell how we live; where we are. By contrast, I'm less well organised, and my notebooks are therefore rather chaotic – full of drafts for poems and formulations which I could use at some time, interpretations of what has happened or might happen. But everything is very disorderly. I often think that Otto's sketch books are like he is, that is, presentable. Using his books, any

museum director would be able to understand every single step, whereas with me there's a big muddle. In particular, my notebooks contain thoughts that I don't want to show anybody. I also don't know whether anybody could make anything of them; in any case I've not set things up that way. Otto doesn't only sketch in his books, but writes too, and in my notebooks I jot down not only verbal, but also visual impressions. Especially when I'm blind I tend to draw a lot in these books.

What encounters and conversations with artists do you recall?
Of the ZERO artists, primarily the encounter with Heinz Mack. I'd heard a lot about him and I was pleased to be able to talk to him very easily and calmly about artistic ideas. We also visited him at his home in Mönchengladbach. At that time our children were still small and they played with his dog, and Mack was very nice to them. The encounter with Günther Uecker is also firmly in my memory. That was in 1977 at the *documenta 6* in Kassel. We presented the kinetic performance sculpture, *Centerbeam,* from CAVS. Fourteen artists, scientists and engineers participated; I coordinated the project. The sculpture was situated *en plein air* in front of the 'Orangerie'. Günther Uecker, whom I didn't know personally at that time, greeted me warmly with that all-embracing smile of his.
Many artists have impressed me and have been important for me – Charlotte Moorman, for instance, who was a really good friend of ours. Although she was very ill with cancer, she gave me so much courage when I couldn't see. We supported each other when going through bad times. Or Nam June Paik, after he, too, got diabetes, he read really *everything* about the disease, including all the medical journals. By contrast, I didn't read anything; I simply wanted to ignore the illness. I just took my medications. Also a few scientists like Doc Edgerton at MIT, the inventor of stroboscopic photography and Rob Webb at Harvard, inventor of the Scanning Laser Ophthalmoscope, were good friends and essential for my work. And we were close friends with artists like the Norwegian, Carl Nesjar and the video artist, Peter Campus, and then, in my view, the incredibly courageous light artist, Dale Eldred, who unfortunately died young. He lived in Kansas City, where my parents lived after my father retired.

Were there also writers who were important for you?
Yes, an important poet and, for me, even a kind of mentor, is Dan Jaffe. I often show my manuscripts to him before they are published, and he helps me enormously. The poet, Gloria Vando, who was the editor of the feminist-oriented publication, *Helicon Nine*, is also very important for me. She writes tantalising narrative poetry, – completely different from mine. Apart from that there are, of course, others, but those I've named are among those whom I've known well.

Which trips do you remember particularly well?

The most memorable voyage was probably the one on a Swedish ship to Europe in the 1950s. I was twelve, and we'd never been in Europe before. I'd also never been on a ship before. We were living in Lincoln, Nebraska, and many foreigners came from all over the world, but people from there didn't often travel to Europe. The voyage lasted thirteen days. We'd bought a Volks-wagen Beetle, which we picked up in Bremerhaven. Our luggage was especially designed for a Volkswagen, including a VW vase. With our thirteen suitcases, the entire car was completely full. In a trunk on the roof of the VW, there was my father's manuscript for his book about *Red Cloud and the Sioux Problem*. At that time there were, of course, no computers. Every night we were obliged to carry the entire luggage, including the trunk, into the hotel. We generally stayed in fairly cheap accommodations. In Paris, for instance, we were in a hotel

on the fourth floor without an elevator. That gave me some training for Hüttenstraße in Düsseldorf, where Otto and I lived for several years. I think that this trip was a turning-point in my young life, because I realised for the first time that a certain internationality was absolutely necessary for my contentment.

Surely you also travelled a lot with Otto.
Yes, of course. They were not trips in the conventional sense, but we do travel a lot. Once, after a Sky Art conference in Alaska where we had prepared a Sky Art event together in Anchorage, we travelled to St. Paul in the Pribilof Islands close to Russia. There you will find enormous colonies of seals. I still remember the King Eider Hotel very well. The windows were wide open and we could see not too far off masses of the huge animals mating. We were often in Tobago,

and for a few years we travelled repeatedly to Morocco – to Marrakesh and several other villages and towns. My favourite place there was Taroudant, close to Agadir, an incredibly beautiful oasis. We resided in the Palais Salam, an Arabian-style hotel with strutting peacocks. Many people prefer the expensive hotels, but I find them too Americanised.

Apropos Tobago: the island was also important for me artistically. During one of our stays there I lost my sight. The only thing that penetrated my blindness was the crowing of the roosters. It sounded like a telecommunication event over the entire island. At that time I used a dictation machine into which I spoke my poems, and the sound of the roosters crowing, of course, was now also on the tape. Sometimes I stopped speaking and gave the roosters, so to speak, 'free range'. Often, when I couldn't see, I made recordings of crowing roosters, and people from all over the world sent me their recordings of roosters. (For example, Itsuo Sakane, then Science Editor of the *Asahi Shimbun*, put me in touch with regional rooster masters in Japan, who sent me tapes of their contests for the rooster with the longest crow.) Before the second Sky Art conference Otto introduced me to the composer and musician, Walter Haupt, who told me about his *Linzer Klangwolke*. I was enthusiastic and made a plan to compose a piece featuring crowing roosters for it; it was to be called *International Alarm*. It lasted

seven minutes. I collaborated with Edward Le Poulin, an MIT composer for electronic music; we compressed live and electronic rooster crows onto an eight-track master recording. That is one of the works I like best. At first it looked as if it would not happen because the organisers, of course, wanted classical composers like Mahler or Bruckner, but Walter said, 'Here, you have seven minutes at your disposal!' So I presented my work on the *Klangwolke* to the city of Linz. That was great. Later, Otto and I performed *International Alarm* together several times as Sky Events, using his inflatable roosters: *Hexagonal Rooster, Silver Rooster* and *Sekhvi Rooster* together with my sound compositions. I will always value times like these when Otto and I work together on projects.

Elizabeth, would you let yourself in for such an artist's life so intensively once again?
Yes, I can't imagine doing anything else.

And what dreams or wishes do you have for the future?
Here I must tell you a story: I recall a situation when, one evening, Otto and I were walking back to our farm and I couldn't see anything at all. He described the sunset to me so vividly and precisely that I really saw it. Otherwise I'm very mistrustful of other people's descriptions. They say, for instance, look out, there are five steps in front of you, when really there are only three. However, Otto described the sunset to me in such a way that it was really there. One of my greatest wishes is that I can make visual experiences come alive for people with impaired vision so that they can experience visual poetry. With the aid of the technical apparatus that I'm developing with people at MIT, this is achievable, but we're still a long way from bringing it to the market. I also hope that the theatre production *My New Friend Su: The Moon's Other Side*, that I'm working on together with Robert Wilson will raise awareness about this process and make it apparent that something needs to happen, and that the research should be continued. We all need to realise that visual communication is possible among people who are totally blind, people who are severely visually challenged and people who see well.

Are you also thinking of those who have been blind from birth?
These people don't have any idea of what a sunset could look like.
Your question is very good and very important. What is basic for me – I am repeating myself – is the following fact: people who can see quite normally, people like me who have impaired vision, and those who have never been able to see – among these distinct groups there is almost never any communication. When I'm walking around with my white stick, people automatically keep a distance, not because they don't like me, but because they don't know how to

behave. They're embarrassed and also don't want to hurt me. People who see poorly, in turn, have a lot of trouble being together with the totally blind. My collaboration with Bob Wilson also has the aim of connecting these three groups with each other.

In this connection I must mention my good friend, Paul Parravano, once more. He lost his sight when he was three years old, and so he has practically no visual memories and is therefore one of those people of whom you just spoke. When we go back together to MIT after lunch, he leads me and I can rely on him completely, for my sight is constantly changing. For instance, sometimes I can see the litter bin on the street, and sometimes I can't. He, by contrast, knows the way exactly. He has this special sense of orientation that I, too, have more strongly than people with sight, but which is weak in comparison to his. On the other hand, there are also things he wants to know from me. He once travelled on the subway and a woman sat down beside him, addressed him, and he explained that he was blind and couldn't see her. And then she said to him, 'I'm blond and beautiful'. He, of course, had little idea of the concept of beauty that she was promoting. He probably would have had to feel it by touch somehow, and blond...? You know what I mean. So I'm thinking about communication on many levels. You need open-minded artists who can take up this subject from many different angles, such as Bob Wilson, who early on engaged himself intensively with autism and deafness. I believe Bob is looking forward to our project. The poet and performer, Christopher Knowles, with whom I enjoyed working last summer at Watermill, is also involved. And, of course, we are happy that Otto is taking part with his perspective as a light artist – and he lives with someone who doesn't see well. Although some days Otto and I think that together we SEE it all!

PARIS – NEW YORK

She went to meet Bruno.
At a café near *Hotel de Ville*
he wished her
success.

Leaving by *Gare du Nord*
she tripped.
The bag with the absinthe
came down hard.
The bottle broke
ruining her drawings and pastels.

In her apartment
there's a cockroach.
She says,
he has a face
so big
she can hear him
chewing.

FURNITURE

They brought your mother's furniture
by boat to Boston,
trucked it to our farm in Groton.

As I open drawers
you sit in the armchair
and the turnkey falls away.

You used to lie on the sofa when you were sick
your growing body wedged
between the ends.
At the desk
your mother
wrote letters
made books.

Stars she stenciled

shine in the lamps
you've made for our house.

Will I disturb you
if I light a candle
or bring a bunch of daisies?

I never knew your mother.
The day my dog died
my own mother gave me
a white handkerchief.
I carried it with me
to Saturday French.

Unpublished poems by Elizabeth Goldring-Piene

For me he's not an artist, but a man

Essila Paraiso

Essila Paraiso, artist, is the partner of Turi Simeti.
We met in Milan in June 2011.

Mrs Paraiso, you're one of the few interviewees whom I've not yet met personally. Where and how did you grow up?
I was born in 1941 in Ivrea, a town close to Turin in Piedmont. My father was Italian, my mother Brazilian. During the war we lived in Italy, but in 1946 we moved straight to Brazil, to Rio de Janeiro. So Brazil is my real home and I've only few memories of my childhood in Italy. Only at the end of the 1980s did I return to Europe; I was the only one in my family to do so.

Do you travel frequently to Brazil?
Yes, my brother (I have two siblings) and two of my children live there, which is wonderful. In the beginning Turi and I travelled to Rio every year together, rented a flat and stayed for several months. Now the stays are becoming somewhat shorter, and I often travel there alone. For some years now I've been staying with my children, in the north outside Rio. Two years ago we were there together for Christmas. Of course we've travelled not only to Brazil. For instance, I like to recall a trip to the Cape Verde Islands which I enjoyed very much.

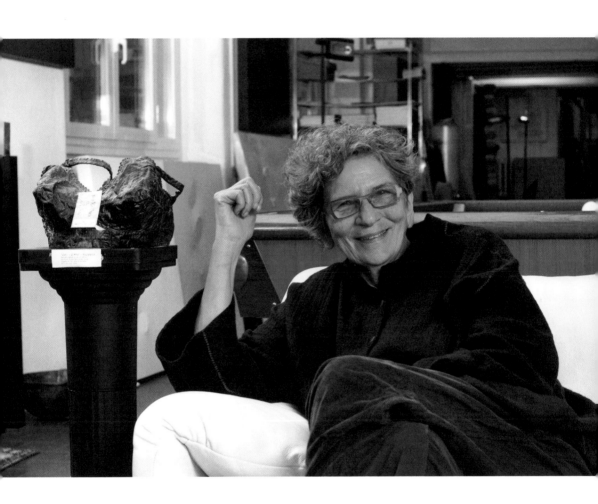

Do you come from a musical or artistic family?
No, not at all. My father was an engineer and my mother didn't work. She was a very gentle woman who has probably left more of a mark on me than my father. When I was little, I often criticised her, perhaps because we were so very similar.

What dreams did you have as a child?
When I was little we were still living in Italy. The war was going on and it was a matter of surviving.

Now you're an artist. How did you come to art?
Well, I was already over 25, and so grown up. I simply started making art for myself.

Did your mother support you in this?
No. At the time I already had three children of my own, so my mother no longer had any influence on me.

Did you want to be an artist earlier on?
No; I really didn't have any idea at first about what I wanted to become. And then I married straight away. In Rio I attended the School for Visual Arts/Parque Lage from 1969 to 1972 and then the art academy. Finally I studied museology at the University of Rio from 1984 to 1987 and worked for many years in this area, that is, in the archives of museums. At that time I'd already long since completed my project, *A História da Arte*.

The History of Art, that sounds interesting. What was it about?
I no longer know precisely how I came to be doing it. Before that I worked in photography. Somehow the idea was simply there; it was more or less by accident. Perhaps the publication *The Open Art Work* by Umberto Eco played a role. In the mid-1970s he was discussed a lot in Brazil, was absolutely *en vogue*, visited the country often and gave readings. Later on his book also appeared in Portuguese. And in general in the 1970s, concept art was more widespread in Brazil than it was in Italy or elsewhere. It was also for this reason that I occupied myself with it, exclusively in the area of installation. For the 1980 work I've mentioned, I collected seven hundred objects over two years on which motifs from the art of different periods were represented. It was a matter of many and varied things used in daily life such as cigarette lighters, coffee mills, a cup with the Mona Lisa on it, books, records, consumables such as tins with sweets, s-ugar bags, cigars – completely trivial, sometimes even kitschy things for which I had only sometimes searched deliberately, in souvenir shops for instance, or which friends sent to me. I ordered everything chronologically and was able to make my history of art come alive on the basis of this installation in a very ironic way. For this exhibition a catalogue was published, and in 1982 a film was made about it with the wonderful title, *Nothing is created in art, nothing gets lost, everything is transformed!* The objects, by the way, are in storage in a warehouse in Brazil. Even today the idea is highly relevant, and at the time this work was important for my Brazilian artist colleagues, precisely because it was so different. Today I no longer exhibit, either in Brazil or in Italy.

Here I've never really found a proper niche, anyway. All that is just a thing of the past. But if you speak about the period of art at that time in Brazil, my name is also mentioned. And that alone is enough for me.

This all happened before your time with Turi. How did you get to know him?
In 1985 in a gallery in Rio which he often visited. I was divorced and already had grown-up children. We're not properly married. We did have a wedding in the United States, but that doesn't really count.

Did you want to have an artist as a partner or husband?
No, that wasn't my idea at all. I was married for twenty years in my first marriage, and that was enough for the time being. It simply happened that way.

Do you keep in contact with other artists?
Yes; early on, artists, mostly friends from Milan whom Turi knew, visited us. I was almost always present at these meetings. Museum people and collectors also occasionally found their way to our place. Now that's no longer the case.

Did you keep records or take photos?
No, not at all.

Which encounters with artists have especially stuck in your memory?
Being together with Gianni Colombo was always especially fine. He often visited us here in Milan. And if I think about the past, of course some Brazilian artists come to mind who were important for me. Our group was a fairly loose affair; we didn't work closely together, but we discussed a lot. We were still young and it was the 1970s. Two of the artists from that time, by the way, became directors of the Museum for Modern Art in the 1980s. But that's a long time ago.

Do you support Turi in his work?
I don't work directly together with him, if you mean that, but I'm his critic, even when he doesn't want to hear and doesn't ask me. And I take care of the organisational work for his exhibitions.

Has living together with Turi left you time for your own interests?
Yes, indeed it has.

Are you occupied with a project at the moment?
'Project' is perhaps a little exaggerated, but until recently I was working on a virtual virus museum on the internet, almost daily, even.

This, too, sounds original. What's it about?
About five or six years ago I started collecting all sorts of information about computer viruses on my website, www.vietatonline.com. In the meantime more than a thousand viruses have been gathered. I've received many links from a friend, and I found some viruses on the internet myself. If you clicked on one of these links, your computer would be infected. I've never been contented with the selfsame material, and this whole virus thing simply interested me, because it's a kind of angst that preoccupies people today. Accordingly, I call this museum

the Museum of Angst. Luckily I have a Mac and so I'm more protected against viruses than I would be with a PC. Of course, once I was also caught out by one. But you don't really have to be scared about it.

And why do you call it a museum?
Well, it's a publicly accessible, chronologically ordered collection that has come about through donations. You can become a member by sending in active or self-produced viruses. But you see, this, too, is intended somewhat ironically. I simply use the language of the Web and mirror the behaviour of museums. Up until now, to be sure, I haven't had much feedback, just a couple of letters. The interest is perhaps more on my side. I've had no contact with internet specialists. It's clearly a housewife's activity, *casalinga*, so to speak. In the meantime I've stopped doing it.

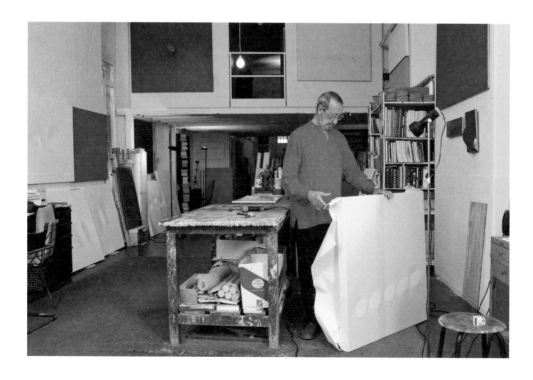

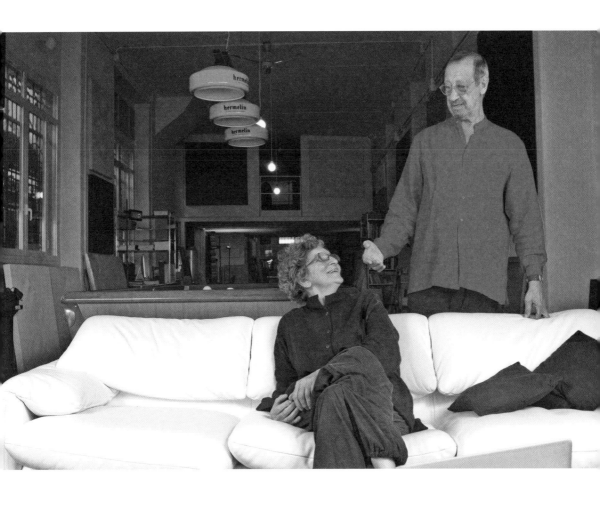

Does Turi also work on a computer?
No, but he likes playing football or solitaire on it.

What do you like about living with an artist?
For me he's not an artist, but a man. And this life has been simply beautiful –
or what do you think, Turi?

What wishes do you have for the future?
Simply to live.

I prefer the visual;
I can deal with it better
than with the auditive

Franziska Megert

Franziska Megert, artist, is married to Christian Megert.
We met in Düsseldorf in June 2010 and updated the
recorded interview in June 2012.

Franziska, you're married to an artist and are an artist yourself. Did art and culture play a role in your family?
Not much, culture perhaps in the sense of trips. We travelled a lot, even with a tent, and visited towns and cities and historical places. We were also in Rome. But the fine arts played only a minor role. I can't remember going to a museum with my parents. That happened only when I went to grammar school.

What did your parents do for a living?
My parents met at university. Both of them were studying chemistry. My mother worked only for a short time, and then the children came. My father was a nutritional chemist at Unilever and travelled abroad a lot. He loved his job. After he retired, he once more set up an ice cream factory in Greece for Unilever, and after that he was supposed to get another one going in Thailand, but he declined to do that. He always made perfume for me on the side because in some way or other, perhaps via spices, he had connections with specialists in Grasse in southern France, the perfume metropolis. He brought back large quantities of aromas from there and today still mixes perfumes for me, just for me.

Where were you born and where did you grow up?
I was born in Thun on Lake Thun in the Canton of Berne in Switzerland, and it was a home birth. But I didn't live there for long because my parents soon moved with me and my brother to Lake Zurich. I attended school in Berne only for a short time and then in Thun. After that I attended school on the Zurich Gold Coast in Stäfa. I started grammar school in Zurich. At that time boys and girls were still educated separately. Right up to the 1970s, Zurich was extremely conservative. When I went back to Berne in 1968 I did the last one-and-a-half years in a co-educational grammar school. My father had been called back to his first work location in Steffisburg, not far from Thun. He was transferred several times by Unilever, and so we had to change our place of residence accordingly and I also had to change schools. I've gathered my impressions from all these places.

Did you have a desire as a young girl to live with an artist later on or to do art yourself?
I can't really say that. Even at grammar school I took on roles as an extra at the town theatre. I wanted to go into film, but my mother, who's still alive, wouldn't allow it. She was extremely anxious and very protective. Up until my sixteenth year I had to be in bed by 8 p.m. That had been the case with her, so it also had to be the case with me, even though she went to a ball at the age of thirteen. I saw that from the clothes which are still hanging in the attic. Even when I was eighteen, she still forbade me to work in film. She was simply very strict.

What precisely did you want to become?
At that time, almost all the girls wanted to become nurses. During my time at grammar school, apart from my film plans, I also wanted to train as a photographer. I took part in a test at a newspaper and was told that I'd done well. My parents were not very enthusiastic about this idea, and in parallel to school it was out of the question. If I were really serious about it, they said, I could do it after I'd finished school. But then I studied psychology in Berne. I already knew Christian at the time because in 1972 he was still living in Berne. At first we lived together in the Matte Quarter down below in the old part of Berne. In 1973 he moved here to Ratingen – the municipality was still called Hubbelrath at that time – and we lived in the Hofhauspresse, the former studio of the printer, Hans Möller, who'd worked for the ZERO people, at least for Mack, and I think also for Uecker and Piene, and many other artists. So I travelled back and forth between Berne and Düsseldorf. When I'd finished my studies, we moved to Düsseldorf to Draklstraße 7, into Dieter Roth's former studio and later Herbert Oehm's.
Even during my studies I documented Christian's works photographically, which I still do to the present day. I set up my own black-and-white laboratory which

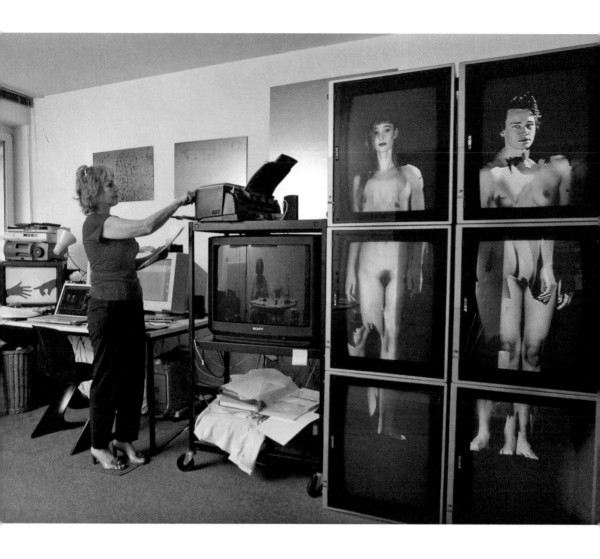

always accompanied me between Berne and Düsseldorf. And finally I started to experiment myself, and so photographs came about that didn't have anything at all to do with Christian's work.

And in this way you came to your own art?
Yes. I then very quickly shifted from photography to video since I could represent processes better with this time-based medium than I could with photo series.

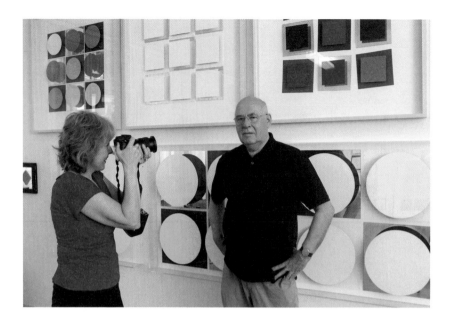

I stayed with that for a long time until I also discovered the computer's potential to process my videos digitally. For several years now I've been making computer animations. I haven't used the camera for my art for a long time. For Christian, at the beginning of the 1990s, I put together various old 16 mm films to make small, 15-minute documentary films supplemented with superimposed photos. Hans Möller spoke a text by Christian to this, the manifesto *Ein neuer Raum* (A New Space), and I added music which Christian had listened to at the time. In this way something completely new came about.

How did you meet Christian in the first place?
That's a long story. For my studies I had to do practical training with children be-cause I planned to specialise in child psychology. You were supposed to have some experience with children to see whether you were at all suited to this area. So I gave lessons, which was still possible with a matriculation certificate at the time, and I wanted to go to the United States for three months to work with children in a kind of holiday camp in the summer vacation. I got on the train in Berne, my parents had accompanied me to the railway station, and my mother asked me where exactly I was going. At first I travelled to Paris. There I intended

to take a flight to New York, and then fly on to Columbus, Ohio. A man standing next to me heard that and accosted me on the train, saying that he lived in Columbus and that I should contact him some time. That was Christian's brother, who taught visual communication at Ohio State University.

The holiday camp was rather boring. You had to keep the children occupied, organise bicycle tours, go swimming with them, organise all sorts of things, and remain in tents in the evenings to be there for them. Every fortnight, when I had time off, I visited this brother. He had a family of three children, and all of them

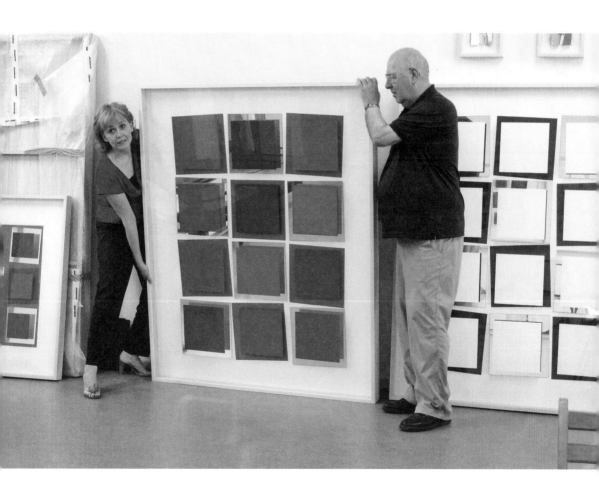

made an effort with me. They taught me water-skiing, arranged large parties for me, even picked me up often in the evenings from the dreary tent camp, and we undertook a lot of excursions together. I found it wonderful there. It was my first stay in the United States, and the fact that I was welcomed so warmly was a gift from heaven for me. They told me about their family, including the brother in Berne whom I was supposed to visit some time. He had just been divorced, they said. After an extensive tour thereafter through the United States, I had to return home, precisely at the time when the 1972 Olympic Games were taking place in Munich. Because of the massacre at the games, many flights had been cancelled and at first seats were given to those who'd already been waiting for a long time, so we couldn't depart from New York on time. We were put up in a hotel for a few nights and were given five dollars a day. We were happy because this way we were able to remain in New York, and with five dollars a day we got on fine. When I finally got home, my brother was enjoying himself with his future wife in my parents' home. They were so much in love that I disturbed them, and they did everything to get rid of me. Of my fellow students, no one had yet come back to Berne, and so I simply visited this brother, Christian. After a short time I stayed with him because I no longer felt comfortable at home. And from this a whole life-story has developed.

Wonderful! And today you document your husband's work?
Yes. As I said, I started doing that very early on.

Does Christian talk to you about his projects, and do you speak with him about yours?
Yes, sometimes. Once he's finished a work he asks me what I think of it. In Berne I visit him several times daily in his studio. Sometimes it happens that, without being asked, I give my opinion about an object that he is still working on. At one point he was occupied with figuring out his contribution to the small ZERO collective portfolio that appeared in 2008, which was supposed to be sold on 27 April 2008 on the premises of the former café at the museum kunst palast to celebrate the imminent founding of the ZERO foundation. On the small sheet

with prescribed dimensions he placed three mirror fragments on black card-board. A single fragment, but somewhat larger, seemed better to me, which he adopted without hesitation. Or once, when he was drawing a draft for a mirror installation, I came in and reminded him that he had really planned curves instead of straight lines. He was very happy about this reminder.

But generally speaking, we only discuss in detail once the work is finished. Of course, he decides himself according to his own ideas; then comments are only suitable *en passant* and also only at the end. Our discussions move in this direction. Christian never asks me directly how he should do something. There's a dialogue, but it's not very profound. Some other couples really do work together closely; that is, they do the work together and also sign it together. In the beginning when I started with video, Christian, too, had the idea that we should do everything together. But that wouldn't have worked out because I have my own, very special way of dealing with this medium.

Did artists often come to your place?
Yes, lots of them; first of all the students. Christian was a professor at the Düsseldorf Academy. He's someone who likes having a lot of contact. He would love to have had a big family, be the boss and occupy himself with it when he felt like it. And when he didn t want to, he'd withdraw. He likes being together with a lot of people. He always had the students congregating around him. That was a particularly intensive time. He still has contact with some of them today.

We always discussed a lot. Mostly it was a matter of the politics of exhibiting, and of course, also Christian's works, or the works of others. The topics were very diverse. We have numerous guests, not only in Düsseldorf, but also in Berne: artists such as David Bill, the grandson of Max Bill, or the composer and conductor, Stephen Harrap, and many others. Christian had a close relationship with Jef Verheyen. We visited him and his family in Provence and also put him up in Berne.

In the 1960s, when Christian still had his studio and his flat in the lower old town of Berne, and Harry Szeemann, with the aid of a few enterprising artists, transformed the Berne Kunsthalle into an international art centre, numerous artist friends from all over Europe stayed with him. On top of that, at the time Christian was operating the Galerie aktuell together with friends. The artists who were invited each time, including many from the ZERO group, worked partially in his studio because they had to realise their works for the exhibitions directly on location.

Which artists interested you?
All of them interested me because they were all unique. However, there were also some who got on my nerves so much that I downright forbade them to

continue coming to our place. They were the ones who thought I was a Sunday painter, although I didn't even paint. They obviously wanted to express by this that in their eyes I was only a hobby artist. I don't want to have people who have views like that at my place. Christian can meet them somewhere without my being there. But they weren't ZERO artists. Jef also said once – and it made

me really angry – that women weren't creative, that they couldn't make art. He really believed that, although his wife was a ceramicist. Presumably there were a lot of arguments between the two of them.

Do you have records or photos from that early period?
Yes, I took a lot of photos, of the British artist, Kenneth Martin, for instance, and of Jef. Christian also photographed Jef, including his children in Antwerp when they were still small. They were sweet with their long curls.

Where did you go on trips?
We really travelled around a lot, not only to set up exhibitions or to go to openings, but also for its own sake, without exhibitions. Our last big trip was to Jordan, to Petra, a town with a strange atmosphere that I found very beautiful. And we were at the Dead Sea. Jordan's culture impressed us very much. When the ZERO exhibition took place in Saint-Étienne in 2006, we drove to the south of France and visited artist friends of ours, including Elliot Bouchard and his wife, Dorothee, who live in the Cévennes. All of our trips have something to do with art and culture; there are no pure seaside holidays. We may go swimming sometimes, but we don't just sit on the beach. We've travelled through all of Greece, France and Italy. We were in Morocco and the United States. However we've travelled separately to Asia. Christian wanted to take me there, but I didn't really want to accompany him because when he travels with students there's always too much interference. I've had my own exhibitions in China, including in Beijing, and then I travelled to Seoul where a former student of Christian's lives whom I had looked after. But let's leave it at that; at the moment I can't tell you about every trip.

Very well, let's come back to you: which artists have been important
for your art?
René Magritte impressed me very much, not because of his surreal components, but because of the way in which he divides up the space, how he structures it. I found that great. Unfortunately I didn't get to know him. In my work there's also this aspect of space, but with a completely different content. In this respect I feel an affinity to him. And I must name the video artist, Peter Campus, who first studied psychology, like I did, and only then turned to art. There are three video works of his from the early 1970s that I love more than anything else. I wish that I had made them.

What do literature and music mean to you?
Literature interests me when the topic fits. I'm not attracted by particular writers, in contrast to art where someone can arouse my enthusiasm simply on the basis

of the person and their entire oeuvre. As far as music goes, I don't listen much. I can't stand loud music at all, no matter what it is. There I get into conflict with Christian because he always likes to have music loud. I like jazz and also other music, but when Christian is there it simply doesn't work. There's a woman who completely fascinates me and whom I can listen to for hours; that's Anne-Sophie Mutter. I got to know her through you both. I think she's so good, so fantastic both as a person and in her professionalism. I have a great many of her early records. Of course, at the time I also loved the Beatles, and I have some of their songs on my iPhone. But mostly I don't get to listen because in the tram, for instance, as young people do, I don't like listening. I also have recordings of philosophical lectures. When I travel by train I like to listen to Villem Flusser, who formulates very precisely and slowly. He has a way of thinking in images that I like, explaining everything from an image that I can then better memorise.

What are you currently working on?
I'm working on a time-space video that formally also has a lot to do with Christian's work. Perhaps I'll dedicate it to him, but I'm not sure yet. It depends on the soundtrack. If I give it a soundtrack that Christian could like, I'll dedicate it to him, but I tend to think that won't be the case. We'll see. My way of working is that, at first, I always make the image and the animation, that is, the video, and then I add the sound. I can't do it any other way. I can't already have the sound in my mind and work out an image for it. I don't have so much affinity to sound, and a couple of my earlier videos are completely without sound.

Which music or sounds do you employ for your videos? Do you also use records?
I added music from a record throughout an earlier video of mine. I had to repeat a sequence and thereafter it fitted perfectly. I was awarded a prize for it because the sound and image fitted so well together. I found that strange. But of course it's also associated with difficulties if you take recorded music for the soundtrack. The rights have to be acquired because if they're not all settled you can't show it on television. And if you can't show it publicly the whole thing becomes uninteresting. Mostly I do the sound myself, often taking noises, without melody. Very rarely have I also used music, but then digitally processed so that something else has come of it. I can work with music and get the rhythm across, but I prefer the visual; I can deal with it better than with the auditive.

But you have an idea about which kind of music you could employ for your videos?
Yes, certainly. I sometimes go into CD shops, listen to a few and consider how it would work, buy something and possibly change it. Or I mix together many CDs.

*And then it's yours, and you don't have any more problems with
the GEMA?*

Yes, because it's no longer identifiable. Sometimes I also use something from Christian's record collection, or I simply play pieces backwards to get a new rhythm on which I perhaps superimpose something else. I have eight tracks available and I can mix the various tracks together just like others bake a cake. I really make my work with the soundtrack very complicated, and it's also an enormous effort until it's finished. I'd like to mention an example: for my computer animation *HOMMeAGE* from 1996 I sought out about two hundred female nudes from European painting over the last five hundred years, from the Middle Ages to the present day. These nudes, mostly details of paintings, I brought to a uniform size on my computer and put them together into a confusing construed architecture, a kind of labyrinth along whose paths an invisible man in the form of a subjective camera walks. For this work I had to find sound; it simply needed sound. I couldn't be lazy and try to get around the work with the sound. And so I collected women's voices from films, no matter which, and changed them a bit. One woman says, for instance, 'Oh, that's a beautiful man!' To this I added an echo, since it's a matter of paths through a labyrinth. And now there are these many women's voices with the echo. At some points they all speak together in such a way that you can't hear the individual voice. But that was very good for the work itself. I'd like to play it for you later so you can hear how I deal with sound.

My last question to you is: what are your plans for the future?

Since 2008 I've become interested in photography again, but of a completely different kind from that in 1981/82. The digital photos printed on stainless steel – I call them *BENCHMARKS* – must be seen in the context of my previous video works. I'm very much concerned with developing this conception further. And there are already innumerable projects for the future. The drafts for them are partly already worked out. Now it's a matter of realising them, for instance, *GAMESTERS' PLAY*, one of my drafts for an interactive stage scenery from 2006: an oversized portable computer on whose keyboard a dancing ballet ensemble of twelve generates philosophical texts and images on the screen about changes to the way of life brought about by omnipotent digitalisation. Such a project demands close artistic and organisational collaboration with many persons over a long period. I already have common projects with Christian up my sleeve which I now also want to transpose from the drawing into real space. Last year, the monograph *Franziska Megert. Werke 1980–2011. Jeu de lumière* appeared for the exhibition at the Centre PasquArt Biel/Bienne. And a comprehensive documentation of my oeuvre is being made in collaboration with Ante Glibota, who recently compiled and edited a mammoth monograph about

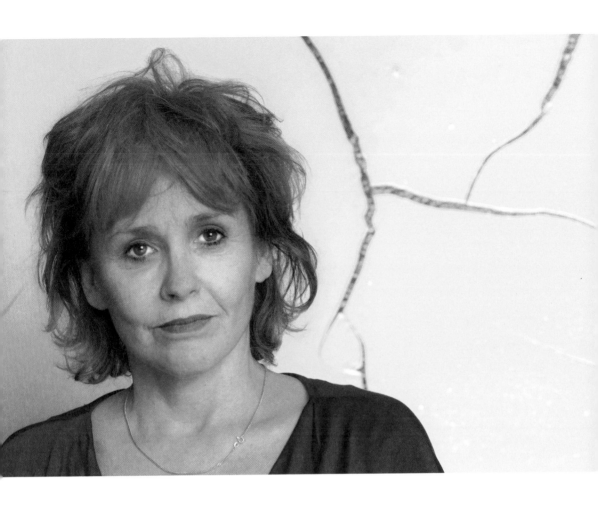

Otto Piene. Working together with other artists and culturally committed persons is becoming increasingly important for me. The 'endless' work on the computer, especially for computer animations, makes me very lonely; in addition there's the fact that works of a certain complexity and magnitude can no longer be realised alone, either financially or organisationally. This attitude permits me to think in larger dimensions in my artistic work.

"My wife earns our daily bread,
and I earn the bread rolls for Sunday"

Gertrud Bartels

Gertrud Bartels was married to Hermann Bartels
(1928–1989). We met at the retirement home
in Erkrath near Düsseldorf in April 2011.

*Mrs Bartels, here in your room you're surrounded by several works by
your husband, Hermann Bartels. Before we speak about your life together,
let's speak about you. Where and how did you grow up?*
I was born, as was my brother who's two years younger, in Holland, in Enschede,
and thus very close to the German border. My grandparents lived in Nordhorn
so it was no trouble at all to drive over and visit them. My father worked as an
engineer with a Dutch company, since he couldn't find a job in Germany. He
was aided by the fact that he spoke Dutch, since his mother was nationalised
Dutch. When I think back on stories about my parents, they really went through
hard times. My father lived through the two world wars, inflation, Hitler. We also
experienced that in part ourselves. I still remember how my parents once really
wanted to relax, south of Munich. They had scarcely arrived when Hitler ordered
a stop to trips, and everybody who was on vacation had to return home immedi-
ately because the trains were required for military transports to the Polish border.

Did you also attend school in Enschede?
No; my mother didn't want me to go to school in Holland. She was worried that
I would then only speak Dutch and perhaps completely forget how to speak
German. Happily, my father got a position with a company branch in Dortmund,
and when I reached school age, my mother also moved there and we attended

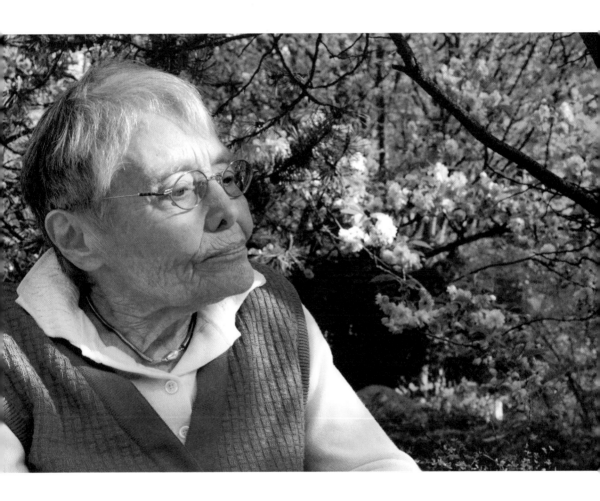

school in Dortmund. Of course, we would have been able to grow up bilingually. Today that would be a clear advantage, but my mother didn't think that was right.

Did you also do your professional training in Dortmund?
That was still a long way off. It was war, and we pupils, together with all the teachers, were sent to the Black Forest for schooling. It was called 'Kinder-landverschickung' and was a sort of evacuation. We lived in a village north of Freiburg from where you could see how the bombers destroyed the entire city within twenty minutes. Everything was in flames. My brother was moved to another place, to the Frische Haff on the Baltic Sea, and as the Russians approached, he was sent to Baden-Baden. Hence we lived separately from one another. When it became too dangerous for us in the Black Forest, we had to leave there and were evacuated several times, finally to Wemding in Bavarian Nördlinger Ries, which is supposed to have formed through the impact of a meteorite crashing down. All the pupils were billetted with local families. The residents were not allowed to protest about it. I remained in Wemding until the war was over. By the way, I saw my first black person there; he was nice and gave chocolate to us children. At that time we were told to be sure to hide your

watches carefully because they were after watches. Mine was a cheap one any-way. Apropos chocolate: of course I remember the CARE packages we received from the Americans. They were a true blessing for us and they saved us from starvation.

Your parents continued to live in Dortmund during this whole period?
Yes, they stayed there. My father had a serious stomach complaint and couldn't digest the terrible cornbread that we got to eat. He was taken to a hospital which was bombed out and was then evacuated to Sauerland with all its patients, including those who'd just been operated on. The wards were hastily-built corrugated-iron sheds. My father didn't survive for very long. When my mother went to visit him one day (she always went by bicycle from Dortmund the whole way) and entered the room, she saw that the bed was made and that his hat was lying on it. She knew immediately that he had died that night. So I didn't have much of my father. When my brother and I were small, he did play with us, but he couldn't really get on with children. I was just starting to engage myself a bit more with my father, since I had to bring him to the hospital on foot, because there was no transportation at the time. The snow was almost knee-high; during those years there was simply so much snow and it was very cold. I delivered him to the hospital and never saw him again because I was no longer living in Dortmund. My mother wrote letters to us children, asked acquaintances who was going where and when. She gave the letter for me to the father of one of my fellow pupils. That's the way I learned of my father's death.

Yes, that's the way it was back then. Many letters were taken by parents to schoolmates and they actually arrived, often by circuitous routes.
In an emergency, people help each other, much more than when things are going well; then you only think of yourself. I was always glad, of course, to receive mail from home, but when my class teacher asked me to come to her and handed over the letter, it was terrible for me to find out about how my father had died in such a way. And I was stuck in Bavaria at about the age of fifteen and wanted to return to my mother.

How did you come back to her?
We formed a group that wanted to risk the journey. All that wasn't easy. There were no passenger trains at all. Only in the Ruhr district was there supposed to be one, but otherwise there were none at all. So we set off on a goods train.

And you managed to reach Dortmund?
Yes, I was on this goods train for a total of eight days. When the train stopped, you had to quickly get out into the bushes and take care that the train didn't

start off again without you. It was pretty exciting. As far as food goes, we had prepared ourselves. Before we left we went from house to house in our Bavarian village and explained to the families that we wanted to travel home and asked whether they'd give us something, a couple of eggs, a piece of bacon, and so

on. The people in Bavaria were living well, while those in the Ruhr district were really starving. In any case my entire rucksack was full of things to eat.

I had promised my class teacher to visit her parents and ask them for some money for their daughter. And we'd given her our word of honour to come back to Bavaria. My mother was harshly criticised by her relatives about how she could allow her child to go off again into this uncertainty. I myself didn't worry about it at all. At that age you're not bothered. And you didn't know anything different, but thought that that's the way life was, just as you'd got to know it. If I'd experienced it otherwise, perhaps I would have reacted more fearfully.

After the adventurous journey I even managed to reach my class teacher's parents in Minden: in the packed goods train to Herford and then, after a long time waiting, I hitch-hiked in the back of a small station wagon. They gave me money for their daughter and put me up at an acquaintance's place, since they themselves only had a small flat. After that I had to go back the whole terrible way and actually arrived in Wemding, only to find that my teacher, who'd insisted on our word of honour, was no longer there. And I'd especially gone back to Bavaria because I'd promised to do so!

And how did you complete school? Did you do a kind of emergency matriculation after the war, like many others did?

At first there were no schools at all. After my time in Bavaria, I lived together with my mother in the Rhineland on the farm of some half-relatives who also had a small orchard which they cultivated after a fashion. The man was a philosopher, and such people aren't suited for such things, and the nominal aunt was deaf. When she heard that the war was over, she hoisted the Nazi flag in the garden. She was probably denounced and, together with other residents, was put in jail.

Gradually the schools took up teaching operations again. The closest one was in Opladen, the Marianum, a convent with an adjacent boarding school which, however, was not yet operating again. I applied there. At first they thought that it was for my daughter, although I was only seventeen. It was a terribly long walk from our place to the nearest station to catch the slow train to Opladen. I stayed at this school for a year and learned a whole lot during this time. We had very well-trained teachers who were nuns in the convent. History was taught by the only man, who was really a priest, and so somewhat higher up in the hierarchy. And there I did my matriculation.

What did you want to become?

I really wanted to study. But there was only one university in Bonn and another in Hamburg. Everything had been destroyed or was just getting started. Both universities admitted only fifty students each. They couldn't cope with more. And you can well imagine how long I would have had to wait for a place!

What would you have liked to study?

I didn't know exactly. Veterinary medicine would have been an option, without my having a precise picture of this occupation. They were probably rather romantic ideas. Today I'm sure that that wouldn't have been right for me. For a short time I thought also about library science, but then that seemed to me to be too dry. In the end it was quite simple: I went to my grandfather's who was still living in Nordhorn and stayed there for a while. I sang in the chamber choir whose choirmaster was a musical director who'd trained in Leipzig and had

ended up in Nordhorn. He really made something of our choir and organised performances. You simply grabbed every straw that was offered to you. At that time in Wemding, by the way, I was infatuated with my music teacher. Perhaps that's why I always got very good marks in music.

And how did things continue job-wise?
While I was in Nordhorn, my brother was working in Düsseldorf. He always wrote to me that I should come there, since Düsseldorf was such a beautiful place. And he sent me the most recent newspaper ads with job offers. One appealed to me: a patents lawyer was looking for someone with a knowledge of English. I applied in writing with a photo and he gave me the job without having seen me. Today that wouldn't work at all. That's the way I came to Düsseldorf. My brother got a sub-let room for me in one of the few houses that were still standing. It was the family's 'good' room which until then had only been used on Sundays, a rather ugly room with porcelain swans on the shelf. You can imagine how I felt. But then I moved into my own flat with my brother, after some difficulties. For at that time you needed a so-called 'building costs subsidy' of three thousand marks to get a flat at all. Where was I supposed to get that? Happily, my mother helped, who in the meantime had received some money. She only had a small monthly pension of 52 marks with which, of course, she couldn't do much, but my father's shares paid something out at some time, and

in this way she could help us financially. When my brother moved out after his wedding and I was unable to pay the rent on my own, I sub-let one room to young women. There were some peculiar experiences. One of them had a pen-pal in the United States who asked her to come over to visit him. And what did she do? She packed a few things, flew over without having seen him before-hand, and married him.

How did you get to know Hermann Bartels?
At the end of 1959, Hermann had an exhibition in a small Düsseldorf gallery. I really didn't know my way around art at all, and also didn't have any strong interest in it, but one of my friends persuaded me to come along once. So I looked at the paintings and on leaving I said, 'Yes, well, does it cost some-thing?' That's the way I met Hermann Bartels. At the time he drove each month from Frankfurt to the Ruhr district to show his latest works to his art dealers. Through the window of his old VW I could see pitch-black gouaches which he'd just done at the time. I asked myself whether, for heaven's sake, I could be together with such a man who painted such paintings. I'll never forget those black sheets; they formed only one episode in his oeuvre. After that he was soon working differently. Hermann wanted to move away from Frankfurt to Munich or Düsseldorf. He had a friend in Munich but he couldn't stay at his place; he had to sleep in his VW by the front door. He decided to move to Düsseldorf. I found that a good thing because, after all, I had my flat there and he didn't need to spend the night in his car. That's the way it happened.

And then you soon married?
Yes, we married on 16 August 1960. At the registry office Hermann wore his old confirmation suit. Before that we had a very beautiful, 'predated' honeymoon trip to the south of France. He had never seen the Mediterranean and was com-pletely overwhelmed by the view of it. I already knew it because in the 1950s I'd taken part in several organised trips, including to Spain.

When I look at your photo albums I get the impression that you travelled around a lot together.
Yes, that's true. Whenever I could arrange it with work, I accompanied him to exhibition openings, including abroad. Often the trip was to Frankfurt because Rochus Kowallek organised exciting exhibitions in his Galerie d, but in 1963 there was also the big group show, *Europäische Avantgarde*, at the Frankfurt Römer in which Hermann took part. And we drove together to Wuppertal to the equally avant-garde Galerie Parnass. We travelled around a lot in general: every now and again to the Mediterranean, to Paris, to the Swiss Alps to ski, even though I myself couldn't ski, and several times of course to Holland, to Amsterdam

and to my mother. I remember one trip to Nordhorn very well because shortly beforehand we'd bought a brand-new Renault R4, which had just come on the market, on credit. Our old VW, which had often got stuck in sand and which we had wanted to drive again, had been confiscated by the police as being not roadworthy. The R4 was an extremely practical car because you could transport paintings easily on its flat floor. Later on we had a Rover, and then transporting paintings was, of course, even easier. And at some stage we bought a paddle boat, and some time after that also the appropriate sails. We tied it onto the roof of the car because it became very tedious to put the boat together each time, which took several hours. By the way, it's not at all easy to sail a paddle boat. You have to steer with the stern and keep precise balance. We never capsized. And I remember Knokke, not only because we once celebrated a New Year's party with friends there, but because a couple of years after that my husband wanted to buy a flat there. I was flabbergasted: in our financial situation he wanted to buy a flat! Earlier on we always cut each other's hair to save money. Once someone even asked me in the lift who my hairdresser was, I had such a striking hairstyle. But something really did become of this flat.

Did your husband work at home or did he have a studio?

He had a studio in Düsseldorf, in a house at the back on the top storey to which you had to climb on a winding wooden staircase. He put a lot of work into setting it up. Wiring for lighting had to be laid and there was a lot he had to work on. But he was a handyman and gifted in such things because he'd trained as a turner and carpenter.

Were you able to help your husband with his work?

No, my work and his didn't have anything to do with each other. I worked for the patents lawyer for fifteen years and after that for twenty years with dpa, the German Press Agency; that was a wonderful time. My husband always said, 'My wife earns our daily bread, and I earn the bread rolls for Sunday'. When he became ill and got cancer, I had to stop working. At that time I was 62 and so had reached retirement age, so it wasn't a problem.

Did you discuss your husband's works with him?

Yes; sometimes he even liked doing that. He said he appreciated the judgement of somebody who was completely impartial and hadn't much idea about painting. So every now and again after work, I went to his studio and said what I thought of the paintings, and occasionally he even changed something. Sometimes even a painter gets colour-blind.

Did you get to know other artists while you were living together? Hermann Bartels exhibited a lot together with the ZERO artists.

Yes, that's right, but there were scarcely any private contacts.

Where are your husband's works today?

Well, some of them are hanging here in my place. From each phase I've kept at least one work, including the paper works. And the paintings that weren't sold went into the Foundation for Concrete Art and Design in Ingolstadt in 2010. The art historians there deal very carefully with the works, prepare everything in a scholarly way, organise exhibitions, edit catalogues and in this way make the works accessible to the public. I know the old museum building. As far as I know, a new building is planned for the future.

I wanted to gather knowledge,
attain insights

Hannelore Ditz

Hannelore Ditz has been the partner of Arnulf Rainer
for almost forty years. We met in October 2011
at his studios in a monastery in Lower Bavaria.

Mrs Ditz, you work here in the eastern wing of this former Benedictine
monastery. How did these studios come about?
Earlier on, Arnulf often travelled by in the train and saw this building. He was
looking for large, cool rooms for the summer because under the roof in his
studio in Vienna it was hot, and in winter it was terribly cold; even today it isn't
insulated. Apart from that, he found it very practical to have a place of residence
in Germany. Forty years ago Germany was already in NATO and he thought, if
the Russians invade, you'd be better protected there. He was a war child, which
makes you think of such things. A further aspect was that he had many exhib-
itions in Germany, and if he was working in Bavaria, most of the awkward
transportation and customs would be eliminated.
At first we rented three rooms on the lower level which, however, were soon full
of paintings and books, so that I no longer knew where to put them. After that,
the owner could no longer maintain the building and wanted to sell it. It was
too big for him alone, and so fifteen years ago he offered to sell us the eastern
wing. We really wanted to buy even more, but that was all that we could get.
The rooms, the roof, everything was in an incredibly bad state, and so we spent
ten years renovating it. Only last year did we finally install heating. Arnulf always
used to send me on in advance at Christmas to get the old stoves going. When
I arrived, it was zero degrees Celsius inside, and the water was frozen.

In Vienna we still have the old studio under the roof. It's remained as it was earlier on. After it became unusable, Arnulf took over a flat in the same house. He simply locked up the top and didn't enter the rooms until I'd renovated everything. Now the rooms below are stuffed with books and furniture and should really be renovated again.

Our daughter Clara then rented a very small flat in the inner city and took refuge there. Sometimes I'd very much like to swap with her. But of course here in Bavaria I enjoy the wonderfully generous spaces, in spite of all the work. The entire complex is almost a thousand years old. When you look out of the windows you have a fantastic view of the river and the small island in it. I really like being here and come from Upper Austria almost every day to work here.

You also live in Upper Austria?
Yes, in a little place in the foothills of the Alps about thirty kilometres from here, in a farmhouse with small rooms and low ceilings, just the opposite to this place. Arnulf loves it. When Clara was born, he really wanted to buy a large flat in Vienna, a fantastic loft right on the Belvedere. But then it became the farm in the dark Sauwald instead. For almost five years we had to get by without a telephone! At first I felt that I'd been carried back a hundred years to the end of the world. At the time Arnulf had a professorship at the academy in Vienna; he came here only briefly and then left again.

When we got the keys to the farmhouse on 1 January 1980, we drove there with summer tyres and, of course, immediately got stuck. It was snowing really hard, and the house is situated on the top of the mountain, but Arnulf wanted to move in immediately, if at all possible. Clara wasn't quite six months old. We'd brought along an electric kettle; we melted snow and made tea. Then we began with the renovations. Each year we erected a building for studios and workshops; it took forever. In the residence we basically left everything the way it was, the old doors, floors and so on. Even today there's no heating, only a tiled stove. Quite Spartan. Later on we built a new studio in addition and then another one. In this way, almost a small village has arisen around the square farmyard on the mountain, interestingly with a completely different energy from that here on the river. Round about there are only fruit trees and meadows. I used to work a lot in the garden, but now I don't have any time for that.

What I like very much is that we've a lot of books at all our places. What you see here is only a small part.

Which is already impressive enough. Is collecting books your hobby?
No, not a hobby, and these days it's already over. Arnulf needed the books to copy illustrations and then overpaint them. Only illustrated books were interesting for him. So for ten years I constantly visited all the second-hand book fairs

and book auctions. To avoid double purchases, I compiled an enormous card catalogue, ordered alphabetically, with a card for each book. Back then, unfortunately, there still weren't any portable computers with enough memory.

Then one day Arnulf began to work in the books themselves, that is, to overpaint the illustrations. There are wonderful specimens that were also exhibited, for instance, a few years ago in Bonn. The copies that haven't been reworked are here on the shelves. I've ordered them exactly according to subject so that I don't have to search for them: geography and travel literature, fish and fossils,

birds, medicine, anatomy. There are many books solely about the human brain, and in the other room, about costumes and old Bibles, and then a room only for flowers and botany.

It's wonderful what's been gathered here by way of knowledge!
Yes; I used to have an almost perfect overview. I only had to see the title page of a book at a second-hand book fair to know whether we already possessed it or not. I have a kind of photographic memory; now I have only drawings and images in my mind. I really loved these auctions and book fairs at the time. The second-hand booksellers are mostly older gentlemen, but even the young ones have something elderly about them. And all of them are very educated and quite witty. If you sit together for three days for eight to twelve hours a day, you get to know and appreciate each other. I was always well-prepared and informed

about the prices and the results of auctions. There was no internet. So I was able to outmanoeuvre other bidders every now and again because I was better informed.

Yes, our library is a great treasure for me too. For some years now, Arnulf has bought only newly published illustrated volumes on art history. We had to clear out an entire studio to store them. There they are stacked up next to and on top of each other. And we also need new book shelves each year on Tenerife.

Arnulf works for a good part of the year on Tenerife, doesn't he?
Yes, throughout the winter. For the past fourteen years. There's no proper studio there, but a spacious apartment, so he paints, weather permitting – that is, only up to storm-force three – on the large terrace with a view of the palm garden and the blue sea. Clara and I travel back and forth several times in winter. Since last year, all the more so; he can't stay on his own so much any longer, nor does he want to.

Quite a bit has changed since Arnulf's stroke in 1994, hasn't it?
Yes, since then he's become even more aware as far as health goes. He was always health-conscious and paid attention to cholesterol and blood pressure, but since the stroke he's become really extreme. I think that has to do with the fact that after a stroke many people fear constantly that it could happen again, and therefore often have anxieties about dying. In the first years after it happened, when he'd forgotten to take his medication, he thought he'd die on the spot. Now he's become somewhat more relaxed about that. And his entire daily routine is more regular. Normally, Arnulf goes to bed every night at eight and sleeps a lot, which is also a good thing. He works daily from morning to evening, but he's an early riser.

Arnulf really was always very disciplined, wasn't he? That cliché about Viennese artists who stay up all night didn't really apply to him.
No, Arnulf never made a night of it. Often I was fuming because at parties we were always the first ones to go home. For instance, at the large, merry parties that the artist, Kiki Kogelnik, organised each year when she came to visit from New York, or at dinners after exhibition openings. He always wanted to leave straightaway so as to be well rested and fit for work the next day. Frequently I would have liked to stay on longer. There were also no alcohol orgies. I've never seen Arnulf drunk, not even once. He can't take much, not even two glasses of wine. In the beginning I couldn't believe it. You always think immediately of Bohemian artists. And I was used to something different from the actors too. After the performance they often chattered on until four in the morning, even when they had rehearsals again the next day at ten o'clock.

Do you have something to do with theatre?

I tried to finance my studies myself and started with journalism. That went badly; the professors at the institute were absolutely hostile to women. After that I studied sociology, education and psychology. An actress at the Burgtheater in Vienna, Susi Nicoletti, who always mothered me a bit, got a job for me as a nursemaid with her colleague, Gertraud Jesserer. So I went in and out of the Burgtheater. Even into old age, Susi Nicoletti was an incredible woman, very affectionate. When I was on the street again at the time without a flat, I stayed with her. The only quid pro quo was to make tea every morning for her husband, Professor Ernst Haeusserman, who was director of the theatre in Josefstadt. Haeusserman was very fatherly. He wanted to have his chauffeur drive me to university. He couldn't understand that this would have been frowned upon among the Marxist-Leninist revolutionaries who were studying sociology with me and with whom I attended every demonstration. When I was ill he sent me to the theatre doctor. And when I'd found a room to sub-let somewhere, they gave me bags full of food. They were really very kind, and I'm very grateful to them.

You studied in Vienna. Were you also born there?

I was born in Innsbruck. My parents were from Vienna, but I grew up in Innsbruck and enjoyed it very much. Munich and Milan were very close, and there you could go to the museums, the opera and the disco. Switzerland was also not far away. And then there were the Alps; I could go mountain-climbing, swim in the lakes, ski in winter. And a lot of Germans came to study because of the skiing, so there was an open, liberal atmosphere, quite different from later on in Vienna. That left its mark on me, I think.

The Rolling Stones performed in Innsbruck at the time, and not in Vienna. I rode by bicycle to the airport with four girlfriends to greet them. No screaming crowd; just we five girls. It was as easy as that. And then when I went to Vienna to study I almost felt that I was at the end of the world; it was the start of the Eastern Bloc. And in the city there were only old people; there was nothing for young people – terrible!

Why didn't you stay in Innsbruck?

I always wanted to get away and be independent. But my parents insisted that first I should pass my matriculation certificate, then I could move out. That's what I did; I went away immediately thereafter and moved around a lot.

Do you come from an artistic or musical family?

My father was very interested in art. We had a large library. Books were very important for us, the ultimate. At Christmas each of us was given five or six

books which were already devoured before the end of the holidays. Once in the summer vacation I read the entire youth library in Innsbruck. And then when I wanted to go on to the adult library, they said to my displeasure that I was still too young for it. At home I'd already read Casanova's memoirs – secretly.

We never did 'classic' holidays, but went on a lot of trips as a family and saw all of Europe, especially visiting museums. For instance, we were often in Rome and Florence. That was my world. And when we visited my grandparents in Vienna, the best thing each time was to go with my father to the Kunsthisto-risches Museum. I've been going there since I was three years old. I can see many pictures in this collection in my mind's eye.

How many brothers and sisters do you have?

I've got two brothers. My older brother emigrated to Holland and has become more or less Dutch. The younger one lives in Innsbruck as a civil servant working as a lawyer for the police. Somehow he's the exact opposite of me. Earlier on we argued a lot, the way that one usually does with brothers. Today our relationship's very good.

Did your mother work?

No, and she suffered from being only a housewife. Before the war she greatly enjoyed working as a company director's secretary. Then she married during the war and had a son who died shortly afterwards. She would have liked to do something else instead of being only a mother and housewife, but she no longer had the courage, once we'd grown up a bit, to start again from the beginning. It's really very sad. She was born in 1914, and at the time women only worked when it was financially necessary. For me that's more of a negative example. I always knew that I didn't want to be like that.

What did you want? What dreams did you have as a young girl?

I didn't have any explicit dreams. I only knew that I'd never marry. I always knew that. I wanted to be free and independent, and not have the constraints of a marriage, even though my parents' marriage was very harmonious. They were never apart, and when my mother died at home of cancer after a long decline, my father broke down the next day and died too. That was a great shock – my father was very important for me.

As long as he was alive he supported me in doing what was important for me. No matter what I studied, I was supposed to gather a lot of knowledge, even if I couldn't use it later on in my job. I never really had thoughts or worries about my personal future, even when I was pregnant. I never knew where I would land, but I always knew that somehow everything would turn out fine. I think this self-confidence came from my father, and I still have it today.

What did your father do for a living?

He was a civil servant, a technician, and taught me how to repair irons and television sets, and even how to mix concrete. I could do everything myself, and this way I was independent. And conversely, apart from technical things, my brothers also learned cooking and sewing, like I did. At the time it took ages until the latest fashion came to us in Austria, and so my younger brother and I sewed a lot for ourselves from illustrations in fashion magazines. When I'd already been together with Arnulf for a few months, one day he asked me whether I had another friend or admirer who paid for my clothes because, since we'd met, I'd never had the same thing on twice. In Vienna back then there was

the Homolka in Mariahilferstraße where you could buy textile remainders for little money. And from these I then sewed dresses and trousers on my old Singer sewing machine.

For the 1978 Venice Biennale, when Arnulf exhibited in the Austrian Pavilion, I had to sew something quickly because otherwise I would have had nothing to wear. At the time we were there for several weeks because Arnulf only wanted to exhibit if the pavilion was renovated beforehand. We had to go to the construction site every day to check on the master builder so that everything would be ready on time for the opening. Before that I'd learnt some Italian so that I could communicate a little with the workers.

Where did you meet Arnulf Rainer?

In the psychiatric ward at the former hospital and nursing home in Maria Gugging. For my studies I was supposed to write a paper on music therapy in psychiatry, and hadn't found any literature on the subject. André Heller, Gertraud Jesserer's lover at the time, offered to take me to an exhibition opening in Gugging. There was a Professor Navratil there who could surely help me. And as I was standing there waiting, Habakuk, who at the time wrote a column for

the *Kronen Zeitung*, came up to me and said, 'Professor Rainer would like to speak to you'. I thought that this was a medical doctor. Arnulf, who at the time wasn't a professor at all, was standing around with a few people. I was supposed to help them. They'd just made a bet about whether I was a painter or a writer. I thought to myself, that's not a doctor, but a patient. I told him anyway about my problem. And he said that I didn't need Professor Navratil at all, and that I should come to him, since he had dozens of issues of the journal *Musik und Medizin.* I was sure that there was definitely no journal with such a stupid title, but it really did exist, and it still does, even today.

And then he offered to give me a drawing from the exhibition because, as always, he'd just bought a lot of works at the hospital's benefit exhibition. You must know that Arnulf Rainer was known all over Vienna as a skinflint, and the rumour went around like wildfire that he'd given a drawing to a complete stranger. I purposely sought out the smallest picture for myself. After lengthy persuasion, I then went to dinner with him. He was dressed pretty badly, drove a rusty Renault 8, a real bomb, and he told me the whole time how terrible life and everything was, and that he'd soon die. I was thinking only about what I was supposed to do with him now. I was scared that I'd have to pay for the dinner because he was perhaps broke.

Finally, because of the journals, I went to see him in his studio. It was an enormous shock; all the walls, down to the very last square centimetre, were covered with *Face Farces*, these overpainted grimaces. When he said to me that I shouldn't look because that was nothing for little girls, I got very angry and wanted to leave again immediately. After all, I was 23 years old. But there really were stacks of *Musik und Medizin* piled up there – unbelievable!

It took months until it occurred to me that I'd already seen an exhibition of his at the Galerie im Taxispalais in Innsbruck when I was sixteen and had even bought the catalogue. Only then did I twig who he was.

When we visited a large pop-art exhibition in the Künstlerhaus which was opened by the Federal President for the first time together, we were shown together the next day in a newspaper, both of us standing in front of a large sculpture. The caption read, 'Arnulf Rainer with daughter'. He was furious.

Were you already a couple at the time?
No, not really. We often went to dinner together, and he rang me up now and again to ask me whether I wanted to go to an exhibition opening or to the cinema. In the cinema he sat as close as possible to the exit, and if he didn't like a film, he'd simply vanish. Unfortunately that was frequently the case. I would have been able to remain seated, but of course I always went out with him. I was angry each time and then preferred to view the films together with other friends.

With him everything was peculiar, always so completely different from what I was used to. Sometimes it was also somehow stodgy. After a few months he then gathered courage and explained to me that everything for him was so difficult because I was so much younger, and he didn't know how to conduct himself. Even our trips to his exhibition openings were strange for me. We travelled by train in the sleeping car, and then straight back with the next train. No hotel, no shower, no getting changed. It was horrible. Everything just so that he could get back quickly to his studio to work.

Do you also go to exhibitions of other artists?
Yes, if it turns out that way, gladly. Recently we were in Paris and saw the Baselitz exhibition there. Nearby at the museum in Baden we currently have a very fine Baselitz-Rainer exhibition. Arnulf is one of the few artists who go to the exhibition openings of colleagues. Spoerri, for instance, is always very glad when Arnulf comes. One of his good qualities is also that he never criticises artist colleagues or grumbles about them.

When you were then living together with Arnulf, did other artists, museum people or collectors visit you?
Yes, continually. I always had to be there and serve tea. There was always tea. You can make tea more quickly than you can make coffee. And depending on the person's importance, there was tea only, tea with biscuits, or tea with cake. I was given very precise instructions there. Yes, I've experienced many visitors. The collector Ludwig came several times. He wanted to buy a large painting, but each time he bargained for an even bigger discount. For Arnulf that was very unpleasant, so a friend of ours negotiated and didn't drop the price, but raised it each time. Herr Ludwig then didn't buy from us, but somewhere else. The work in question, a large overpainting, is now hanging at the UNO building in Vienna.
Today Arnulf is still glad to push visitors onto me. When I came home with Clara three days after her birth, he sent an important art dealer and collector to me. I was supposed to show him paintings. He was so shocked that I was alone with the new-born baby and was even supposed to work so soon, that to the present day he's still angry with Arnulf. For me that was completely normal. During the entire pregnancy, I'd continued working in a gallery in Vienna.
Yes, I've met many interesting people, including many artists.

Who particularly impressed you?
Oh, that's difficult. Every artist has something special. That time at the Biennale I was together with Mario Merz a lot who one night even wanted to seduce me because, as he said, he begrudged Arnulf Rainer having me. I found Günther

Uecker very impressive with his sculptures. There were so many encounters. Joseph Beuys sometimes came to Vienna. By chance I once spent a long time travelling in the same train compartment with Gerhard Richter, during which time we had very interesting conversations. Gotthard Graubner visited us in the country, as did Emilio Vedova with his wife. Of the 'young' artists I value Hubert Scheibl and Peter Kogler.

Recently Georg Baselitz impressed me with his knowledge of art history. He's a great collector of old art and also very political, which I like. From me it's interesting that he took his experiences with him from East Germany instead of liberating himself from them. The Israeli artist, Mark Spitzer, used to come to Vienna often, and many, many others.

At Arnulf's opening at the Maison de Victor Hugo last year in Paris, we met Christian Boltanski again. I find his works very unsettling. And Michel Nedjar, a so-called outsider, but amiable and charming.

I'm most impressed, however, by Anish Kapoor, not only by his works, but also his personality. He's not only an excellent artist but he also has a lot of humour, and that's important to me.

That's also the lovely thing about Arnulf, that he's humorous and laughs extremely frequently, even about himself.

Have you been able to support Arnulf with his work?
Yes, I had to. In the beginning I often had to mix colours. All the red, yellow and orange had cadmium in them at the time and were therefore very poisonous, and also very expensive. I had to take care and not spill anything. Arnulf taught me how to stir them like pudding; no lumps were allowed to be in there, and so on. And then I also had to procure working materials every now and again. When he was working on overpainting death-masks, I sat for hours on end in the photographic collection of the National Library in Vienna, seeking out the death-masks of artists from A to Z there and ordering the photos.

With Arnulf everybody has to help. All the visitors who came to the farmhouse had to lend a hand, even if they couldn't do anything but pull out stinging nettles. Arnulf still does this today, not to exploit people, but because he thinks that everybody gets bored when he doesn't give them something to do. Nobody knows how to fill their time, and so he assigns to each an activity that seems sensible in his eyes. He's very practical.

For about twenty years, apart from the job as chauffeur, nurse and caretaker of our residences and studios, I'm almost exclusively occupied with organising exhibitions and book projects. Happily, Clara came back from abroad a few years ago to help me. We also try, if there's time, to document as many works as possible and to work on the extensive archive.

You said a short time ago that you met Arnulf when you were a student.
Did you complete your studies?

No, I no longer managed that. After Clara had grown up a bit, I did try to finish my studies. I already had an exciting dissertation topic, but I didn't have the time. I would have had to write between two and five o'clock in the morning. I typed my final papers in the night in a tiny room. Arnulf slept in the next room and got upset that the old typewriter was so loud. I had to put it on a piece of foam.

It was never important for me to have a title. I wanted to gather knowledge, attain insights. I'm really incredibly curious and interested in almost everything. I go through the daily newspaper from front and back, omitting only the job ads and the marriage announcements.

When you're working on something for your studies, you're forced to occupy yourself intensively with the topic and to read a lot. And in this respect Arnulf was fantastic. He'd already always received catalogues from specialist publishers, including for psychology. I only had to tick the titles that were interesting for me, and he ordered everything for me. I'd never have been able to afford that myself. I still possess this specialist literature today and follow what's new in these areas, nowadays more in the scientific journals and magazines.

Did you have any time at all for your own interests?

Yes, I simply took time for myself. When Arnulf was in Vienna, I could mostly make the appointments to suit myself, and when he's working on Tenerife in the winter, likewise. Then there's often a free weekend. If we're together, I'm there for him, not for him as a person, but as a support for his work, which he also expects.

What were you interested in?

I've always read and, after a few lectures on Wittgenstein, devoted a lot of time to philosophical questions. Of course, Buddhism has something to do with that. And then when we were in the countryside, I was absorbed by nature and redis-covered it for myself.

How did you discover Buddhism?

I grew up in Tyrol with religion lessons in school, but, like my parents and grand-parents, I wasn't religious. I always ask myself why people need a religion or a god. In Vienna I then attended lectures in comparative religious studies to get to know all the religions. One day I visited an event in the Künstlerhaus with a fellow student where a high Tibetan lama held a ceremony. I didn't understand at all what was happening there, but you could sense an incredible spiritual con-centration, and everybody was happy and laughing, completely without any affected piety. Years later I accidentally learned that this lama who'd visited

Austria in 1977 was the 16th Gyalwa Karmapa, the head of the Karma Kagyu tradition, and that I'd taken part in a very rare ceremony. My interest was awakened. I began reading about it, met teachers every now and again with whom I studied, and then met in India for the first time the twelve-year-old 17th Gyalwa Karmapa, the reincarnation of the 16th Karmapa. Through my preoccupation with philosophy, but also through years of living in nature, I had a lot of knowledge, but not the right language to express these thoughts. I found all this in Buddhist teachings.

For about fifteen years, Khenpo Rinpoche has been my teacher. We study Buddhist writings regularly, and I try to meditate and practise under his tutelage. Almost every year, Clara and I undertake a pilgrimage with him. We've been to India several times, and last year we travelled in Buddha's footsteps through Sri Lanka. Khenpo Rinpoche is not only a connoisseur of Asian art, but is also interested in our Western art and values Arnulf's work highly.

You've undertaken these pilgrimages without Arnulf. Do you also travel a lot together?

No. He's never liked travelling, and the trips had to be as short as possible. I've always regretted often having to travel alone. He does go, when he absolutely must, to his exhibition openings and then looks around in museums, but he's not interested in sightseeing. The days spent in Venice this year, however, were a lot of fun for him, for instance, the excursion with you on the boat to the islands. He'd already been in Venice so many times, but apart from the museums and the Biennale he didn't know anything.

With Clara I've always done a lot of sightseeing in foreign cities, for instance, the Eiffel Tower in Paris. I don't think he's ever been up there, even though he lived in Paris for a time.

If you could, would you spend your life once again with an artist?

Oh yes, indeed. You're absolutely privileged. Often I think to myself that I haven't earned it at all. Living together with him as an artist has been and still is a great happiness for me. It's a great inspiration to experience every day his seriousness and concentration on artistic work. When I was younger, I hadn't yet understood that. Also how simply, almost frugally, he lives. When sometimes I was so angry with him, I only had to go through the studio once, and I was reconciled again immediately. As soon as I see his paintings, I can't be angry with him any more. But Arnulf, too, has changed a lot. He could sometimes be really obnoxious. But it's an absolute privilege, and I couldn't imagine being married to some civil servant or banker or other. I'd despair and prefer to live alone.

I can only confirm that from my point of view. We too, as collectors, feel very privileged to have contact with artists; it's simply wonderful.

Yes, people who collect art, collectors, are also interesting personalities as a rule. During the course of the years I've learned a lot from them and how they view and seek out paintings. And of course, also from the museum people and curators. Arnulf has already had very many museum exhibitions during his life, and during the last 36 years I was almost always present. If I'm travelling alone in some city or other, I mostly go to a museum. This way I'm at home almost everywhere.

What wishes do you have for the future?

That Arnulf lives for as long as possible and remains healthy. If you see what's happening all around us: his friend, Markus Prachensky, has just died. Yes, you are afraid somehow. I can't imagine at all what life would be like without Arnulf. Of course it's sometimes sad to see how he's getting old, that physically and

mentally he can no longer do things which he used to do without trouble. As he himself always says, in old age the focus becomes smaller. Today he has to be fully concentrated on his work; there's no longer any room, any energy for anything else. Even travelling to his exhibitions is becoming more difficult for him. For this reason he prefers to remain at home in his studios.

Despite that, I simply can't imagine it. Sometimes I think about Picasso's last wife who shot herself after he died. To this day Arnulf doesn't believe it – a woman doesn't shoot herself... But she did, and somehow I understand that she no longer wanted to live without Picasso. Of course, I wouldn't shoot myself, but without Arnulf my life would be pretty empty.

For myself I wish a place for books, art and friends

Karin Girke

Karin Girke was married to Raimund Girke (1930–2002). We met in Munich in February 2011.

Mrs Girke, from what region and surroundings do you come?

I was born in Miesbach in Upper Bavaria. Because of the war, my parents were living by the lake at Neuhaus on Schliersee. I can still hear the resounding laughter of the class when, at the beginning of each school year, I had to stand up and say my name and birthplace, because Miesbach means, literally, 'rotten stream'. It's long since become a tourist resort. I was there briefly with a friend about ten years ago, but haven't been back again since. I've only a few memories of the area.

When I was six years old, my family moved to Unterhaching near Munich, and a few years later my parents separated. My mother then lived with us three children in Munich-Schwabing, and I attended St. Anna's School in Lehel. On my way to school I went through the park, along the Eisbach which flowed through the wonderful Englischer Garten. School at the time was still quite authoritarian and rather gloomy, at least as I remember it. Schwabing, by contrast, was full of promise: the art-film cinema in Occamstraße, the lively activities in the evening along Leopoldstraße. Without my mother's knowledge, I often wandered around there and sold paintings for a painter who produced tourist pictures. He gave me a pile that I put under my arm and worked my way through the Schwabing bars. For every picture I sold, I got one or two marks as a kind of commission.

Do you have any brothers and sisters?
Yes, a sister who's seven years younger and lives with her family here in Munich and with whom I have good contact. And I also have a brother who's three years younger and lives in Austria. He doesn't have much to do with the family.

Was your family artistic or musical?
Indirectly, I'd say. My maternal grandfather was very interested in art, but I only really found out about that later on. My grandparents were also separated. These family difficulties seem to continue through the generations a bit in our

family, and that's not the ideal conditions for feeling comfortable. But somehow or other, through friendships, other options have turned up to compensate for that by developing other ties of belonging. From an early age I was very fond of books. Art didn't appear until later.

What did your father do for a living?
My father came from an estate in Saxony, but had then lived in Berlin. He was in the war and after that was a prisoner of war in France. I know almost nothing about that today, which I regret very much. It was a subject that was never talked about. Parents and children rarely talked about anything like that; today it would be unthinkable. After having returned from imprisonment, my father built up a general agency for a radio and television company in Munich with which he was quite successful. His passion was hunting, which I found deeply repulsive. I was also really scared of it. My father died very early, at the age of 58, and I know very little of him. After separating from my mother, he married again and in this second marriage he could finally realise his life's dream of

having his own farm. I saw him only very rarely, once again briefly after finishing my studies which, after a few stumbles, I finally did complete. My mother also died early, at the age of 71.

Did your mother work too?
No; my mother came from an upper middle-class family in Bielefeld. My grandmother had brought a tobacco factory with her into the marriage, and my grandfather managed this company, but also cultivated his hobby, which was to collect art from the period of Frederick the Great: porcelain, tobacco tins, and so on, and also Delft tiles and similar things. We children experienced him only from a distance. There were invitations to go on holiday, and once in the three weeks we spent there, we were invited to lunch on a Sunday, very ceremoniously, and we went there looking neat and tidy, behaved ourselves and politely said 'thank you' and 'goodbye'. My grandmother played a larger role in my life. She was a very open, progressive, rationally thinking woman. After separating from her husband, she surrounded herself in her own home only with plain, modern furniture and objects. I've a lot to thank her for, for instance, that I learned to swim and ride a bicycle, skills which later played a decisive role in my life. But her interest in political events and also in classical music affected me.

In which ways did your mother influence your development?
Let me answer this question in a different way: under no circumstances did I want to lead a dependent life as a housewife. Despite that, I slid into a marriage much too early, which was annulled only a few years later. But after a few detours, I finally succeeded in studying in economics and social science at the Hamburg University for Business and Politics, supporting myself with the State student grant and various part-time jobs. That was a very pragmatic decision, for my interests went more in the direction of the arts. But during the preceding years, when I had earned my living in Hamburg advertising agencies, with Deutsche Grammophon Gesellschaft and finally in an architects' and town-planners' office, I managed to develop a certain sense of reality.

What kind of dreams did you have as a young girl?
I've only a few memories of dreams. Above all, I liked being alone. That was because I was very shy and extremely short-sighted; I was also a bit awkward and didn't like being criticised very much. I was good at keeping myself occupied alone. With books you're in good company. I had difficulties at school, with teachers and fellow pupils, and the gymnastics lessons were shameful defeats.

Did you want to go to the art academy?

No; I never thought of that. I sometimes considered studying architecture, but my parents didn't support me at all with that.

How did you get to know Raimund Girke?

That came only much, much later, in September 1989, during the days around the fall of the Berlin Wall. But there were several stages in between: first I finished my studies in Hamburg. Even before the final examinations, I was appointed to the freshly created position of press- and public-relations officer at

the newly formed publishing house, Klett-Cotta Verlag, in Stuttgart. So, after my final exams, I moved from Hamburg to Stuttgart. I had a very free hand with everything I had to do for the publishing company. For three years I travelled almost continually to build up and cultivate contacts with the public domain and the media. That was a lot of fun. I also learned a lot about how our cultural life works. But I also wanted to work more with the books themselves, that is, to work with content. And then I heard from one of the publisher's authors who'd written a book about the history of the word 'intellectuals', and who knew the publisher of the DuMont publishing house in Cologne well, that they were looking for editors in the field of art books. So I applied through the usual channels, was invited to an interview, got the job and moved in 1980 from Stuttgart to Cologne. I no longer had to clean the steps each week as I had in Swabia!

I lived in Cologne for nine years without coming across Raimund Girke. But about six months before I met him personally, I visited an exhibition of his in Schloß Morsbroich in Leverkusen, a major retrospective of his works on paper that toured through several museums. That was a wonderful experience. I knew nothing of him beforehand; there I saw his watercolours and gouaches for the first time; I was delighted by their richness in nuances and the characteristic

style of his brushwork. We finally met in Cologne at a regular meeting held by Hein Stünke, who'd established a monthly fixed day at an Italian restaurant in Südstadt, a suburb in the south of Cologne. At that time I was moving house once again and had had enough of boxes and crates. We got talking fairly quickly and intensively. And then our relationship developed. I was much more frequently at his place, in his beautiful house in Kaesenstraße, than in my equally beautiful new flat. Marrying was not on the cards; both of us 'had a past' and were well-practised singles. I also had my demanding work with DuMont which

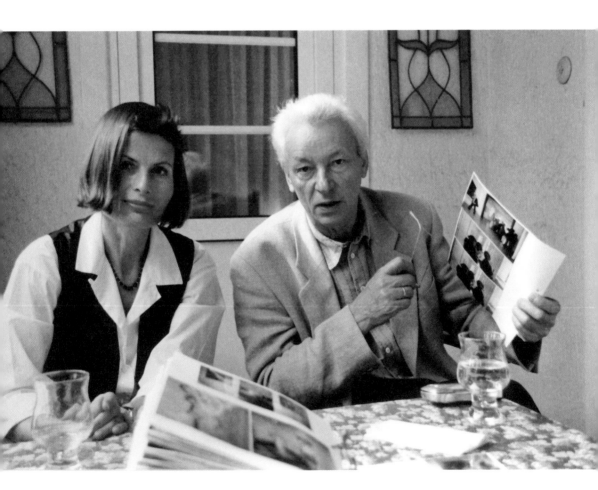

occupied me very much, often also on weekends. And Raimund had his work in the studio, the exhibitions and his teaching activities in Berlin. But then in 1993 everything changed with his illness, and after he had got through the first big operation and had more or less recovered from it, he thought we could risk a path together after all. Over the years I'd already gradually moved to his place, book by book, because every evening, when I came home after work, I would take something round to Kaesenstraße on my bike. You'd probably call that creeping in.

Was there an exchange with other artists during your time together?
Raimund was extremely critical and reserved with other colleagues. But he highly esteemed Rupprecht Geiger and Fred Thursz, for instance. Otherwise there was hardly any exchange. His studio was in Thürmchenswall in the north of Cologne near Eigelsteintor. It was a shut-down factory building in which several artists had their studios. There were friendly, collegial contacts with them, but not in the sense of artistic dialogues. Since 1970 Raimund had been professor for free painting at the University of Fine Arts in Berlin and was there every two weeks for a few days consecutively. When my editing job permitted, I went to Berlin now and again over the weekend. We spent all our time visiting museums and exhibitions. Raimund took his teaching job very seriously and made a great effort with his students. I typed up referee's reports and other things for him, since I was the only one able to decipher his handwriting.

And did collectors and museum people come to you in the studio or to your place?
A frequent guest, almost a housemate, was Dietmar Elger, who at the time was curator at the Sprengel Museum in Hannover. He put together the large retrospective with a catalogue in 1995/96, but was also previously involved in organising exhibitions. He also played a large part in the exhibition of paper works I've already mentioned, which was shown in Dortmund, Leverkusen and Ludwigshafen. He was a very early, committed companion of Girke's work, and also wrote catalogue essays and took care of the photos and the archive. Elger had a good, friendly relationship with Raimund and often stayed with us at home. He's certainly the person who is most familiar with Raimund's oeuvre. By now I also know it very well, because, bit by bit, I've made an inventory of all the works in the studio and all the documents, but that's a retrospective knowledge. Dietmar Elger, by contrast, followed the growth, the development of the oeuvre over all those years together with the artist. Today he's the director of the Gerhard Richter Archive at the Staatliche Kunstsammlungen in Dresden.
We developed a friendship that was important and enriching throughout all our years together with the Düsseldorf collector, Willi Kemp, whom we met in 1989

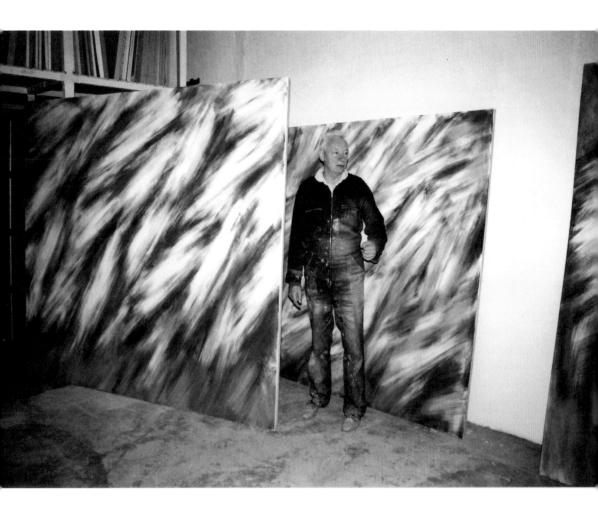

at the opening of the *Bilder für den Himmel* (Paintings for the Sky) exhibition. This show initiated by the Goethe Institute in Osaka, *art kites/Kunstdrachen*, went on tour for twelve years through the world's great museums. I don't know anybody who engages so emotionally and continually with art, and at the same time with such profound expert knowledge and unflagging commitment to the artists. We had many fine experiences with him and his partner, Ursula Kaechele: studio conversations, exhibition visits and new contacts with other people interested in art. Each new acquisition for his collection was celebrated with a glass of wine and an intensive viewing of the work from which a good piece of writing

frequently arose. Apart from that, Willi Kemp is a practised photographer to whom we owe the professional documentation of important art events.

Which meetings or conversations with collectors or artists do you particularly recollect?

Oh, there was an abundance of unforgettable exhibition openings in galleries and museums with stimulating discussions, festive dinners and, above all, the joy over a successful exhibition. There were wonderful contacts with art historians such as Gottfried Boehm and Wieland Schmied, who followed Raimund's work over a long time attentively and still write about it. A particularly wonderful event, for instance, took place in October 1989, pretty much at the beginning of our relationship: initiated by the Zurich gallery, Brandstetter & Wyss, Raimund had spent the summer working on an exhibition on site in Castel Burio, a somewhat dilapidated castle or estate similar to a castle in Piedmont where architects were also working. The opening took place over three days in this divine, late-autumn landscape and with a cheerful tumult of people enthusiastic about art. The art dealer, Carlo Grossetti, was there with his family, and so were many artists such as Giuseppe Spagnulo and Marco Gastini, and also Andrea Alteneder from Zurich, a former pupil in Raimund's master class. The musician, Fritz Hauser, from Basel staged an overwhelming solo performance with his percussion work.

But every exhibition opening was a really stimulating experience because Raimund prepared everything very, very carefully. A precise and generous hanging was enormously important for him. I experienced that several times; I found it so exciting and also had my own enjoyment from it. Over time I then noticed that I'd obviously developed a good eye for it. Raimund could speak very well about his own work and did so often.

How did living together with Raimund Girke change your own interests?

My life was enriched enormously through Raimund. He was also very much interested in literature and encouraged me to buy books. Through the publishing house I was always well-informed and could purchase many books at a discount, so that buying books was like buying groceries. We really did it to excess, and regularly went foraging at a second-hand bookshop in Cologne. But I'm immeasurably indebted to him in particular with respect to art. These special stimuli that I've received from his understanding of art have been very formative. I had already engaged with art early on, but with what was usual in the field of classical modernism. That began back then during the holidays in Bielefeld. There I had an uncle, a medical doctor, who was very enthusiastic about art and full of imagination. I was allowed to go with him once a week to the bookstore and seek out three art postcards for myself. And at Christmas and on my birthday I received one of those small Piper art volumes: on the Tunis trip

of Klee, Macke and Moilliet, about Chagall, Kandinsky, and all the rest. Classic modernism, in other words. I still possess almost all of them today. They were my first hesitant contacts with art. For my family in Munich, art was not on the map. During my later activities with the publishers, DuMont, I was then in the thick of things, but other criteria mattered.

Do you still work for DuMont?
No; I've long since passed through the sound barrier, and the next generation urgently needs work. For a time I continued working on a freelance basis in Cologne. Then I gave up editing and engaged intensively with my particular hobby, the art of drawing, and also wrote a bit, for instance, reviews of exhibitions. Since I've been living in Baden-Baden, I've also been more actively involved with contemporary artists. Last year I organised a very fine exhibition there for Andrea Alteneder in the Old Steam Bath, an impressive historical building. To prepare an exhibition is an enormous effort over weeks and months. Your entire thinking is called upon; it is, after all, a real creative act. And, apart from sales, you must put across something that changes awareness.

Was travelling important for you?
For Raimund, going on holiday was a horror trip because he always missed his studio. We went to the North Sea for three days now and again; then he took watercolours with him. But a real vacation – no, not at all. Nor did we go on long journeys. We travelled over the weekend to exhibitions in Paris or Dresden or Munich, to Titian or Turner, to Seurat or Cézanne; they were pilgrimages. To view the works together with him meant a great change and widening of my perception, simply a much more intense and complex way of seeing.

Then for you he was also a good teacher?
He didn't give lectures at all, but the way in which he commented on a certain detail of a painting or a perspective, a style of brushstroke, a single detail or a particular nuance of colour was spot-on. I found the topics about which we spoke extremely interesting. For him, in addition, memories of his home in Lower Silesia, the great cultural landscape around Wrocław, played an essential role. It was really a daily recollection, especially at breakfast, as if with the first cup of tea for the day the entire scenario of his old home spread out before him.

When did he have to leave his home in Lower Silesia?
That was in 1944, when he was fourteen years old. This flight, this deportation went in stages. After the family had come together again, they settled in Quakenbrück in Lower Saxony. At the grammar school there, Raimund had a very good art teacher, Kurt Dittmann, who recognised how gifted he was and

strongly supported him. He was a teacher who encouraged his pupils to make a point of travelling to see the art works in the original, and to visit as many exhibitions as possible. And so Raimund went on a bicycle tour to Paris with his brother and with very little money, if I recall correctly, to visit the Louvre there. Teachers are incredibly important. They can destroy something or else make it really flourish.

How long did you live together with Raimund Girke?
We were together from 1989 to 2002, that is, almost thirteen years. Of these, ten years were overshadowed by his serious illness. But when I think about what immense energy he generated in spite of that! During this precarious period he still had very important exhibitions, including the major retrospective in 1995/96 in four museums as I've already mentioned, and in 2000 the exhibition on his seventieth birthday at Ingrid Mössinger's in Chemnitz. There, however, he was already very, very frail so that even the journey was risky. But it did him so much good to experience all that approbation, so many words of comfort, and to see gathered together all that he'd created since the mid-1990s under these circumstances. He had always relied so much on his own energy and endurance, and he had been formed by his Protestant family to live a disciplined life and to be strict with himself, so it was infinitely bitter for him to discover that his will-power couldn't help him.

That was certainly also not easy for you.
Yes, more and more details of everyday life became precarious and complicated. Moreover there was the tension and the angst. Nonetheless we also had hope and intensive experiences every now and again, whether it was through music, through literature or also through short hikes. During the last phase of his life, Raimund still drew a lot, which is documented by a wonderfully designed book by the art dealer, Edith Wahlandt.

What wishes do you have for the future?
For myself I should like a place for my large library as my books are still partially dispersed in storage; a place for art with the possibility of putting on small ex-hibitions, so a place for friends so as to enjoy them together. And a place that's easy to reach. Now I live in Baden-Baden; it's pleasant here, with magnificent surroundings, and I have the great good fortune of having found good friends here already. There are interesting possibilities for discoveries of all kinds in the vicinity, from Karlsruhe to Freiburg, and from Strasbourg to Basel, to say nothing of the vast number of other little towns.

So you've moved around a lot and lived in many cities.
Yes, starting with Munich, then in Bielefeld, Gelsenkirchen, Hamburg, Stuttgart, Cologne. I was in Cologne for thirty years. I still very much enjoy going there to visit friends, about once a month, travelling in the morning and coming back at night, or perhaps staying overnight.

Are you now looking after Raimund's artistic estate?
No; the situation is somewhat more complicated. Raimund has three children from his first marriage. The estate is in the hands of his youngest daughter, Madeleine Girke. However, from Raimund I received as a gift a bundle of paintings, including some from his early period, that were especially important to him. And it seemed to me most sensible to give these works gradually to museums where there is already a connection with Girke and where there's an especial interest: Boston, Cologne, Düsseldorf, Bottrop, Berlin, Karlsruhe, Munich, Nuremberg and other places. Then there was a long series of exhibitions in museums and galleries in the years after Raimund's death. In the meantime we also have a website for Raimund Girke, so there's been and still is a lot to do.

You've also worked through the entire studio. Did you have help with this or were you at least able to get advice from somebody?
Yes, I followed to some extent what the wife of Ernst Wilhelm Nay, Elisabeth Nay-Scheibler, did. For me she embodies the ideal of an artist's widow: absolutely professional, with the highest degree of personal commitment and a lot of expert knowledge. And I've been helped wonderfully by our collector and friend, Willi Kemp, from Düsseldorf together with his partner. Every Sunday for six months, carrying the paintings back and forth, recording everything carefully, photographing, numbering, referencing. Rather like a catalogue raisonné, we produced a chronological catalogue in several binders. Using this you could initially prepare exhibitions fabulously at your desk, defining their size, and then continue work in the studio. That has been and is really an important tool.

You said a short time ago that you were interested in drawings.
What about those, then?
It all began with a visit to the Graphic Art Collection of the Leipzig Museum of Fine Arts with its magnificent Baroque drawings from the estate of Queen Christina of Sweden who, after her conversion to Catholicism, travelled to Italy and acquired art in grand style during her journey. When, after the fall of the Berlin Wall, the Leipzig Museum was a guest at the Kunstmuseum Bonn, I saw these drawings for the first time and was bowled over: they were utterly free, moving, full of spirit. At first I read catalogues, then I visited exhibitions of Italian drawings in Bremen, Düsseldorf, Darmstadt, Stuttgart and elsewhere. In this

way I gradually found out about everything that happens in collections of prints and drawings. A little later I bought something at auction for the first time at Lempertz in Cologne, a very fine sketch by Palma Giovane. I was very surprised that that was possible, because it wasn't all that expensive. As an editor I had a quite modest salary. And so I came into a special new world. I really plunged into it and bought all the specialist literature, including in second-hand book-shops, and then also entered a rather crazy circle of people. When in the begin-ning I turned up at the Galerie Bassenge in Berlin, I still didn't know anything or anybody and didn't know how it all worked. At a preview I looked awe-struck from side to side. People were standing together and I asked myself what they were all talking about. That was fascinating, and remains so today. Over the years I've met many of them and have been able to say my bit. Then I visited the Salon du Dessin in Paris or the auctions in London, where there were mas-terly engravings, museum pieces to admire and occasionally even favourable purchasing opportunities for myself. Finally, a small museum exhibition of 'my Italians' even came about, for which a catalogue was published.

How has your collecting developed?
To the Italians, who are no longer to be found so easily, I have now also added nineteenth-century landscapes: there's still a lot to discover there. Apart from that, I find contemporary artists very important too. At the beginning of my collecting, I wanted to create my very own area. But Raimund was also inspired by what I was doing; it stimulated him greatly to draw, and we had lively discussions about it. Often I was also in the favourable situation that dealers tend to purchase what is perfect and drawn to completion, whereas I was more interested in what was sketchy, and an assured attribution was also not so important for me.
With regard to contemporary art, I collect artists whom I've met personally. The art dealer, Werner Klein, in Cologne, who does excellent work and organises particularly fine exhibitions, represents several artists from whom I possess works, including Linda Karshan and Katharina Hinsberg, who's also very interested in the history of Italian drawing. A mass of literature is available about the extensive *disegno* discourse since Vasari or even prior to him. And then there are all the artists' writings! Of course this connection with literature attracted me strongly.
All this gives me a lot of joy, especially when you meet people who are also en-thusiasts. In Frankfurt there's an artist who works at the Städel Museum whom I met very early on at Bassenge. He has incredible knowledge and a sure eye, which he camouflages with the greatest reserve. He repeatedly makes signifi-cant discoveries where nobody had expected them. His opinion and advice are also sought out by specialists. It's a pleasure to talk to him, and I also value his painting highly. There's still so much to investigate and discover, all these large and small graphic collections. I can scarcely keep up with reading *Master*

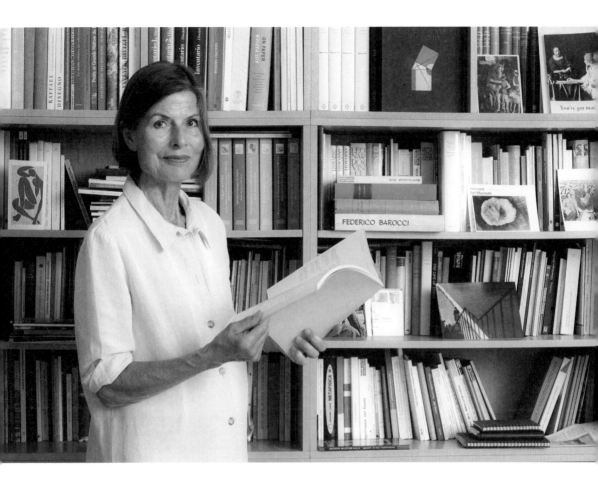

Drawings, the only specialist journal for the art of drawing, which has now also opened up to modern art.

And as far as Raimund's oeuvre goes: there are such beautiful paper works of his that are waiting to be seen. I'm hoping for an opportunity for exhibitions and a good publication.

All this is absolutely my life

Kitty Kemr

Kitty Kemr was Gotthard Graubner's (1930–2013) partner.
We met on the Insel Hombroich in November 2011.
Gotthard Graubner died on 24 May 2013.

Kitty, what was your childhood like? Where were you born and how did you grow up?
I was born in Ljubljana in Slovenia which, at the time, was still part of Yugoslavia. Shortly after the war my parents moved to Radenci, a spa in the triangle of Austria, Hungary and Slovenia. My father was director of the spa and the mineral-water springs.

As a child I was outdoors in the countryside a lot, in the forests, mostly together with my brother, who was seven years older, and his friends. At first it was probably bothersome for them because they didn't always really want to have his little sister tagging along, but I finally managed to get to play with them. We stomped around on the banks of the Mur River, along streams and the mineral-water springs.

It was not only nature that was so formative of my childhood and youth, but also the cultural diversity of the region where borders didn't matter. That was a wonderful and important time for me.

Tell me something more about your parents.
My parents come from Ljubljana. They belong to the generation formed by the Second World War. Both of them had joined the resistance but didn't know each other yet at the time. My father succeeded under difficult circumstances in

escaping political imprisonment by the Nazis and afterwards joined the partisans. My mother experienced the liberation in the Nazis' prison in Klagenfurt. After the end of the war, my parents met and started life together in Radenci.

Doesn't the famous Radenska Mineral Water come from Radenci?
Yes, the water with the three hearts. In the 1950s and 60s, my father had the mineral water exported, which wasn't easy at the time. Today you can get Radenska anywhere.

Did your family have artistic or musical interests?
My paternal grandfather came from Prague and played the violin in the Philharmonic Orchestra in Ljubljana. He had founded his own music school and was also a bandmaster. My father's cousin, Josef Kemr, is still well-known today in the world of Czech theatre and film. My maternal great-uncle was an autodidactic painter and earned a living manufacturing marionettes and glove puppets.
My parents were not themselves active artistically, but open to everything related to the arts. As the director of the spa, my father made numerous cultural events possible. In this way we had an open house for culture. My parents gave a lot of parties; actors, artists, musicians came to our place, and that left its mark on me as a child and also as a teenager. My parents enabled us children to dip into this world of culture in a more or less playful way. I still remember a party where I imitated Josephine Baker; at the time I was four years old. My brother's girlfriend had made me a little skirt out of raffia and bananas; they put me on the stage and I danced. Above all I loved my ballet shoes which my father had brought me back from Italy, and as a little girl I was 'on my toes' the whole day. My parents also enabled me to attend a music school where I learned to play the piano. Apart from that, we went on cultural trips, especially to Italy. Without these trips, my brother would surely never have become an architect.

What kind of professional training did you have?
After passing my matriculation certificate, I left home at the age of eighteen to study in Ljubljana. There I registered at the university at first in law, but remained in this faculty for only two semesters because I discovered that law was not at all suited to me. After that I studied art history for three semesters. At the age of 21 I moved to Bonn and continued studying art history there, along with archaeology and sociology as minor subjects. My teachers were Günter Bandmann, Heinrich Lützeler and Eduard Trier.

How did things work with the language?
At home we spoke Slovenian. At school I learned Serbo-Croatian, German and Russian. At the University of Bonn I had to attend a German language course and pass an examination in German.

Could you leave Yugoslavia at the time without difficulty?
That wasn't a problem. Yugoslavia wasn't the Eastern Bloc like East Germany or Poland, but much freer.

Back to your personal development. So you studied art history?
Yes, I studied in Bonn, but had to earn money during my studies. At the student employment office they asked me what I'd like to do. I said that most of all I'd like to have a job in fine arts, in a museum or a gallery or in the field of music. They said that they'd indeed have something for me there. And I was given an address with a telephone number: Johannes Wasmuth, Bahnhof Rolandseck. I then tried to reach him countless times, but didn't succeed, and I was too shy

simply to go there. So at first I earned my money from various jobs, in a plant nursery and with a bookbinder.

At a dinner one evening someone asked me what I was doing apart from my studies. I said that I was doing part-time work at various places, but not in an artistic field, which was what I'd really like to do most of all. This person said, without being more specific, that there was something that could be interesting for me. And the next day I actually received a phone call, 'This is Johannes Wasmuth'. I caught my breath. He'd heard of me, but he had had a problem making an appointment because at the moment he was lying in hospital. I replied that I could visit him there, and finally I got into my old VW Beetle

straight away and drove to the hospital. We spoke with each other for about one-and-a-half hours and at the end he said to me that I could start the next day. That's how I came to Bahnhof Rolandseck, and that has affected my entire life from then on.

What kind of activities did you have at Bahnhof Rolandseck?
At first I only sold concert tickets, but quite soon I started organising exhibitions and musical events. I also had the opportunity of helping to look after the

collection of works by Hans Arp. This also included research in his studio in Meudon near Paris. During my stay there I had interesting conversations with the artist's widow, Marguerite Arp-Hagenbach. I even had the privilege of living in Arp's studio for several months and getting to know Paris.

It was quite decisive for me that from the beginning, Wasmuth brought me together with countless artists and musicians, including Gotthard Graubner, the man who to this day is the most important person in my life.

I could list all the many famous musicians whom I met there, but I only want to mention a few names: Martha Argerich, Pinchas Zukerman, Chaim Taub, Elisabeth Leonskaja, Zubin Mehta, Daniel Barenboim, Benedetti Michelangeli, Maurizio Pollini, the Beaux Arts Trio, etc., etc. I also met Marcel Marceau, the clown Dimitri, and of course a lot of politicians. The entire world of music and culture gathered at Rolandseck because Wasmuth was skilled in bringing people together. Bahnhof Rolandseck itself already had a long cultural tradition. I remember how Svjatoslav Richter liked playing for hours on end in the dark. Sometimes I even crept into the hall unnoticed and listened.

Often we dined together with the artists, and when Wasmuth brought in more and more guests, Rosalka, the good spirit of the house, simply had to extend the soup. After dinner, one of the virtuosos sat down at the piano and played for us all. It was like a family at the time. Later on I even lived for two years in the tower of Bahnhof Rolandseck with a view of the Rhine.

And how did the encounter with Gotthard develop?
Gotthard and I saw each other for the first time in 1976 at Bahnhof Rolandseck. It was a very fleeting meeting, but at the same time an encounter that went very deep and left its mark on both of us.

After that we met several times at various events. There were intensive discussions, but also a certain distance. Finally in 1980 he persuaded Wasmuth to give him my address. Since then we've been inseparable.

When Gotthard came to visit me the first time (I was already living in Bad Godesberg), he was very surprised to see etchings of his hanging on the wall. I'd already collected his art before meeting him personally. Even as a student I'd bought art and paid it off in small instalments. Today I still own everything I'd bought then.

When we met I was so fascinated by Gotthard's personality that I was interested only in him, and even neglected my studies for a while, even though I really only needed my final exam. But he repeatedly admonished and encouraged me to bring my studies to a close. Finally I concluded my studies with a master's degree.

We went on a lot of trips together. Our journey in 1992 through Yemen was extreme. It was the period when North and South Yemen were united. So we

crossed the desert on the Incense Road and visited, among other places, the temples of the Queen of Sheba in Marib and various places in Wadi Hadramaut with the multi-storey houses made of mud. We spent the nights in small tents in the desert. I preferred to spend the nights in a sleeping bag beneath the open sky which, of course, wasn't without danger because of the snakes and lizards. There was a good reason why our guide slept on the roof of the Range Rover. On the whole, on our trips there were several incidents that were a bit risky.

During our travels we listened to concerts everywhere in the world. And of course, intensive visits to museums were part of our trips.

Through Gotthard I've learned to see art completely differently. He gave me access to new dimensions within the fine arts and taught me to read the language of images.

Sometimes I was allowed to be at the correction sessions with his students at the art academy. These are unforgettable hours for me. Gotthard also had a studio in Berlin where we spent a lot of time.

Were you still working at Bahnhof Rolandseck at the time?

For a short period, because at Bahnhof Rolandseck I also met another person who became important for me: Karl-Heinz Müller. Our first meeting had been in the 1970s, and was followed by an invitation and visit to Düsseldorf where I saw his private art collection, which filled me with enthusiasm. In 1981 Karl-Heinz Müller entrusted me as an art researcher with compiling an inventory of his collection. Already at that time his stocks had assumed such dimensions that art works were even stored under his bed. I agreed spontaneously and first worked with him in Düsseldorf. When I completed my studies in 1982, Müller had just acquired the Insel Hombroich and asked me whether I wanted to start working on the island. That was thirty years ago.

He had in mind that Gotthard should become his artistic advisor. The two of them had known each other since the early 1960s. So from 1982 on we became a real trio: Karl-Heinz, Gotthard and I. We made plans for the Museum Insel Hombroich, undertook many journeys together, travelled to exhibitions, visiting museums all over the world and purchasing art. Gotthard advised Müller on the purchases and on setting up the museum. He had his own views on the ways of making works speak, and I was continually learning to 'see' anew. It was an exciting time for us and for the Insel Hombroich.

What kind of man was Karl-Heinz Müller?

He was single-minded and a restless seeker. His visionary quality impressed me. When we began here on the Insel Hombroich in 1982, the island consisted of old parkland. The surrounding fields were bought up bit by bit. Müller imagined several locations for his collection, at each of which an artist or a culture would

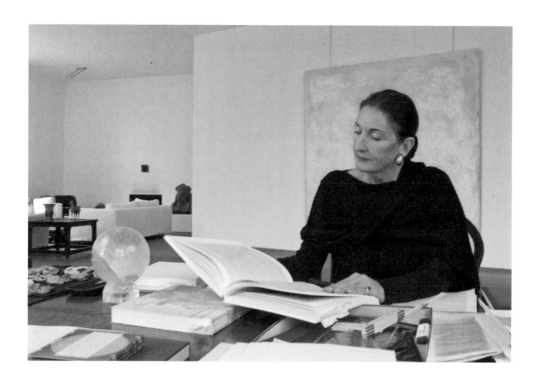

find its place. With this the project of the museum pavilions was born. Erwin Heerich designed them and they were built in several phases.

At the time the landscape architect, Bernhard Korte, found that the old park on the island had become wild and overgrown. On the fields he rediscovered traces of the old landscape and renaturalised them with great sensitivity. 'Art in parallel to nature', a phrase from Cézanne, became the island's motto from then on.

Gotthard had the individual museum pavilions and buildings built in such a way, and also staged the collection in such a way, that the visitor could see and experience completely new interrelations between cultures and times, sculpture and painting. I accompanied the museum's construction and the design of the spaces at all times.

And you went to Asia with them in 1983 to purchase art?

Yes, that was a legendary journey. Müller didn't normally fly; he was afraid of flying. But he'd promised Gotthard the trip to Asia and he then kept his promise, although every flight was accompanied by great suffering. We were

travelling for a very long time, in Russia, Japan, China and Thailand. We didn't really buy much there; we bought more at auctions and galleries in London, Paris, Berlin, New York, etc. I only want to mention one visit at this point: the first one to the Asian art dealer, Günter Venzke, in Berlin in 1983. When we entered his premises, we never tired of seeing his Khmer sculptures and Chinese objects. The Khmer culture became a new area for Müller's collecting, in which he developed an innate fear of not being able to stop collecting. We stayed for hours. Then Müller decided to buy everything, pack it immediately and take it all with him in his car. So Günter Venzke was standing there perplexed with a cheque in his hands, and his shop was suddenly almost empty. He'd never seen us before. A close friendship developed from this encounter, and the museum has 'grown'.

On our journey to Asia our prime concern was to get to know the cultures. We visited cultural sites, temples and Ming graves. I prepared this journey on the basis of old Chinese books and knew exactly which places we should see. We travelled as a threesome on paths that lay far from any kind of tourist track, which was very rare in 1983, but of course we always had a Chinese 'minder' with us.

These journeys and art purchases were only one aspect of your activities?
I initiated and organised concerts and readings and philosophical and sociological symposia on the island. In my contract it had been agreed that I'd have free time to pursue my doctoral project. Work on the Insel Hombroich became so time-consuming, however, that I was simply unable to complete my project. Public concerts have been held there since 1982. The relationship between fine art, music and poetry was intensified in subsequent years. The friendship with Johannes Wasmuth and the ties with Bahnhof Rolandseck led to my being able to win over the musician friends I'd made there for concerts on the island. The Beaux Arts Trio and the Guarneri Quartet gave unique guest performances. The Tel Aviv Quartet was also a frequent guest. From 31 May to 8 June 1986, the first 'Insel Festival' took place. There was music in the tent, and in the park I'd organised artistic actions with Nam June Paik and Gerhard Rühm. In the labyrinth, which was still a construction site, H.C. Artmann, Oskar Pastior and Lew Kopelew gave readings. There were many premières, including works by Helmut Lachenmann, Heinz Holliger, György Kurtág and Wolfgang Rihm.

New friends were made at later events, including Heiner Müller, Inger Christensen, Thomas Kling, Anne Duden, the Arditti Quartet and the Keller Quartet, András Schiff, Pierre Laurent Aimard, etc.

So you took care not only of the classical music, but also put together programmes with contemporary music.
I very much wanted to support young musicians, I thought it was important to do so. I invited many, including some *wunderkinder*, from Israel and all kinds of

countries. We established the series 'Hombroich : New Music'. The composers Georg Kröll and Christoph Staude supported me actively and advised me. Hombroich gave commissions for compositions and supported young composers whose works were premièred there. But the aim of the programmes was always to combine contemporary and classical music.

And the artists came because they knew you personally?
Yes, we invited the musicians and poets. And when they'd seen everything here, most of them were very enthusiastic about the island's atmosphere and were soon willing to play or read. All really good musicians, in my experience, are also interested in the fine arts. It was a great joy for them and for me to walk over the island, and to go through the museum and to experience the art together.
It was important for us when Karl-Heinz Müller had a studio built by Heerich on the island for Gotthard; it is supposed to become a Graubner museum one day. We were able to move into it in 1997. The Insel Hombroich thus became our permanent living space.
At the request of the violinist, Anne-Sophie Mutter, recordings were also made in Gotthard's studio for a film for a new CD. As a gesture of friendship, Anne-Sophie made the extraordinary offer of giving a concert for our friends in Gotthard's studio. I made of it a charity concert for the benefit of the Insel Hombroich Association in order to foster young musicians.

I know that you were awarded the Order of Merit of the Federal Republic of Germany for your work on the island.
I was very pleased about that when the German President, Johannes Rau, presented me with the award at Bellevue Palace in Berlin in front of Gotthard's paintings. It's a wonderful token of recognition, not only for my work on the Insel Hombroich, but also for the island itself.

When did you stop working on the island?
It was a painful decision for me in 2003 to have to give up my activities of 23 years for the island. I did so with a heavy heart. Years of attrition tactics finally forced me to decide to give notice. Happily, the tension was lessened through a conversation with Karl-Heinz Müller that he'd requested only a few days before he died. It was liberating for us both.

This certainly signified a great turning point in your life. Was it difficult for you to fill this gap?
Giving notice, of course, meant a change, but now I was able to concentrate entirely on Gotthard's work. And in the past few years, that had become an ever-growing challenge in terms of organising and dealing with inquiries from

galleries, museums and collectors. Of course, everyday life with Gotthard is also very demanding, a full-time job. I take care of everything, plan and work out exhibitions, catalogues, books. I'm responsible for all the contacts, requests and appointments that people approach him with. In addition, I also have to protect Gotthard so that he can work in peace and without being disturbed. That demands a lot of energy. There are no regular working hours with us. My work for him is continual deployment, but very exciting, because I accompany his work directly and experience many stimulating visits from other artists, museum people and collectors. The list would be too long, however, to name all the names. I've made some notes and could write a book about it.

Do you still travel frequently with Gotthard to your old home?
Yes, we travel whenever possible because Gotthard, too, loves the people and the landscape there. Close relationships to a few friends have remained since my childhood, and there is also my brother, who's also a friend. Gotthard gets along very well with him, too. We're in Ljubljana quite often, or in the mountains in winter, where my brother has a farmhouse. And we frequently visit Istria. After

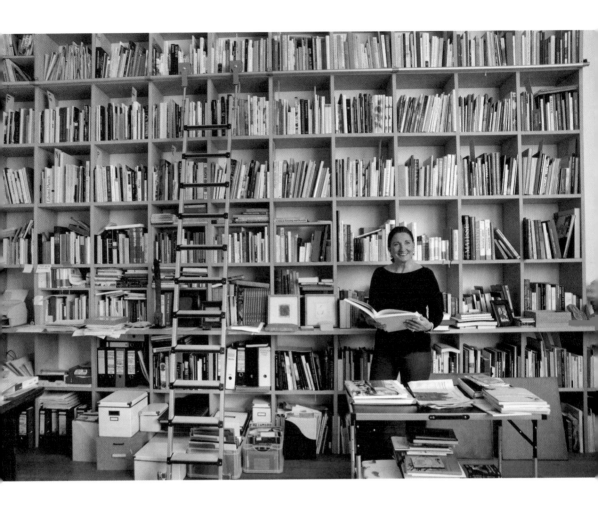

our mother died, my brother and I extended a little old house there to make a studio apartment. So there are still strong ties with my home.

In conclusion, what do you like so much about your living together?
Everything. It's incredibly lively, stimulating and exciting. I had the good fortune of having the same interests as Gotthard from the outset, and we are in a continual exchange of views. Everyday life is very demanding, but something new happens every day and it never gets boring, even after thirty years. Everything's always in motion. All this is absolutely my life.

Dani Franque – a brief portrait as related by her daughter

Léonore Verheyen

Dani Franque (1932–1989) was married to Jef Verheyen (1932–1984).
We met her daughter, Léonore Verheyen, in April 2012 in Mechelen
near Antwerp for a conversation about her mother.

Léonore received us in her home in Mechelen. She had prepared our meeting perfectly and permitted us to look at her family archive which she administers and works on. We looked at photos, and Léonore told us a lot about her parents' lives and shared experiences.

Her mother, Dani, was born in Antwerp in 1932 and lived there until 1974. She grew up as an only child in creative surroundings. Her father, an engineer, drew designs for a Belgian engine and car factory. Dani's mother was a dressmaker, creating unusual clothes for herself and her daughter from precious materials. Léonore and her brothers and sisters have preserved these clothes. Dani had a close relationship with her grandfather. After elementary school she attended an art-oriented school and then went to the Royal Academy for the Fine Arts where she took courses, including those in drawing, painting and ceramics with Olivier Strebelle. At that time students' art training was very broad. Apart from drawing and painting, they also received instruction in engraving and, of course, ceramics. Perhaps she was inspired by Strebelle to become a ceramicist. There, at the beginning of the 1950s, she met her new classmate, Jef Verheyen, who was the same age and had previously studied in Lier near Antwerp. It was love at first sight.

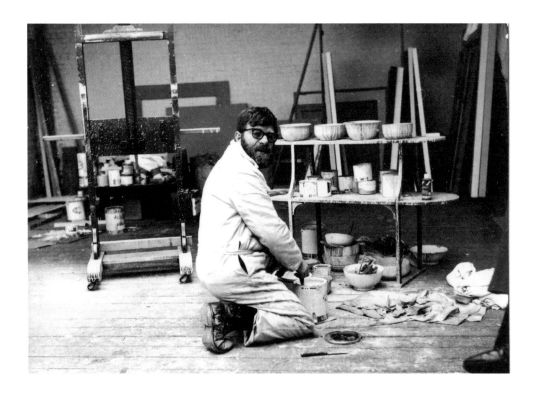

They both completed their university degrees in 1954 at the Hoger Instituut that was affiliated with the Academy and, together with two friends, they opened a ceramics studio in a small shop directly opposite Rubens House. *L'Atelier 14* was named after the number of the house in which they also lived and sold their ceramics. The wedding planned for the same year didn't take place. The registry official at the town hall informed the young couple that the bride's parents had not approved the marriage. Dani's mother had written to Jef's mother saying that she thought the bridegroom was not good enough for her daughter since he was only an artist. Nonetheless there was a celebration, but the contact with Dani's mother was broken off. Only a year after Léonore's birth in 1957 was there a rapprochement, and two years later a reconciliation.

Until the beginning of the 1960s, Dani was active as a ceramicist. She developed a very special technique which enabled her to produce her works with very thin walls, so that they appeared very fragile, almost like porcelain. She didn't use a potter's wheel, but made everything slowly by hand, first forming small strands

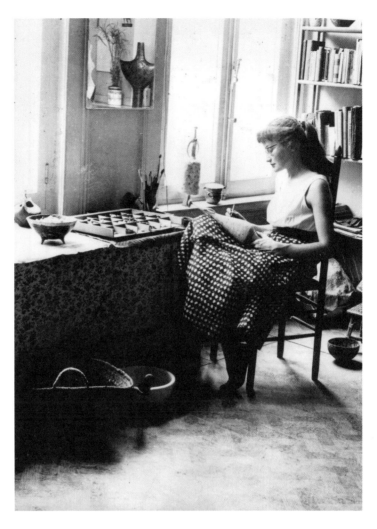

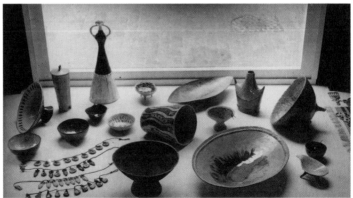

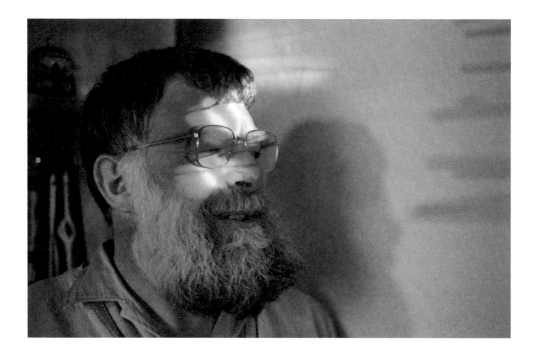

from the clay and from this gradually building up a surface. As she did so, the material had to be kept wet all the time. Forming, enamelling, firing – the entire process demanded great skill and patience, as Léonore knows from her own experience. When her two sons were born, Dani ended her ceramics work. Three children were a great responsibility and time became scarce; apart from that, she also had to be there for Jef. She closed down her kiln; a few unfired pieces still exist in Léonore's home. Did she find this decision difficult? She didn't speak about it, but after Jef's death she wanted to take up pottery again, above all for Léonore who thought, however, that she must do it for herself. But she never started again; perhaps she was too ill and didn't have the energy. She maintained friendly contact for a long time with her fellow students from the academy, especially the women who had continued their work in ceramics. Dani's ceramics are carefully preserved in glass cabinets in Léonore's home: cups, bowls, ashtrays, tiles. She also possesses jewellery and small sculptures made by her mother which Dani called 'mammiks'.

Jef had already decided a long time before that to give up his work with drawing and ceramics, and to paint exclusively instead. Apart from a few portraits, for instance, of Rotraut Klein and Christine Uecker, he concentrated very early on the abstract, panchromatic paintings that are typical of his work. Dani supported him at the time, not only financially through selling her ceramics, but also psychologically. She encouraged his visits to Italy that often lasted several months, during which time he met important artists such as Piero Manzoni and Lucio Fontana, who acquired a painting from him as early as 1957. Dani wrote Jef a lot of letters during these years, on the basis of which her daughter is now able to order events chronologically.

Dani liked living in Antwerp; she loved the city. When the weather was fine, Jef and Dani spent their weekends with the three children in the countryside where Jef had built a little house of stone and wood on a large plot of land in the forest. They slept under the roof. Léonore remembers vaguely her first trip with her parents in 1959 to Gordes in Provence. After that they wanted to buy a

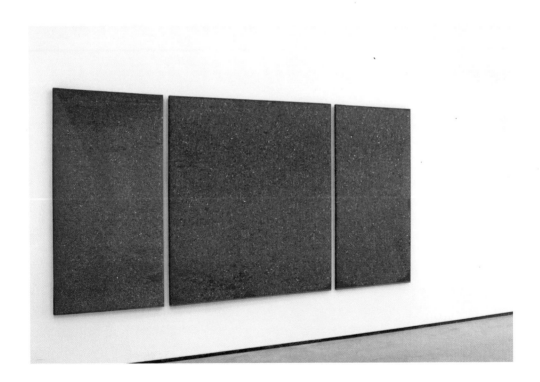

house in the south of France. For Jef, the different light, the blue sky and the entire atmosphere was irresistible. And for Dani it had perhaps gradually become too difficult in the city with three small children and the constant stream of visitors. In 1974 – apart from Léonore who had turned eighteen and at first stayed on her own in Antwerp until September – the family moved to the south of France into a large house for which Jef designed the garden gates. For the children this meant an enormous re-orientation: new schools, another language. Apart from household chores, Dani spent many hours in the garden and looked after the two horses. She lived there until her death in 1989.

The family travelled a lot in Europe, frequently in connection with exhibitions: to Switzerland, to Tuscany, Venice and Carrara in Italy, to Germany, here mainly to Düsseldorf. Léonore especially likes to recall the two one-month trips to Spain which they undertook together. The car journey lasted four days on hazardous roads – at that time there were no motorways. The three children sat in the large luggage-space of the Armstrong Siddeley. They stayed at a hotel in a small fishing village – quite luxurious for the time.

The Verheyens kept an open house both in Antwerp and later in France. Many artists, including German and Dutch ones, as well as museum people, came to

visit and stayed overnight with them, as Léonore recalls or can reconstruct in part from letters. Hermann Goepfert and Günther Uecker, to whom Jef had a close relationship and whom Léonore wanted to marry as a child, were frequent guests. Dani and Jef possessed a very large collection of paintings in which the artists of the ZERO group were represented, which they had built up through exchange or purchase. Dani took care of the household, organised everything and cooked together with Léonore for up to twenty guests, often during the entire day. She washed up until late into the night; later on Léonore's husband helped. Apart from making breakfast, Jef's culinary skills were minimal. In the 1960s they got to know the neurologist, Jos Macken, who acquired many of Jef's works from an early date, and some time after that, the collector, Axel Vervoordt.

Having two artists as parents who, moreover, had strong characters, wasn't easy sometimes. Through her intensive occupation with her parents' archive, including all the letters and documents, Léonore, an art historian and linguist and mother of two children, has gained yet another perspective on Dani's and Jef's lives.

I love enjoying life

Marie-Madeleine Opalka

Marie-Madeleine Opalka was married for decades
to Roman Opalka (1931–2011). We met in March 2011 in Salzburg.
Roman Opalka died on 6 August 2011.

Marie-Madeleine, for me you are the French woman par excellence.
Where were you born?
In the heart of France, in the département of Aveyron near Roquefort, which is
very well-known. At that time, my father moved around a lot so that my brothers
and sisters were born in different places. I had two brothers and one sister, so
we were four children.

Does your place of birth still mean something to you today?
I was too young when we moved away so that I can't really remember what it
looked like then. I've not been back there for many years, but when I think
about it, it's always associated with a hint of melancholy; I can't really explain
that properly.

Do you come from a musical or artistic family?
Yes, especially on my mother's side. My grandfather was a friend of André Gide
and Paul Valéry. We had some very beautiful paintings hanging at home, old
ones of course; I inherited some of them. And now, when I look back, I remember
that my mother studied with the sculptress, Germaine Richier. My father was
more technically gifted; he was responsible for electrifying various départe-
ments in France, including Aveyron, Lozère and Brittany. In the late 1920s there

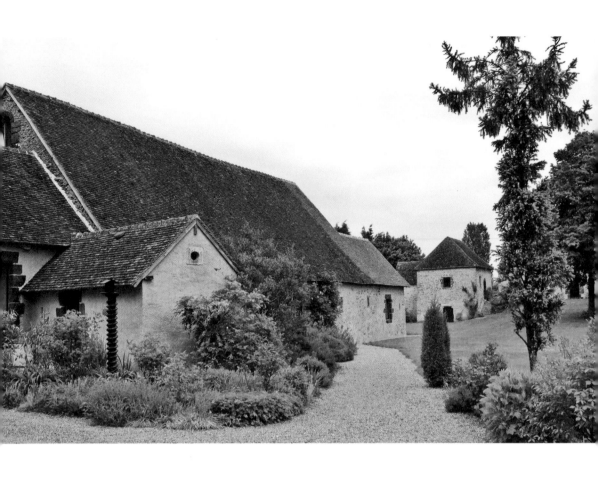

was still no electric light in most parts of France. He attended the École des Travaux Publics. His father didn't have much money, but a teacher at the high school recognised my father's mathematical talent and made it possible for him to attend the grammar school on the strength of his capabilities. In this way he actually did his matriculation exams and even finished school as the best in his class. Apart from that, my brother, too, is gifted scientifically.

Even as a child I didn't have a traditional father-daughter relationship with my father. For him I was not a little girl, but rather we stood, so to speak, on the same plane. I liked that. When I passed an exam with good marks, I was surprised that he didn't praise me at all. He found that quite normal. I admired

him greatly and adopted many of his character traits as my own. He had a great influence on me, and I probably also had a great influence on him. He took an enormous interest in everything I did.

Did your mother work too?
No, she looked after the family and had a firm grip on the household, almost like a matriarch. She was a strong woman, really authoritarian, but with her feet on the ground: one life, one husband. She, too, also influenced me, of course, although she was very different from me.

Where did you go to school?
At first in the département of Lozère because my father was working there at the time. The school was excellent, but we were also educated very strictly and devoutly, and lived under constant surveillance which, however, was very good for me. Once I had to make a very great effort in order to pass two classes in one year, but that, too, was a good thing because you shouldn't waste any time. After classes we studied for another two hours without heating in terribly cold conditions. Yes, life was very harsh there!

What dreams did you have as a young girl?
I had dreams, and I remember them well. At that time I was not much interested in sport and completely ungifted in gymnastics, even though I was very slender. I didn't dream of marrying a prince; I wanted to be Tarzan and to swing from vine to vine like he did. That was my dream as a young girl for years on end.

Did you have a specific wish regarding your future career?
Yes, I wanted to be a doctor and began studying medicine, but then there were problems. When my father got cancer I had to earn money to finance my studies. At that time I was living with my great aunt in Paris and didn't have to pay any rent, but life was nevertheless difficult. In summer I travelled to work in the mornings around six o'clock in the crowded, stifling métro, which was not always pleasant. When I got married to my first husband, I stopped my studies. Strictly speaking, we had had an agreement between us; he had promised me that if I married him I could do what I liked. I found that a good thing, so we married. But when we came back home from our honeymoon trip to Israel and I wanted to continue my studies in Geneva, he said, 'No, I don't want my wife doing anything like that'. So I broke off my studies and after that it was too late for medicine. So I studied philosophy of art. A few hours a week were acceptable. However, I could only really get stuck into it after we divorced. At Geneva University there was a wonderful dean who was of the opinion that students needed time to dream, which appealed to me very much. Later on I worked as a

business manager in an art investment company. I enjoyed these activities because I could spend many hours in art libraries and read there as I had to write texts about the artists whom we represented, for instance, Kandinsky, Braque, Schiele, and Bacon. By the way, my boss founded the auction house *Finarte* in Milan. I always tried to persuade him to include contemporary art in his programme, but he always put me off and said he would do it later. When he decided to sell only old art and moved to London, I gave notice.

Did you experience the desire to get to know an artist?
To get to know artists, yes, of course, but I wasn't actively searching for them! I never wanted to share my life with an artist. In my opinion artists are impossible people, yes indeed, they are. They lead a wonderful, dynamic life, can never rest and can never say, 'Today I'll do nothing' – they're artists! They take you over completely; they suck in your oxygen for themselves. They need your energy; they need something from you, not for their art, but for themselves personally to live on, in order to be a good artist, or even a bad one. They live in another dimension. You have to accept that. Earlier on, when I was young, I didn't want to see and accept that, but now I know. All this has something pathological about it, at least something pathetic. They feel alone even when they have people around them. They need somebody to breathe. This holds true not only for artists, but for men in general. I have seen that often in my life, even in the most perfect husband. Men themselves don't know it, but that's the way it is. They need something from you, always.

How did you meet Roman?
That's a long story. In 1974 we had to go to *Art Basel* because I had business to do there. At that time there was no motorway, so the trip by car from Geneva took five hours. We set off at five in the morning, and after we'd arrived, eaten and looked around, we still faced the prospect of this long journey back. I therefore argued in favour of setting off again, although I hadn't seen the first floor of the art fair at all. But there hung a painting by Opalka. My friend insisted that I take a look at it. What a shock! I was overwhelmed. It radiated such strength, but nothing at all wild, trans-avant-garde or whatever was in fashion at that time. All these waves of white and grey simply emanated peace.
In 1976 the story continued. At that time I had a relationship with a conservator who organised a César exhibition in Geneva. And when César arrived (he came from the south of France and loved eating) we became friends with him. After that, César had an exhibition in Rotterdam and my friend thought I should also travel there. That didn't really suit me because I would have missed my daughters' first day of school. But my friend said, 'You make César laugh, even now when he isn't well'. That convinced me. The same day an exhibition of

another artist opened and César proposed that we look at it together. It was eleven o'clock in the morning. We came across a series of sixteen paintings by Opalka in a large hall. I could only stare at them agape. And I will always remember César's reaction to this room with Opalka's works, of course, in his inimitable southern French accent: 'Marie-Madeleine, I, I would go crazy, but just understand, that is a painter!' After the official opening there was a dinner; I saw Opalka there and was blown away in an instant. This man with blonde hair and these special blue eyes, dressed completely in black velvet, like Hamlet! And he radiated such sadness. The artist, Stanislav Kolíbal, later explained to me, 'But Marie-Madeleine, you don't understand that properly; we Slavic men pretend to

be sad for that way we are much more seductive'. Opalka looked at me, and I looked at him, and then it happened. That was really the moment.

Fantastic.
But you can't imagine how difficult and even exciting life with an artist is, especially with a Polish artist!

Do you really believe that nationality makes a difference there?
In Roman's family only the sons counted; in my family that was not the case.

In what way were you then able to support Roman in his artistic work?

As far as his work goes, I'm not important at all. Some artists' wives may play a role there in the sense of a muse, but otherwise, in every other area, I am right there in the foreground. Roman was always totally involved with his work. In the beginning he made six or seven works each year; now it's only one. He can only work for a maximum of one-and-a-half hours at a time. After that he has to rest. His legs get tired from standing for a long time, and then he is simply exhausted. And apart from that he has a problem with his eyes; he had glaucoma and the only solution the French doctors know about is an operation. Now we have a doctor who swears by naturopathy whom Roman trusts. He studied traditional medicine at university, was in China for three years and now uses completely different healing methods. In just three sessions he succeeded in normalising the pressure in Roman's eyes.

But back to your question as to how I have perhaps been able to help him. When an exhibition of Roman's works was planned somewhere in the world, I tried to clarify things, helped to look after the insurance, the transportation of the works, that sort of thing. That, in my opinion, is what you can do for an artist. I also took care of the correspondence, and a lot more which, properly speaking, the galleries should have looked after, but didn't. As an artist's wife

you have to do everything yourself. We even had to compile the bibliography ourselves. That is not acceptable. Some galleries demand fifty per cent, and then they don't do their work properly.

Yes, a lot has changed. But art dealers today also have it tougher and have to earn their money.
And the artists don't? For them, too, a lot has changed. It isn't their business to contact important museums about possible exhibitions; it's the galleries' job. That's what they're paid for, and not for telephone conversations with their collectors. After all, it's the artists who make a gallery's reputation.

Were there contacts with other artists from the beginning?
Yes, a lot, from the very start. At first with two important artists who always supported Roman: Günther Uecker and his sister, Rotraut Klein, who was married to Yves Klein. Rotraut always praised Roman as an artist and said he was one of the best. I got to know her even at the second meeting with Roman in Paris. She is quite a wonderful, endearing and strong woman, and creates very beautiful works herself. Roman and I like her very much.
From the early period I particularly recall a meeting with Joseph Beuys. We visited *documenta* in Kassel, were standing alone in a hall with paintings by artists who were not very interesting, when suddenly Beuys came into the room. He saw Roman, went up to him, embraced him and whispered in his ear, 'Strange!' To which Opalka immediately replied, 'Tragic!' Beuys laughed and asked him mischievously, 'Always numbers?' 'Of course!' responded Opalka. Beuys embraced him once again and said, 'Very well!' When Beuys died, Roman wrote a short text, 'In my work I stride into infinity; Beuys is already there'.

How was it with visitors? Did collectors and museum people come to you?
Yes, of course. Roman never went to the museums himself to ask whether they would purchase, but rather, the people from the museum sought him out, and quite quickly too. Even early on, the Italians came to see his works and to support him, for instance, Luigi Carluccio from Turin. The first painting was purchased by Ryszard Stanisławski from the Museum Sztuki in Łódź, and then Dieter Honisch from Germany acquired works, at first for the Museum Folkwang in Essen, and then later for the Nationalgalerie in Berlin. Before that, Dieter Honisch had visited Roman in Poland together with Günther Uecker.

Where were you living at the time?
When I met Roman in Rotterdam in 1976, I was living in Geneva. Opalka had just received a DAAD stipend for Berlin, and after that he wanted to move to Paris. I didn't think this was a good idea because his gallery representative was

John Weber in New York. I therefore thought it would be better if he went to America, to New York. But he thought that he was a European and should stay in Paris. Later on France became interested in his works and supported him, but they have bought very little.

Have you records of your time together?
I only wrote about what concerned my work with the art investment company, nothing about Opalka. But Opalka himself is always writing.
However, when queries come about a text by Opalka, which happens very often, we do it together. We often fight over it. Roman speaks French well, but I know how to express myself more elegantly. Thus it sometimes gets difficult because he insists on his own ideas. Happily, I don't speak any German or Polish, so that I pass on this correspondence directly to Roman.

Did you also have contact with Roman's friends?
Of course, from the outset, with Uecker, Gotthard Graubner, Kolíbal, Bob Ryman, Pierre Soulages and many Polish artists whose names I no longer remember. Via Günther Uecker and Dieter Honisch we also very quickly got to know Gerhard Lenz, your husband. I met him for the first time in St Gallen when he came from an Opalka exhibition; I no longer remember in which year. Gerhard simply has an eye for paintings, for art. At that time he said to Roman he would buy his last painting. And then you two did just that.

Which encounters with artists were particularly important for you?
At all the meetings I found the conversations between Opalka and his friends exciting and interesting. All the meetings with artists became enduring moments, and the more I became involved with their works, the more I liked them. And of course, the times spent with you two are unforgettable!

But we're not artists!
I mean all the parties that you've organised for artists. They were always the best. Well, which artists have impressed me most? Yves Klein. I met him as a student during an opening in Paris, without knowing his work beforehand, and was then very excited because I saw a painting by him that fascinated me greatly. But for me the artists who opened wide the doors for modern and contemporary art are Malevich and Rodchenko. Of Picasso Roman says, he's like a gardener who takes all the flowers for his garden. I also treasure him greatly. But when you see one of his late works, even his little *Goddesses*, it's simply a matter of a circle of naked women, and nothing divine. If, by contrast, you look at the *Lady with the Ermine* by Leonardo or his *Mona Lisa*, there you can see God. That's the difference! Leonardo never claimed he was making something divine, but he did it nevertheless. You can see something there. With Picasso, however, one colour study touches me greatly: the *Scream*, a citation from *Guernica*. This woman with her mouth wide open expresses pure terror; you can really hear the scream. This work bears another dimension, a tragedy within itself. That no longer has anything to do with a gardener.

You spoke just now about artworks. Which artists have you particularly admired?
Roman, of course, is the one I treasure most.

Did he leave you room for your own interests?
In the beginning, yes; then I had time for my stuff, but not any more. Only in Venice. Venice is my place.

Were journeys important for you?
I used to dream about journeys; I wanted to see the whole world. Now I travel almost too much. The journey that left a lasting impression on me was my first one to Israel in 1959. At that time everything was so new. On the road from Tel Aviv to Jerusalem, tiny trees lined the edge of the road. When we returned

there in the 1970s, I didn't recognise the road and was almost convinced that this was not the route we took in 1959. A woman enlightened me, 'But Madam, there is only this one road'. Everything had changed so much. And I remember well a few voyages by ship. Yes, we had wonderful trips. But travelling with Roman is different. When we travel somewhere, on arrival I have to be alone for two days to feel the atmosphere.

What do you particularly like about being together with an artist?
That you always learn something.

Do you mean with regard to human relationships?
No, mainly in things to do with art, but also in what concerns philosophy and the art of living, *savoir-vivre*. I'm very different from Opalka. He follows the straight path; he's always open for philosophy and reads a lot. But he shapes his life completely differently from the way I do. I'm in love with life; I love enjoying life. About a year ago he said to me, 'Marie-Madeleine, I've understood; for you life must always bring what's best'. But of course! You only live once, and you have to make the best of it even when things are not going so well. Life has its ups and downs. And mostly you're not at all aware that you're happy. There are only a few moments when you feel: I'm happy now.

How would you describe happiness?
Happiness is the moment between two moments in which you are not happy. However, that doesn't apply when you're completely desperate!

Would you let yourself in for such a life again so intensively?
Yes, of course!

What dreams and desires do you have for the future?
Just to have more time for and with Roman.
I like Venice so much because I enjoy everything there that I do, every second. Perhaps also because there I don't live surrounded by tourism. I simply enjoy everything with Roman. For instance, when we arrived in Venice last year on 31 December, we wanted to go out for dinner, but were still sitting in our small salon. It was a day when you thought that you're in a Turner painting. Those colours! It was so beautiful. We stayed at home. I didn't have anything special to eat there, just noodles, olive oil, bay leaves, salt, peperoncini, garlic and a good bottle of wine. That was one of the best New Year parties – you don't need anything special. That's Venice!
And you always want to find out more about all the art works. This year there was a fantastic Giorgione retrospective with *La Tempesta* and the *Three*

Philosophers. You always have something new to learn. Pure joy whilst enjoying time, that's what I need.

When you're sitting in your apartment in Venice and looking at the lagoon in this special light, that really reminds you of Turner.
Yes, I think Turner is one of the greatest artists in the history of art. I looked at the Turner in Venice exhibition three times.

With my ideas I was always a bit too early; that was my problem

Nanda Vigo

The architect and artist, Nanda Vigo, was the partner
of Piero Manzoni (1933–1963) for several years.
We met in Milan in June 2011.

*Mrs Vigo, we are meeting today for the first time and I know only a little
about you. Before we speak about your time with Piero Manzoni and your
own artistic work, please tell us something of your childhood and youth.*
Okay. I was born in Milan and did not have any brothers or sisters. My father's
parents came from Mulhouse in Alsace, and those of my mother from Vienna
and Budapest. Because I grew up with my mother's parents I am, as I always say,
Central European, a product of the Austro-Hungarian empire. My grandmother
was strict but she was a wonderful woman. Her partner was an artist, and there-
fore she was the only one who understood me and my inclination toward art.

When did you begin to get interested in art?
Oh, that was very early on, at about the age of four. At that time my father had a
house in Moltrasio on Lake Como, so we often drove to Como to shop. And
there the fantastic buildings of Giuseppe Terragni fascinated me. As I learned
later, he was one of the founders of rational architecture and worked a lot with
glass and glass-concrete. His buildings absorbed the light, changed it; at each
time of day they looked different. They were so beautiful. Soon after that I knew
all of his houses in the town. This light situation and the changing impressions
of space through light – that fascinated me.

Did you come from a family interested in art?

My mother's father was the director of La Scala in Milan and an agent of Toscanini. And his father, in turn, was a very famous tenor. Over there you can see his bust as Pollione in Bellini's *Norma*. As a child I was always sung to sleep with 'Coro Muto' from *Madame Butterfly*. As far as music is concerned, I have been strongly influenced by my family; the other arts had less importance. Today music still speaks to me but I do not play an instrument.

What was your father's occupation?

My father was the son of a very successful businessman who was director of an Italian bank. He was so successful that he crushed his son and was a very hard and terrible man. He put everybody down. This grandfather handed the management of a company over to him but, because of his father's negative influence, my father didn't have a chance of gaining a foothold. Therefore he wasn't really able to work. Incidentally, he was not so important for me; I looked only toward my grandmother. She took care of everything.

Where did you go to school?

At first I attended the art grammar school in Milan. Even early on I dreamed of the United States because the most important architects, such as Frank Lloyd Wright, worked there and in the States I could also find the best music. However, since at that time the final certificate of the polytechnic school in Milan was not recognised in the U.S., I subsequently attended Lausanne Polytechnic. There, while still a student, I taught first semester students and organised projects to earn money for my trip to America.

What did you want to do in the United States?

I wanted to work. I spent about two years there, finished practical work in San Francisco and then attended Taliesin West, Frank Lloyd Wright's school in Scottsdale, Arizona. But the teacher turned out to be so dreadful that I went back to San Francisco and became active in various architectural studios. Somehow, however, this time around 1958 in the States seemed to be too early for me: in every large studio you went to, there were about thirty men sitting densely packed, each working on a detail. One did the windows, another the doors, and so on, and they spent their entire life treading on the spot. Anyway, that was how it seemed to me. That didn't conform with my idea, including my idea of architecture. What they developed was decoration, rather, and I didn't want that at all. And so I began my own work, set up a studio in Italy and started, together with two engineers. My first large project was a cemetery for a small village near Milan, not an ordinary cemetery, but situated in a multi-storey building. Nobody had ever thought of something like that before. I designed it

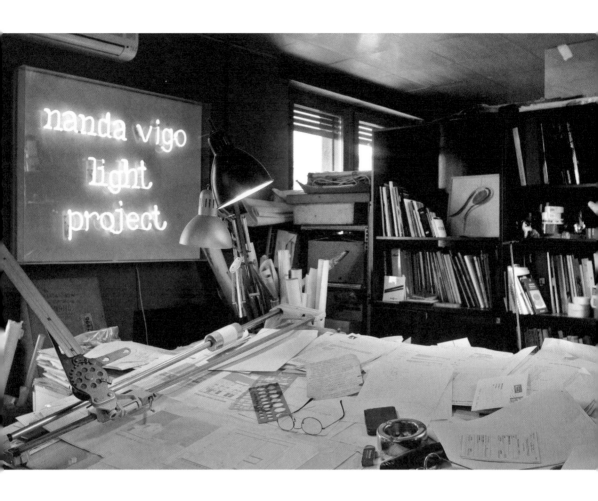

in 1959. The project could not be realised in full because all the Catholic priests opposed it. In their eyes it was impossible to bury a deceased person in such a cemetery. For this reason it wasn't possible to raise the necessary money. Only the plans for the offices, small church and a flower shop were realised.

Today, perhaps, this project could be realised
Yes, possibly, in view of the lack of space in cities. With my ideas I was always a bit too early; that was my problem. Even at the age of fourteen I made my first

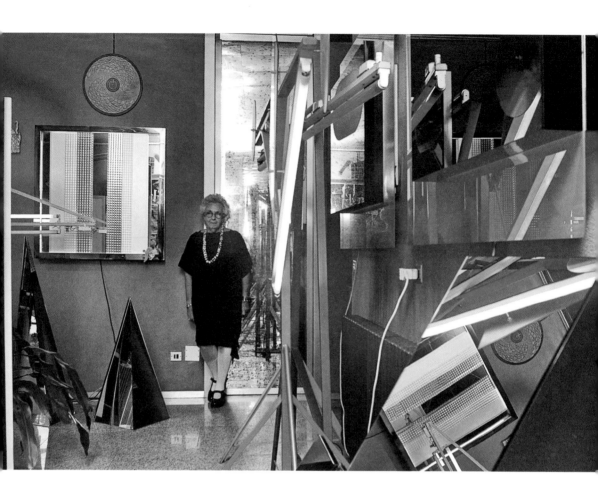

architectural design. I was always a pioneer in some respects. Today, many young artists are taking up my ideas from that time.

What would you call yourself, more of an architect or more of an artist?
Among other things I am an architect, but primarily I'm an artist. I earn my money with architecture so that I can live with my paintings. Already during my studies I tried to combine the two. Art alone wasn't enough for me, and architecture wasn't either. Therefore the encounter with Giò Ponti was so important for me

since, at that time, he was the only one who combined architecture with art and design in his work. Nobody else, not even the younger ones were doing that in the years 1958/59. We became close friends. When I met Piero Manzoni at the end of the1950s, I had already been working for a long time in this direction. We met at various exhibition openings in the city. One of my friends at that time, one of the first Chinese artists in Milan, knew Manzoni and introduced me to him, and likewise Mario Arcanini, who usually printed his exhibition catalogues. So we met several times. And one day we were standing opposite each other in the Bar Jamaica in Brera, looked into each other's eyes, and then it happened. It all went very quickly.

At that time you were already a successful artist?
At that time none of us was a successful artist. Even Piero only became really well known several years after his death. At that time we found ourselves outside the art system; we did not have any galleries where we could show our works. The ZERO founders exhibited in their own studios. In 1959 Piero established his Galleria Azimut. As I said, in 1959 I was occupied with my cemetery project and had just started working on the ZERO House. But I had only just got together with Manzoni when I had to stop. He didn't want me to work. I must tell you a story about that. At the age of 21 I had the opportunity of collaborating on the design, including interior design, of a house in Milan. I was just finishing this project and needed large paintings for the dining room. Then I met Piero. At this time he was making those paintings with the white bread rolls. And I thought, something like that would be fantastic for the room and asked him to create such a work for one of the walls. But he was so jealous and refused. He didn't want me to work at all. However, I had begun the project before we met, so I also had to finish it. Finally, Enrico Castellani, with whom I was friends, said he was willing. Then the project's principals died, the house changed hands and the new owners had nothing better to do than to sell the works by Fontana and Castellani immediately. They destroyed everything, those stupid people. Today the house no longer exists. And yet another story is characteristic for Manzoni's jealousy or envy. In 1962 we went to the town hall to prepare a publication for our planned wedding. Our witnesses were to be Castellani and Antonio Maschera, the typographer and printer. But Piero said to me, if I didn't give up my studio he wouldn't marry me. That was simply too much for me! Of course I did not close my studio. I had just come back from the States. I didn't like what I had seen there. Instead, I had the desire to do everything differently and was enthusiastic about my work. And now Manzoni wanted me to stop! Appalling! Hence I was not officially married to him, but that doesn't matter.

Did you then live apart, or did you continue to live together?
After that we had a big fight. Before he set off for his last important solo exhibition at the Gallery Smith in Brussels, he wrote me a long letter in which he asked me what I really wanted. I came and went, it was a back-and-forth. So I travelled to him and we were together at this last exhibition. One month after our return he died of cirrhosis of the liver. In retrospect I'm glad he died. I was sometimes so angry because he was so much against my work that I might have killed him.

Were you a couple for very long?
For a few years, his last years.

Let us come back once more to your time with Manzoni. You surely got to know a lot of artists, didn't you?
Yes, I knew some. They lived in Brera. All the artists were there at that time, including many artists from Germany and Holland. Of course, we didn't communicate by e-mail like we do today. We mostly met in the Jamaica Bar and spoke about exhibitions and exchanged information. I was still living with my parents and they didn't want me to bring artists home. I lived with Manzoni in his studio in the Via Fiori Chiari. We could only go to his home when his parents were on vacation. They had a house in Albisola and another in the countryside near Brescia. When they were travelling we sometimes met there to make a risotto. Piero was a good cook.

Was there any artist you particularly admired?
Yes, Lucio Fontana. I really wanted to meet him because his *Manifiesto blanco* had impressed me so much. In it I found once again what I was really interested in, just as I had with Giò Ponti. Both played a major role for me. I then became a kind of apprentice to Fontana, that is, I assisted him in his studio mixing paints. He was a fantastic man, a real gentleman; his self-confident manner, his strong belief in art – all that had an effect on me. If you ask me what I learned from Fontana, it is perhaps the love of art.

Did the artists around Fontana belong to your circle of friends?
No, mostly not. They didn't work in such a contemporary way and were already somewhat older, such as Roberto Crippa. They were doing completely different things from what we were doing, and we didn't like them much.

Who, then, were Manzoni's artist friends?
Primarily Vincenzo Agnetti and Enrico Castellani. And many other artists with whom he wanted to form an artists' group, including Ettore Sordini, Angelo Verga and Arturo Vermi. Manzoni often exhibited together with them; they

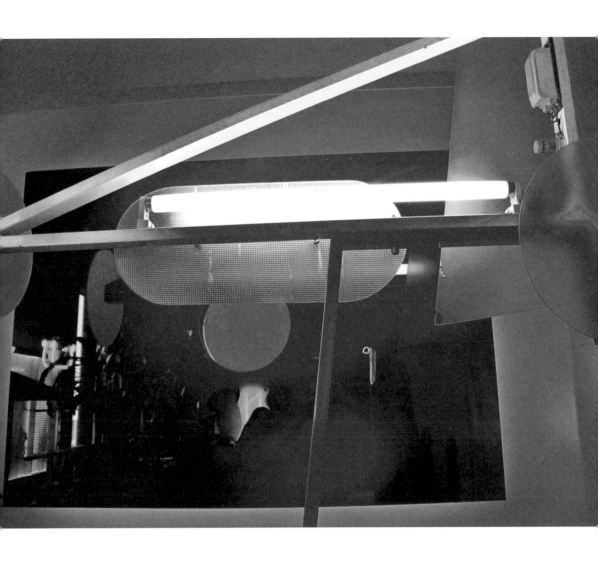

drank day and night. Uliano Lucas was a good friend; he accompanied Piero as a photographer. In the bar in Brera we often came across a young man about whom nobody really knew what kind of art he was making. But Piero thought that this young man could become a good artist. That was Luciano Fabro.

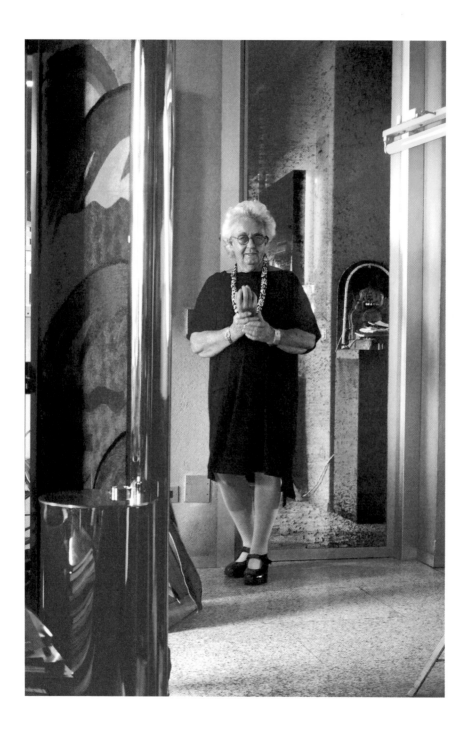

Did you go on trips with Manzoni?

Now and again we went on holiday. And we travelled to the exhibitions in Europe. In Germany, for instance, we stayed in Frankfurt with Hermann Goepfert, and in Delft with Jan Schoonhoven.

You told us of your stay in the United States. Did you also travel there together?

No, Manzoni didn't want to. He was interested in action painting, in Pollock, Jasper Johns and Rauschenberg, but not in the United States as a country. I had a strong inclination toward African and Asian culture and philosophy, but he forbade me to speak about them at all. He said I was an Italian and didn't need it. After he died I travelled a lot, including to Africa, India, Afghanistan, Tibet and Australia. And I became a Buddhist. Piero had no interest at all in things like that.

To what extent has Buddhism influenced your work?

I called my works 'Cronotopi' after the Greek words for space and time. In the manifesto I wrote in 1964, I say that with the geometric concepts of square and rectangle, which include all the other forms of geometry, you have a kind of key in your hand that opens the gates to perception of the fourth and fifth dimensions of space and time. To this extent, my investigations come very close to the main principle of Buddhist philosophy, not in the sense of an influence, but rather as a confirmation.

After Manzoni's death did you have relationships with other artists?

Yes, of course, with many artists. For a short time I was in love with Otto Piene, and he was also in love with me. His thinking was very philosophical and that attracted me. I can only speak with artists; it doesn't work with anyone else. With Jef Verheyen, with Jan Schoonhoven and Heinz Mack it worked, and I could also converse well with Soto. It was possible to have an exchange with many artists, but with Günther Uecker I found it difficult. I didn't find any point of access to him. And, incidentally, I didn't exchange any works with him, but I did with the others. The photographer, Lothar Wolleh, who worked for ZERO and was a close friend, for instance, gave me his nail work by Uecker for my work by Castellani. Wolleh took such fantastic photos of Fontana and me; I'd so much like to have them. I remember one in particular; we were both wearing eyewear by Courrèges when he photographed us.

What are you working on at present?

As I said already, I work as an architect to earn my living, mainly in Verona. I build houses and restore old buildings. At the moment I'm working on renovating a

large palazzo from the sixteenth century with frescoes, and I'm continuing to do my paintings and exhibitions. I will do this as long as I live.

What is your next exhibition project?
I'm currently organising the exhibition *ZERO Italy* for Moscow; it will take place in mid-September at the new Multimedia Art Museum that opened a few months ago. This year the links between Italian and Russian culture are in the foreground. I would have liked to make a comprehensive ZERO exhibition and, of course, to have included Mack, Piene and Uecker. I also had a lot of discussions with Tijs Visser from the ZERO foundation to include them also. But there are official guidelines that the artists exhibited must be Italian, and must also have worked in Italy, that is, Fontana, Castellani, Manzoni and Vigo. Furthermore, Italian kinetic art from the 1960s must also be represented. Hence I'm restricted in my planning. What I'm particularly interested in and what I want to show in the exhibition is the phenomenon of group-formation in Europe at that time by the artists themselves, without any critics being involved. They always wanted to get into the limelight, but the artists did this quite independently of them, completely autonomously. Of course, preparations for exhibitions are a lot of work and are associated with a lot of bureaucracy because it's a matter of a highly official, political affair financed by the Ministry of Culture. Before that, however, I must finish a large installation for *AbitaMi*, the design trade fair that will take place at the beginning of September in Milan.

Tell us a bit more about your future plans. What are your dreams?
For my life? In this respect I'm satisfied. As far as my work is concerned, I want to create a completely new work for which I'm co-operating with a scientist. I've discovered a specific quality of certain stones from Ukraine and Siberia, namely, that they have a natural light. Have a look here at the powder of this stone. Under blue light, the stone powder develops its own light effect. Without the blue light you can't see it, but as soon as the powder is beneath the lamp you can see the stones' light. My dream is now to make a work with this natural light. I imagine that you will go into a darkened room and will be surrounded by the pure light radiated by this stone, by infinitude. But I don't have the money to push on further with my project. The stones are expensive and at the moment I've only a small number to experiment with. The further research, of course, is also expensive and it's hard to find financial sponsors. Everybody only wants my paintings from the 1960s.

Intuition is our
authentic well-spring

Rotraut Klein-Moquay

Rotraut Klein-Moquay, artist, sister of Günther Uecker,
was married to Yves Klein (1928–1962).
We met in Düsseldorf in November 2010.

*Rotraut, we'd like to find out something about your time as the partner and
wife of Yves Klein. In our conversations until now it's become apparent that all
our wives and partners of artists are strong personalities. You once put it this
way: as the companion of an artist, you have to be a strong woman.*
Yes, you must have a great potential within yourself and also self-confidence, so
that you know that you won't lose yourself when you give yourself over to
someone else. If you've the opportunity of helping an artist, it's like a blessing.
When, after Yves died, I was able to look after his oeuvre, it was a gift and a
great honour. It's hard to describe what it means to work together with an artist.
As an artist, you're embraced by the divine; it's something quite special that
runs through you, and you try to express this in whatever form. And if, as a
woman, you're allowed to live in this sphere, but you don't possess any artistic
sensitivity or can't take in this immaterial dimension, you've got a problem.
However, inasmuch as you have this feeling, or you're an artist yourself, you
know how delicate the procedure of art and all the associated processes are.
You leave the other space. And you're there nevertheless when support is
required.

You were born on the Wustrow Peninsula. Was life there in this landscape formative for you?

I'd say that it's still with me. Wustrow is really almost an island because there's only a small path connecting Rerik with Wustrow. It's situated in the Baltic Sea opposite Denmark. My brother, Günther, and I visited our home once again this summer. Wendorf Manor House, in which Günther and also my sister Edita, who's four years older, were born, has become a very fine hotel. And also the house on Wustrow, where I was born at home, is still standing. My father worked for Wendorf Manor; he was a specialist for engines of all kinds and looked after the electricity supply not only of the manor, but also of the entire village. My mother's sister worked as a governess at the manor house and got my mother a position there as a young girl. This is how my parents met. My uncle was responsible for the manor's plant nursery. In this way my father learned everything you need to know as a gardener. After the war, thanks to his knowledge, he took over farming in Wustrow. Of course, this helped us in the emergency situation at the time, because the family had to make ends meet some way or other. Observing nature, which my father taught me, has probably formed me strongly. He treated animals and plants so lovingly, like a baby when you put it into the bath tub for the first time after it's born. These emotions he felt he transferred to me.

I was able to help my father with a lot of agricultural work. For me the best thing was the noise when, later on, he mowed the grain with a sharp scythe at my grandparents' in Schwansee. Your ear then becomes very sensitive and alert, and you hear all the stalks ringing together as if in a symphony. I tied up the sheaves and set them upright. At first Günther also assisted with the work, but when he went to the West, my sister helped. I also loved hammering the scythe. I held the handle while my father hammered; the blade must be precisely positioned when you hammer it out so that it becomes sharp. Somehow it had something religious about it. After all, the scythe meant our daily bread on the table. All these processes were very important for me, and I believe they prepared me in a certain way to be Yves' assistant.

You just mentioned your grandparents in Schwansee. Did you also live there?

Yes, when I was twelve years old we went to Schwansee. The Russians had annexed the land in Wustrow we'd cultivated for over three years, including our house, the well and the orchard. We had built up everything ourselves there since we'd been assured that this land wouldn't be used for military purposes. But things turned out differently, and we had to go away anywhere we wanted. So we moved to my grandparents' place in Schwansee and obtained land with the same number of hectares. At first there was no place for us to live. We stayed in our grandparents' house. I had to sleep in the living room. Later on we

got a shed in which my father erected walls so that we had four rooms. Our land had never been cultivated before and there were huge numbers of stones on the field which you had to laboriously first get rid of. I was quite sad because we continually built up enormous heaps of stones, but nevertheless there were always new stones showing up after ploughing and harrowing. It seemed like it'd never end. But my father said that the soil was quite new, that it had never produced anything, and we'd find that all the farmers who were now laughing at us would become envious. And that's the way it really happened. We had the finest grain, the largest potatoes; it was unbelievable. In our collective farm, by contrast, which gradually had been established and where the people looked disapprovingly upon our private enterprise, there were many problems. The machines were broken and you couldn't repair them, and then the grain was lying in the rain. We always did everything with our horse and by hand. These entire experiences are my private treasure. It'd be really fantastic if today children in school had a little allotment so that they could experience the miracle of planting something themselves and seeing how it grows. Then you get ambitious and also proud when you've done your work well.

Did you go to school in Wustrow?
I started school before the war at the age of six and had difficulties there. At first I'd liked going to school, but I was left-handed, and a teacher hit me on the fingers with a long stick every time she saw me doing something with my left hand. I was shocked, because I was over-sensitive, and I then cut myself off totally. After a while the teacher told my mother that it'd be better if I stayed at home, that I had to play a bit longer. She simply couldn't get along with me. As I said, in 1947 the Russians took over our house and the small settlement. We moved to another part of the peninsula and were able to buy fifty hectares of land. School was seven kilometres away. In winter I had to go on foot right through the forest in deep snow because there was no proper road. The seams of my boots were already split open at the top, and when I got home, I first put my feet into warm water so that they could thaw. At school there were a lot of Russian children and they didn't treat each other at all gently. I, at least, was always full of snow. One mother often accompanied her two daughters and took care of them. She had time; my father, by contrast, had to work a lot; after all, we built the house and the well. I had to go to school at the time; it was obligatory, but I went only every second day. The march to Rerik was simply too strenuous. When I arrived there, I was already very tired from the long hike. That lasted three long years, and when I was twelve, I went to school in Schwansee at my grandparents', straight into the fourth class, although I hadn't really gone through the first three classes properly. That was something I was always lacking. And I never had the energy to catch up. If I'd really tried, I certainly

would've managed, even though I was dyslexic. My sister was very good at school, but I had nobody to help me. Nobody helped me to learn in the way I could learn. I practised the multiplication tables a thousand times, but when I was asked, I no longer knew. Animals and nature, however, always meant a lot to me.

What dreams did you have as a young girl?
I recall a very intense day-dream. I was on the field looking into the distance. I was about sixteen or seventeen, and it was fine day; the sky was very blue and I said to myself, 'Somewhere there is the man with whom I'll spend my life.' I'll never forget this blue sky. And when I was together with Yves and we made love for the first time in the early morning, the sky was dark blue, and then, when he died on 6 June, the entire sky was the same sky-blue again as it had been back then. And I thought, that's what you saw at the time. And I also thought that Yves is still here.

What did you want to become?
As I said, I loved farming and animals, and I really liked observing nature. As a small child I often played alone and always observed everything minutely: small worms, little frogs, and I made a lot of things with my hands. But I think I would've liked to continue going to school, like Günther. I knew, however, that I'd never have the ability because I hadn't attended elementary school. I was lacking those first years. Once I had a fantastic teacher who encouraged me before writing an essay. And then I wrote this essay and got excellent marks from him – that was the first top grade I'd had in my life. In this essay I described something that had happened to me. There was a deluge and the sea came through the village, and people piled up all their sand-bags so that the water wouldn't come up the avenue. I rode around on our horse and noticed that the tall oaks had been torn out and the roots could already be seen. The flood waves came toward the village like great rolls and loosened up all the ground. I described all this, and then my teacher said that my essay had no mistakes. I always thought that he'd just said that. But recently, after fifty years, I met my friend again, the daughter of this teacher, and she said to me that I could always write so well. I could scarcely believe it.

Did you have the desire at the time to get to know an artist?
I knew one; that was Günther, and for me he was my best family. I've repeatedly sought something like that because there I felt at home, in thinking, in being, in conducting myself and acting, and also with regard to the spiritual. Günther is really my guide; he's so spiritual, so sensitive. My father was also sensitive, over-sensitive, but could also be like thunder. Günther can be like that too. They're

things with which I've grown up. This power! Just like the different kinds of weather, the storm and then those holy days on which everything is calm and the warmth perfect, and you feel: what a divine moment! In our family there were very many emotions that were seldom held back. My children are similar in this respect. My mother, by contrast, understood everything, and she held the family together with a lot of love.

How did you get to know Yves Klein?

I'm completely indebted to Günther for this. It's rather a long story. After I came to the West I turned eighteen. I loved painting passionately and made impressions of my reliefs. To earn money at first I went cleaning in various households. Once I was cleaning the staircase at a family's place, and people were constantly passing through. When you're farming, you're your own master. I've never felt myself to be any sort of servant, and I was never ashamed, even though shame

wasn't alien to me, because I didn't know, for instance, what eight times nine is, or things like that. There I was ashamed because you should know things like that. You also always had to be able to say your date of birth immediately, and I couldn't. But when people were simply going down the staircase there, I sensed that for them I was not a human being at all, but just a being there to do the cleaning. With another family there was a gentleman who threw his shoes at me for me to clean them. They were experiences that hurt me. Later I worked in a factory.

Günther at some point also didn't know how I could carry on like that. At the time I was already a young woman; he had a lot of friends and he always asked them to keep an eye on his Rotraut. They did that, but I always had the feeling that nobody liked me. At a party for Carnival I sat under the staircase, drank my first beer and looked at how the others were dancing, and I thought once again, that they all didn't like me anyway. That was quite strange. Günther had a friend called Robert Lewandowski who knew Arman from Nice, and he finally suggested sending me to Arman. He had three children and needed an au-pair for them. And there I'd live in an artistic atmosphere and, on top of that, learn French. So I did that, and there I met Yves. I'd already seen his paintings once at the Galerie Schmela. I was very impressed by them and somehow felt something over time. When I arrived at Arman's, a small red painting by Yves was hanging in the hallway. I couldn't speak any French yet; I just looked up at the painting, and would have liked to say how fantastic I found it to be. And then I got to know Yves a couple of days later. He came to the door, I was alone, and he wanted to know whether Arman was at home. No, I said, Yves should come back tomorrow. I didn't see him, just heard his voice, and my heart was thumping. And then he came back the next morning.

Please tell us something of your life together with Yves.
It was sensational. Art was our baby. And we looked after it tenderly and lovingly, and nourished it. I had a room at the top under the roof where I could paint. I also painted in the kitchen while I was cooking. Yves supported me a lot. Once in 1958, when I had just come back from Arman in Nice, we went to Ratinger Tor in Düsseldorf, where Hella Nebelung's gallery was located. Yves said, 'Why don't you go in and show her your paintings. And if she'd like to buy them, tell her that each one costs 500 marks.' His monochrome paintings at the Galerie Schmela also cost 500 marks, as I found out later! With this he wanted to make it clear to me that, in his estimation, my paintings were just as valuable as his. That was incredible! So I went into the gallery and presented my stuff, and of course she didn't buy anything. Luckily I still possess these paintings. And then he sent me to Lady Norton in London for two months, who was also a collector. He had given her a small sponge relief so that she would take me in and I could

learn a bit of English there. I was allowed to paint her chairs white in the garden. And one day she permitted me to paint one of her rooms. This room was completely yellow. This yellow gave the most beautiful light of all. I didn't want to take away light from this room, but rather reinforce it, and that could only be done with white. So I took the container of white paint that I'd used for the chairs, dipped a large cloth into it, wrung it out, and threw it against the wall. The cloth spread out, and the folds pressed the paint onto the surface. When all the walls were covered, the impressions seemed like frost-work.

I'd learned something similar from Günther earlier on. When we painted our house, he showed me how you rolled together cloths so that something basically resembling today's paint-rollers results. This is the way the farmers used to paint their walls. I then did many paintings with this technique, in black and in white. Lady Norton even organised an exhibition for me in London in 1959 with completely new reliefs and the black wood-impressions that I made at the time. By the way, I came across the reliefs by accident. Günther had shown me how you make wood-cuts. In doing so, I hurt my hand; you can still see the scar today. That was an experience that triggered a lot in me. I immediately had the feeling that I shouldn't keep working this way because it didn't suit me. Why should I cut into the surface with a knife to make a relief, when you can also apply it. During the war, Günther had used flour and water to glue postage stamps. And now I didn't have much material, and scarcely any money, and mixed together flour with water and Caparol, and then applied this mass quite spontaneously to my wood. I've preserved this spontaneity throughout my life. Already when I was small, I scribbled very fast when drawing, like children do. And in these scribbles I always saw completely different things, such as a deer. When I showed it to others, nobody could recognise it. The forms in my sculptures today also come about in a split-second action from this reflex energy, from this natural, instinctive potential that every living being has. You sense with my paintings that they possess an inner energy, that in some way they've a soul like an animal, a human being or a plant.

Were you able to help Yves with his work?

Yes, definitely. He gave instructions on how I could assist him. I was always at home with him when working. When he went out, I cleaned up the studio and cooked because he frequently came back with a couple of friends for lunch or dinner and showed his new paintings. Or we went to the Coupole together, where artist friends often dropped by to present their newest works and to get his considered opinion. In the morning he liked sitting at Select opposite the Coupole, drinking his coffee and reading the newspaper. There he wrote his judo book earlier on. Now and then he also went to galleries to inform himself and make contacts. But otherwise we were mostly together. I was very skilful. I

knew how you rubbed wood to round off the corners; I could work with files and other tools. I had a sense for that, as I did earlier when helping my father hammering out the scythe or with many other things in farming, or observing my brother, Günther. Now I was simply helping Yves with preparations and with everything he needed.

Were you often together with other artists?
Yes, constantly. Even in the café there were many acquaintances, including people who weren't artists. A waitress inquired often what Yves was working on, and whether he was still always using this blue. And then he showed her his notebook with the reviews and his remarks, and explained it all to her precisely. They were great relationships with quite normal people.

Do you still have personal documents from this period; did you have a kind of diary?
No, I've never had a diary, but Yves' press books are there, as I just mentioned, with press reports, his own notes and photos glued in. Every so often Yves gave me his camera, a very good one. He arranged the settings for me, and showed me how I was supposed to photograph him at work. The photos of the impressions on the banks of the river are mine. I also took shots, for instance, of Arman, Claude Pascal and Martial Raysse in Paris when Yves covered them completely with plaster. Only a straw for breathing poked out. Harry Shunk always collected the negatives or photographed the photos and put them together in his archive. We recently rediscovered his archive at the Roy Lichtenstein Foundation which now owns all these things, including photos of Yves as a baby. Everything there is well-sorted, mostly even in duplicate. Many negatives haven't yet been developed. We can order prints and they then send them to us. Fantastic!

You were in America very early on. Which encounters and conversations with artists there have especially stuck in your memory?
When we were in New York in 1961, we met a lot of artists who impressed me greatly. I even remember dancing with Franz Kline. When Yves went to Arman in Nice at the time and saw my room with all my paintings on the wall – back then I sometimes worked quite abstractly with black ink –, he said that it looked like a Franz Kline. At the time I didn't yet know who that was. I also met de Kooning, and Larry Rivers took us around a lot. One evening – he was wearing a checked dressing gown over his pyjamas – he proposed going to the Four Seasons. When we arrived there, all the doors opened and the waiters were standing ready to serve. We sat in front of his enormous painting. On the left there was a small pool, and Larry threw in the strawberries from the dessert – in one of the most expensive restaurants of all, where a steak cost twenty dollars! But the

waiters said to the guests that he was the artist who had painted the picture; artists were allowed to do things like that, and now they had the honour of seeing the artist in person.

We were in a lot of studios, at Jasper Johns's and Rauschenberg's, and we went to dinner three or four times at Barnett and Annalee Newman's. I was fascinated by the conversations between Yves and Barnett Newman. There was always a harmonious atmosphere; both of them were very warm-hearted. Later on I also visited Annalee in her New York apartment. We also ate a couple of times at Teeny and Marcel Duchamp's. Then we met the graphic artist, Saul Steinberg. We saw Indiana briefly at an exhibition. And Rothko! We wanted to welcome Rothko at an exhibition opening in a gallery, but he immediately turned around and left; I don't know why. I also don't know whether he'd recognised Yves at all. Yves had just had his show with the large blue monochromes at Leo Castelli's, and perhaps in Rothko's mind there were already the black spaces which he did later, and maybe it seemed to him that Yves had somehow antici-pated something. In any case, Yves went toward him cheerily, but Rothko simply left. He was probably a complicated man, I've heard, and also inclined to depression. Jasper Johns and Rauschenberg, by contrast, were very sweet. Jasper was so easy-going and so amiable.

Which incidents during your trip to America do you still remember?
We travelled to New York by ship in third class. Every now and again we got dressed up, sneaked into first class, and danced there. Sometimes we climbed down into the 'basement' to our boxes and checked whether everything was still standing properly, because his blue paintings were in there. Then we arrived in Manhattan and saw the skyscrapers for the first time – that was overwhelm-ing. The sculptor, Richard Stankiewicz, showed us around Manhattan and also took us to places where he found iron scrap for his sculptures. He worked with scrap-pieces in a way similar to Jean Tinguely. He signed and gave us an objet trouvé. Later he exchanged another sculpture for a *Monogold* by Yves. He was an impressive artist whom I still collect. Then we visited Lee Bontecou in her loft. She made works whose large, dark depths had a magnetising effect on me. She was a fascinating woman, quiet, very reserved, very intelligent – a great artist in my estimation. After not hearing anything more of her for a long time, now she's coming on strongly, and you can see her works at auctions and exhibitions. She likewise exchanged works with Yves.

At the time that was quite usual, wasn't it?
No, I don't think so. I think at the time this was really one of Yves' ideas. Later on, this idea was then adopted by others, including Günther. Yves also exchanged works with Bernard Aubertin. Aubertin held Yves in high regard. He also wanted

to paint monochrome above all and requested downright permission from Yves. Yves was so happy about this respect that later on he gave him a blue monochrome and received in exchange Aubertin's red painting with the relief in oil, which I still possess. This exchanging was important for Yves. He did the same thing with all the artists whom he estimated highly. You give a gift and you receive one, just like with the Indians. We didn't have any money to buy a gift, but we had our own paintings and thus a lot more, because the personal element was expressed in it.

Now something happened that still makes me very sad. We published a book, *Yves Klein: USA*, in which all the exchange objects from and with Yves in America are described and illustrated. I don't know how it happened, but by mistake the work by Lee Bontecou wasn't included in the book. We still have the small wall-sculpture of hers. When I saw the completed book, I was aghast because I esteem her so greatly. Only recently I saw a photo of her in which she has Yves' monochrome right next to her. That was painful.

Rauschenberg, too, exchanged with Yves. He gave a very interesting object, a kind of walking stick on which he'd stuck a dry bread roll. For this he received a monochrome from Yves. Frank Stella also received a monochrome and always wanted to give Yves one of his paintings. After Yves' death I went to Stella and

also spoke with Ileana Sonnabend in Paris who assured me she wanted to fix this matter. I believe that 30 or 35 years went by, but still no painting came. In the end, Stella sent back Yves' monochrome. Since we'd had to live for so long without this painting, we gave it to a charity auction with paintings by prominent artists which my present husband, Daniel Moquay, organised for the Fondation Claude Pompidou. We called it the 'Frank Stella painting' so that Stella knew that he was participating in a philanthropic event. Daniel was quite

proud because, working day and night, he'd gathered an enormous sum through this fund-raising event.

To what extent did Yves leave you the option of painting yourself?
You always find time if you want to express yourself, just as you always find a place to work if you want to. Yves proved that because at the time it was, strictly speaking, illegal to work at home. And what works he created there! When Daniel and I moved to Phoenix, our daughter, Lorraine, was still very little. It was already a long time since I had done any painting myself, since with the three boys and matters to do with Yves' estate, there was too much to do. Daniel had a restaurant, so he couldn't take care of the children. So a nanny helped us with the boys. But when our daughter, Lorraine, was born, I didn't want a nanny; I wanted to be with her myself and see how she grew up. She was, after all, my last child. Then I got breast cancer. Somehow a kind of dam had built up in me. A dam has to give way when there's too much water pressing on it – I simply had so many things pressing on me that I had to let it out of myself. So I started painting again, at first, *Galaxies*. I bought myself a large canvas, rolled it out before the garage outside at home, and made stars with the paint-dripping technique. Even earlier on, for the exhibition at the New Vision Centre in London, I'd made material drip-paintings. So I always found possibilities to work. When I couldn't sleep at night, I simply worked.

I really meant here more your time with Yves Klein. Were you also able to work then?
Yes, as I mentioned, I had a room at the top under the roof, and sometimes I also painted in the kitchen. And Yves had given me the opportunity of an exhibition in London through Lady Norton. Later on, he urgently needed time for himself alone. He was intensively preoccupied with the immaterial and wanted a free space for himself. At the time I was in Düsseldorf again, didn't have a studio and at first stayed in a flat where I was allowed to paint. But there the heating was on, and I didn't have any proper wood as a base, but only pressboard on which my mass didn't stick because, as a result of the heat, everything fell off. I already had an entire exhibition ready, and then everything was in ruins! Then Günther found a place outside Düsseldorf for me: a floor, three walls and a tap, in the middle of winter. First of all I had to sweep out the snow. But once again a coincidence helped – perhaps Yves had organised it behind my back. None of us had any money, not even he himself; it was 1959.
In any case, I got planks of wood, applied my mass, covered everything with black ink, and rubbed the stars or the relief out with sandpaper. Very constructive forms came about. Basically, if I see these works once again today, I can already recognise great similarities with the forms of my sculptures now. I also

kept on working with plaster and painted the forms, and already I sensed in doing so how they gave me energy back, and not only to me, – a kind of regeneration which I'd created myself. Like others went on vacation for recreation, I only needed to paint such a painting, and then my powers were there once again. I saw the life of this form; I sensed that it was held fast within and wanted to come out into the world, just as you release your child into independence. Even today I'm overjoyed when I can finally erect a sculpture. I don't know whether others perceive the same thing in it as I do, but they can at least see it. That was my childhood dream, that someone saw in what I had scribbled what I saw in it. That's wonderful when others sense precisely what you do, when you

can share it with somebody. You don't want to carry your feelings around alone. For me that was a kind of miracle even during my childhood: to recognise an animal in what I'd painted not even consciously; it simply appeared. I also don't make my sculptures consciously. Rather, I give my subconscious, my reflexes absolute freedom without intellectual manipulation. Intuition is our authentic well-spring in which that of which we aren't aware is also stored. And these sculptures show me so much, including who I am. In my opinion, we human beings are all connected with one another, and I have perhaps found a language that brings us together because basically we have the same powers and sensibilities. I find that we're like communicating birds; there is a lead animal, but really it's a matter of a shared feeling and system that connects them when they're flying in the sky. *L'accord parfait*, the perfect accord, also within yourself – I've always sought that. And now that can come to expression precisely in my sculpture, which comes about in a fraction of a second. It's very interesting how the immaterial plays a part in everything.

You should perhaps tell us something about Yves' wall reliefs in
Gelsenkirchen. Was this his first public work?
Yes, apart from his exhibitions. This commission for the wall-reliefs at the music theatre in Gelsenkirchen was very important for him. Norbert Kricke had mediated that. Kricke, like Yves, exhibited his works at Iris Clert's gallery or at Schmela's in Düsseldorf. He knew Yves well, and arranged a meeting with the architect, Werner Ruhnau. Kricke brought a lot of people together and, like Yves, always supported his friends. At the time, Yves saved my life. He wanted to show someone a jiu-jitsu figure and made the appropriate movement. This movement frightened me so much that, standing behind Yves, I stepped back one step in a reflex-movement. There was no railing, and the staircase was 20 or 25 metres high. Yves saw from the terror in the eyes of person opposite him that I was about to fall and, instinctively and charged with masses of adrenaline, was just able to grab my hand at floor level and pull me up in the last second. When Ruhnau heard of the incident, he was of course agitated. I wasn't insured; I was nineteen years old; Yves and I slept together; the journalists – the scandal! Ruhnau then forbade me to stay. And that also saved my life, because I always stood next to Yves when he fixed the sponges on the wall. Heat and steam were generated in doing so. Imagine when this twenty-metre-long wall is steaming, and you're standing very close to it! If we'd worked together there the whole time, I too would have died very soon. I find it really amazing how life takes its course! Ruhnau is really not a friend of mine, but I've never forgotten this episode with him.

What dreams and wishes do you have for the future?
You know that Yves' oeuvre means a lot to me. My first wish has always been that his works are represented in renowned museums and collections; that they hang in a good place. I think a lot about that, since we don't live forever. We make books, document the exhibitions, all the things that seem important to us. Yves lived for only 34 years; he has only a small oeuvre, and I find it amazing that we got as far as we are now. We're indebted to my husband, Daniel Moquay, for this, also for the many high-quality exhibitions. He has the great talent and ability to sense Yves' comprehensive vision and to make the public aware of it. But you know how things are with art. Rembrandt was forgotten for a hundred years. Such things happen quickly. Today we've a very active younger generation, and it's already remarkable how many artists take a new path through Yves.

If you're happy,
everything else falls into place

susanne de vries

susanne de vries has been married to
herman de vries for decades.
We met in June 2010 in Eschenau in Lower Franconia.

*susanne, we're sitting here in the sunshine in your wonderful garden that is
so luxuriant that it seems like a jungle. How and when did you come here?*
That has to do with herman, of course. We met in 1971 at a party that my
parents gave for Bernard Aubertin. At the time, herman had an exhibition at the
Galerie Ursula Lichter in Frankfurt and was also invited. He talked to me so
enthusiastically about Eschenau – he'd moved there the year before from
Holland and everything was completely new for him – and said I must definitely
see it some time. So before long I went there with him, arrived, looked around
and found it simply magnificent, and also unusual. I'd grown up in Frankfurt
near the Central Railway Station and had completely different experiences from
people living here. Eschenau was a real revelation for me. And with herman it
was great because he knew all the plants; he'd discovered the forest, whereas in
Holland there's not much forest. He used to have fun simply walking off some-
where randomly where you almost get lost, in order to find out how he could
best come back home. This way he learned to find his way around. That's the
way things started for us, in a world that was new for us both.
At the time herman had plans to travel. He told me with great enthusiasm of a
stay on the Seychelles and of his desire to travel to India once again during that
year. His proposal was that we do this together and see how we get along. For
me that was a couple of sizes too large, but I thought to myself, well, if that's

what he wants, let's see what comes of it. And on this journey he adapted himself to me, and I adapted myself to him, and it was wonderful. Not a vacation as you speak of a 'wonderful vacation', but really strenuous. But with a lot of experiences. We learned to understand each other and then we stayed together in Eschenau.

You spoke of Frankfurt. Were you born there?
No, I was born in Bad Homburg near Frankfurt in 1944. My mother had been evacuated there. But I don't have any recollections at all of the place because, as I said, I grew up in Frankfurt.

Do you have any brothers and sisters?
Yes, I have two half-sisters from my father, Hermann Goepfert. I call him my father, but he's really my step-father. One sister is four years younger than I am, and the other seventeen.

Hermann Goepfert was not only an architect, but also an artist.
Yes, he was also an artist, a ZERO artist. herman and he often met in Frankfurt.

What occupation did your biological father have?
He was in commerce. We saw each other sometimes because he also lived in Frankfurt with his new family. But I didn't have much to do with him apart from the fact that he was accidentally my father. Until my eleventh or twelfth year my mother also worked – as a technical draughtsperson – and with her money she enabled my step-father to study. And my little sister and I also had to be cared for. I grew up with one of my grandmas, the mother of my mother, and my sister, Charlotte, grew up with the other grandma in Bad Nauheim.

What role did art and music, and culture in general, play at home?
That's hard to say. This amusing sentence occurs to me: "Mum, what's this water people are always talking about?', asked the little fish.' In other words, I grew into it and never knew anything else. And even later on, I sought out herman as a partner out of interest. His life was normal for me.

Where did you go to school?
I attended secondary school in Frankfurt, but the intermediate certificate there didn't satisfy me. I wanted more; I wanted to do my matriculation certificate and then study architecture. At the time that was my great passion and I am still enthusiastic about it today. And so I considered training in technical drawing and going to the State Building School. Everything had been planned, and I began my training in technical drawing in Frankfurt. But the problem was that I was continually sick and was treated medically for two years without any proper diagnosis being made. This way I lost a lot of time. I always thought that they must be able to find the cause; that something or other was wrong with me. I was eighteen years old at the time. Before that I'd already had glandular fever, and therefore the doctors thought that I was simply sensitive; such things happened at that age. At first they didn't discover that I had a brain tumour. Then I was operated on and afterwards I was paralysed on one side, and had problems with balance and orientation. Of course, my plans therefore came to nothing. But I finished my interrupted training and also passed the apprentices' examination. I then worked with my father at the architecture firm that he had together with Johannes Peter Hölzinger in Bad Nauheim, partly also to provide

me with contact with people. After eighteen months, this was no longer sufficient for me; I wanted to do something else. I wanted to look for an office in Frankfurt where severely disabled people could also work. That way I'd at least be in the city and could live my life there a bit more intensely. But then, as fortune dictated, I met herman.

Did you want an artist as a partner?
No; that was a pure coincidence at that time, in 1971. We've certainly put up with each other for a long time, haven't we?

In which way can you help herman? Do you discuss his work?
Yes, we're continually talking about it. With everything that happens in this respect, we're both involved. It's not that herman always listens to me, but we consider together what could be different, how his ideas could be communicated better, or what materials should be used. As far as the office work is concerned, for several years now we've had an assistant, Marion, who comes each day from Haßfurt and, for instance, takes care of the paperwork. She finds it easy, whereas herman and I both find it difficult, so she looks after that. She's part of the team, and we almost always travel together.

You told me once that herman wanted both of you to sign his works?
Yes. In the first phase of living together, herman was still making his white random reliefs. Since I was mostly also present, he asked me whether we should both sign our names underneath. But I refused. After all, it was his work. I was involved in it, and went through it together with him, but I didn't find it necessary to add my own name.

Do other artists visit you?
Yes, now and again younger artists come to us, and sometimes also colleagues and friends who want to discuss something with him. There are exchanges every so often. Summer is the time when we have the most visitors.

Do you make records or photos?

Yes, I take photos, perhaps in a way similar to how you write a diary, but not consistently. I really have a completely free life. In the beginning, I found that difficult, and every morning I asked herman what his plans were for the day. That disturbed him a lot, and so I resolved to drop the habit. herman had been a civil servant in Holland, and as soon as he'd given up his profession, he also threw away his alarm clock and his neck-ties. From then on he wanted to live a life without compulsions. I wasn't allowed to call him back. I adapted myself and in the meantime I've become just like him. That's the way it is when you've been far away from order for a long time.

Do you have interesting conversations with your visitors?

Yes, of course. I find it interesting to hear what our guests have to say. In that respect I tend to be isolated. I find it good to learn things from them, so that I

know they exist, but it all seems far away from me. Here I have my peace and quiet, can go into the forest with herman and see how everything changes each day. If I were living in Frankfurt or Düsseldorf, or herman still lived in Holland, we would often be distracted from living and working.

But your life is also exciting, only in a different way.
Yes, that's the way I see it, too. When I was first in Eschenau, I often spent the whole day outdoors, in the forest or in my garden, and I discovered how it is, for instance, when the flowers turn toward the sun. When I was living in Frankfurt, of course, I didn't have such experiences. I still like sitting in one place, looking about.

What trips have you undertaken with your husband? You said that you travelled to India at the beginning of your relationship?
Yes, with a stopover in Cairo, my first far-away destination. Even there it was rather adventurous. At the airport, officials were standing at the luggage belts and casually rummaged around in the suitcases and even took television sets

apart – it was a completely different world. And when we left the airport build-
ing, the taxi drivers almost beat each other to death to get customers. That's a
good start, I thought. When we arrived at the hotel, it was complete chaos. The
innumerable guests were divided up in some way; some had to share a room as
a threesome. Many of them, like us, had flown on cheap student tickets, so you
had to accept such things. And on top of that, herman was worried that we'd
have to be housed separately because at the time we weren't yet married. Then
we flew on to Mumbai, also an exciting city. We wanted to change money in an
area that herman didn't know, and I noticed how in the taxi, as a precaution,
he'd positioned a knife underneath his shirt, but everything went well. Of
course I also saw the poverty. On the way into the city we drove by enormous
concrete pipes that people were using as temporary housing. And when we
arrived at the hotel that night, I saw men and women sleeping in the courtyard
and on the street; there were beds everywhere. There, everything is simply
different. We've also undertaken relatively long journeys to Laos (at a time when
there was a cease-fire in the war), and to Senegal, Nepal, Thailand and
Morocco. In Morocco in particular we've had some wonderful experiences; we
know it well.

*Have there been encounters with people who've been particularly
important to you?*
I find it difficult to pick one out. Many individuals have stimulated me, but one
person in particular has perhaps especially fascinated me: the poet, Robert Lax,
whom we often visited in Greece. He spent long years as a hermit on various
Greek islands prior to returning to the United States shortly before he died.
When I met him, he was living on Patmos and was already an old man of eighty.
Robert Lax was someone who impressed me with his kindness and calm. He
really didn't possess anything, had a simple house and lived from food given to
him. He offered his guests water, but also profound conversations. He had a lot
of cats, all stray, for which he fetched fish-remainders daily from the port. I
found it great to live so simply and also to write such simple, completely
reduced, minimalist poems. I like one especially: 'turn ing the jun gle in to a gar
den with out des troy ing a sin gle flow er'. That's the poetry that also surrounds
us and which I can understand well.

It's as if it were written especially for you two!
Yes.

Does literature mean something to you?
Yes, for me it's a part of life just like art and music. Through herman's multi-
faceted interests I also learn a lot. Almost daily he has a new book in his hands,

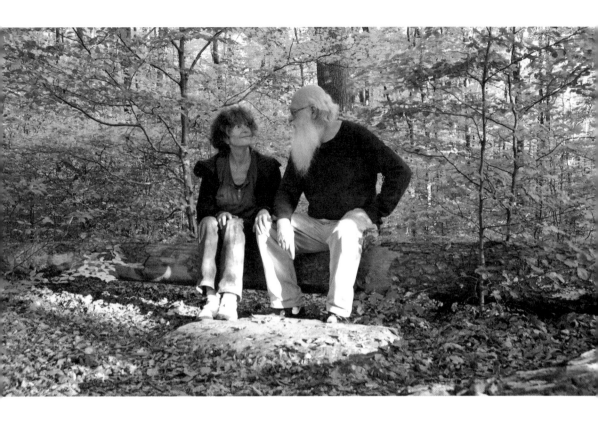

and on top of that there are the catalogues and newspapers. Sometimes I become engrossed more deeply in books, for instance, on behavioural research into animals and human beings, brain research, ethnology, the writings of Henry Thoreau, haikus or, as I mentioned, in the poetry of Robert Lax or, for some time now, Wisława Szymborska's poetry. When I was living with my parents in Frankfurt, even at a young age I was enthusiastic about Gottfried Benn with his precise, expressive language and his poetry. Even today he's part of my stock of thought, and I sometimes cite him.

What's your wish for the future?
That for as long as possible I can be together with herman, because it's wonderful and it makes me happy. If you're happy, everything else falls into place. And I wish, if it should become necessary, that I could stay here and keep living here alone. There are also many friends living around us.

I've always drawn the strength
to cope with everything else from painting

Uta Peyrer-Prantl

Uta Peyrer-Prantl, artist, was married to Karl Prantl (1923–2010)
for 52 years. We met in May 2010 in Pöttsching in Burgenland.
Karl Prantl died on 8 October 2010.

*Uta, you're not only the wife of an artist, but you are also an artist yourself.
How much time remains for you for your own art?*
Each day I go to the studio, except when there are visitors, which is always a
good thing, because breaks are also important.

Did you engage with art or music already early on?
Mainly with music. But at home there were paintings, of course, old, traditional
painting, and no modern art on the walls. At an early Schiele exhibition my
mother wanted to buy a work, but the five children always had to be fed, and
you had to think differently then. I know that in 1946 or 1947 at Christmas there
was a Schiele portfolio lying under the Christmas tree. In Salzburg we saw
Kokoschka exhibitions, and later on in Vienna one on Zen, also on Klee. And,
when I was fifteen or sixteen years old, there was an exhibition of American
abstract painting which greatly aroused my enthusiasm. That's roughly what I
got from the fine arts as a child. Everything else I acquired together with Karl.

Do you see changes in your artistic work?
Yes, my paintings have definitely changed. On my fiftieth birthday, our daugh-
ter, Katharina, compiled a catalogue for which Gottfried Boehm wrote an article
which I've recently read once again. And I noticed that this article, that's over

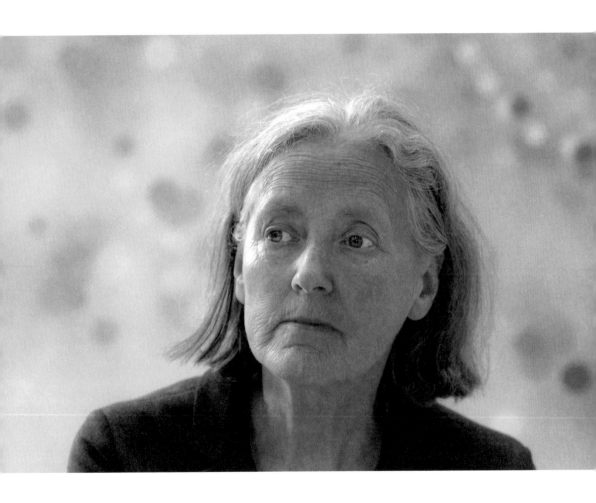

twenty years old, contains what I'm still looking for. In my view it's completely up-to-date. As far as engrossing oneself goes, nothing has really changed. I believe that things always alternate, that sometimes a certain work goes over the edge, and then I have the feeling that I no longer know at all who I am, and ask myself how I can bring myself to order, or how I can change myself. After all, we all torment ourselves with these problems. And then the quiet phases come once again. It's always really first one thing and then another. And there are also lots of changes. Let's take these paintings here, for which I developed the concept over ten years from the mid-1970s: seven identical formats, so that when they're hanging next to each other, they form a large horizontal because in middle of each there's a concentration. It begins with a white and ends with a very colourful painting; one more colour was added each time. At the time I listened to *Drumming* by Steve Reich; this piece has a lot to do with painting: yet another rhythm, yet another colour, yet another tone. And so I dedicated these paintings to him. They are like scores, like movements.

Did you acquire these techniques yourself?
I didn't attend an art academy, if that's what you mean. The technical aspect is experience. You have an objective to attain; you work toward it and finally you gain experience, each time anew. You know that I've polished very many stones for Karl by hand – a tedious activity until the stone is finally finished. Of course, I can't change the form itself, but during this work, a desire for depth arises, and also a physical affection for the stone, as you handle it and caress it. You get to know it through and through. And then it happens that the stone totally surrenders its colour. Otherwise you still see the traces of the tool that Karl wanted to smooth out and which I often helped him to do. And when I'd adjusted myself to doing it, I did it very gladly. As far as my own painting goes, there I have a great need, of course, to clarify for myself as to what a chromatic space is, and I spend a lot of time making it. If, for instance, I have a white canvas and I paint it red, then at first it's not my red that comes about because all the colours have to go into the red I want. Perhaps it will become red at some time. That's the objective I want to attain.

But basically that is characteristic of every form of art, that at some point in time you say, now it's there, what I've been looking at the whole time in my mind.
Yes, you strive for something that's never been seen. On the one hand, I notice repeatedly that it's not possible to make something I've never seen; I must have already seen it once, perhaps as a child. Then it can be discovered. But the desire for something completely new is always there.

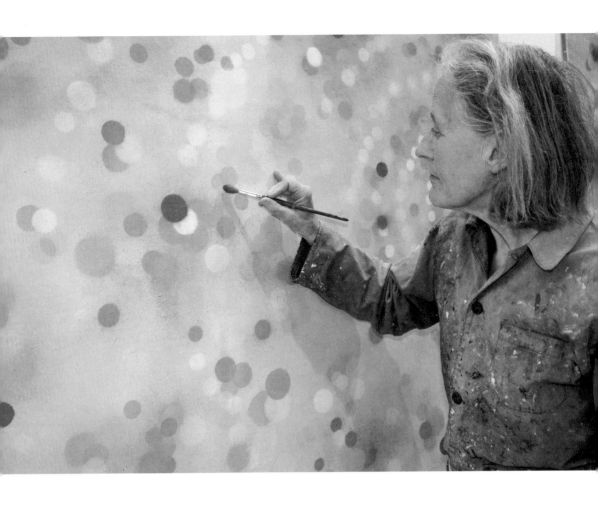

As Klee said: genuine art consists in making the invisible visible.
There are paintings with which I know exactly that that hasn't happened there. Then I put them away and try to forget them – but I don't forget them. They preoccupy me. And when a similar problem crops up once again, I fetch the appropriate painting, and sometimes it then works. Often they're only fine nuances, a change in climate, a fragrance or another atmosphere that play a role.

Uta, you seem to be so at one with this region here. Were you born in Pöttsching like Karl was?

No; I was born in Oberpullendorf in Burgenland. My mother's family comes from Wachau and on my father's side from Salzburg. They came here after Hungarian Burgenland was assigned to Austria in 1921. The young Hungarian academics had gone away, and there was a search for academics from inside Austria. My father was working as a trainee notary at a notary's office. He had advertised in the newspaper for 'a candidate with chamber music qualities', and that was the case with my father because he played the cello.

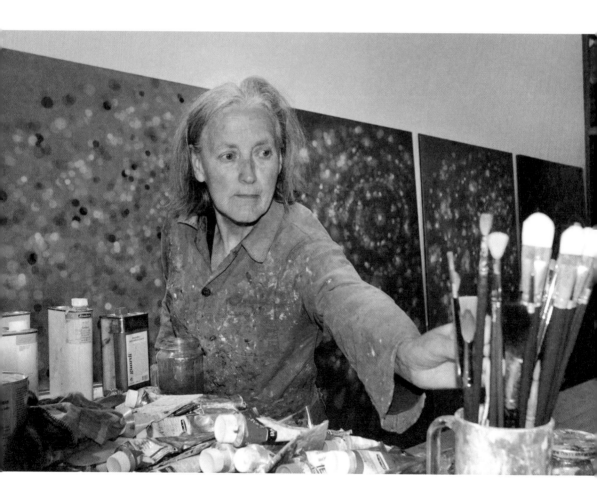

So you grew up in a music-loving family?
Yes; my mother was a good pianist, and we five children – I had three brothers and a sister – all played an instrument and practised regularly: string quartets and quintets with piano. In the country we had a lot of time. And there was always the desire that one of us would make music into his profession, but they all became lawyers or doctors. The music was cultivated only in an amateur way over many generations.

Your father was a notary. Did your mother also work?
No; with so many children that wasn't possible.

Where did you go to school?
We had fled out of Burgenland from the Russians and lived with our grandmother in Salzburg in the American zone. In 1945 I started attending the primary school in Seekirchen on lake Wallersee, together with the many refugee children from White Russia, Romania and other countries. Since, tragically, my father had believed in Hitler, he couldn't work for five years after the war. Finally he got his own notary's office in Burgenland. And so we returned and I went to grammar school in Oberschützen. So I grew up in the country.

What kind of education did you have?
Well, after the fourth class at grammar school, I went to boarding school in Vienna, a strange school, a kind of fashion school. It was always said that I was gifted, and the idea was that it had to be fashion. So I attended this higher teaching institution for three years and was very unhappy. I'd met Karl already at the age of fourteen and knew exactly that this was the path I wanted to follow. And yet I finished this horrid school and left at the age of seventeen. After that I would have had to do the practical training for the vocation of dressmaker, but I didn't want to, and my parents gave me the freedom to do what I wanted. I attended the academy on Schiller Square in Vienna for three days, but somehow I couldn't concentrate there because I was continually distracted by my fellow students. I then stayed at home in the student flat with my brother. There I had a small room with a single window and I began painting, from morning to night.

Did you have a dream of what you wanted to become?
Of course, I then had to catch up with drawing and so I attended courses. But the whole time I wanted to test myself. At the age of eighteen I married Karl, who was 34 at the time, and therefore a mature man, and I was still very young. I completely adopted his worldview at the time, and only recently have I become aware of what and how much I perhaps also brought in myself.

Had it been your wish to marry an artist?

My eldest brother attended boarding school in Eisenstadt with Karl from the ages of ten to fourteen. After the war they accidentally met again on the tram in Vienna. My brother, who studied law, was so fascinated that Karl was attending art academy, and didn't lose touch with him again, and then he brought him home to visit us at Wallersee. It was in the garden that I then met this man who was so different. My brother bought me drawing pads at the time. And Karl always said that I was so gifted. Of course, that flattered me a lot.

But it wasn't love at first sight.

No, for that I was still too young. But I always watched him lying in the grass staring at the sky and asked myself what that meant.

Did you then want to go back to the art academy, or did you abandon an artistic career at first in favour of your husband?

No, I didn't. Of course the situation was peculiar for me. We then had two children straight away. And when you're very young, naturally the children and the family are what is most important to you. But I painted every day. I've always drawn the strength to cope with everything else from painting. In contrast to many colleagues, who had to give up painting because of the family, I never gave it up. I didn't have to earn money because our parents supported us for a very long time. They simply couldn't do anything else because we had two small children. I very often had to do a lot of persuading, also with my parents. However, they soon saw that we were serious with our work, especially Karl. My mother in particular believed very strongly in him. My father was a different personality, but because of my mother he simply went along. And I also always had to explain to my mother-in-law how we saw our lives with art. She was of the opinion that Karl should get a job somewhere, as an art teacher, for instance, and then each time I sat with her for two hours and talked to her until she understood again: no, a job was out of the question.

How long were you supported by your parents?

With Karl it took until he was about 45 before he could sell a small stone here and there. Nothing ever really came of commissions. Every now and again he was supposed to make a stone for somebody, so he bought five stones, worked on them, and then it didn't work out anyway. But of course it's much better working for yourself. Something completely different comes of it. Strangely, we've tended to live from the art trade. If I think of his colleagues – many took on a professorship because they had a family. A few times Karl was supposed to take on a position at the academy, but in the end he said no because he didn't believe in it. He never wanted to have students, but only colleagues. I was also

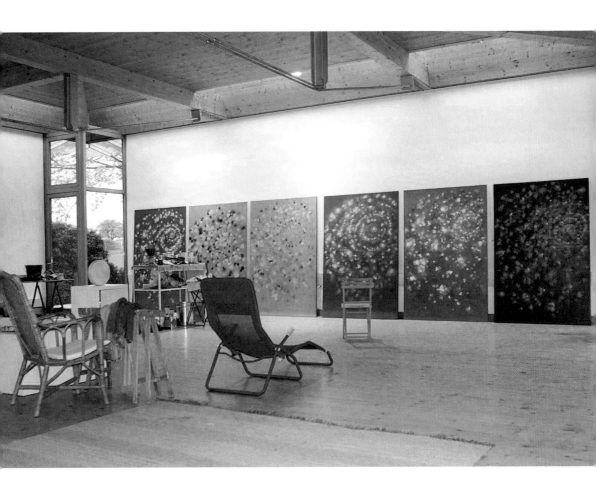

in favour of his turning down the professorship because he would have become so involved. Yes, it was the art trade, although we didn't contribute much to it. Our children scolded us and said, 'Do something! You're living in the country, you must now...', but we thought, we simply had the good fortune that we always got by and always had time for ourselves, and things went on without our being subjected to external pressures. The pressure you make for yourself is enough.

Did you become involved in your husband's creative work very much?
Yes, you could say that. When I look back, that's the way it really was. Karl's biography is completely different from mine. Because of his sculpture symposia, he simply had the feeling that he was an egoist when he worked on his own for himself. You had to fight for art, and that together with your colleagues. He always had his colleagues in mind, and I was the one who had to make him concentrate on *his* work. In winter that was also fairly easy. He had his sculptor friends, and I took care of his work. He valued my work highly, and it was important to him that I got around to doing it – many partners can't bear that. In a marriage that's often very difficult. But of course it was a matter of who, at the time, was able to concentrate. Karl was always a periodic worker with breaks, whereas I was a regular worker. And that was fundamental to our family life, this question as to how I could help him so that he could concentrate on his work again, because then he's bearable once again, feels better and the depressions evaporate.

So there was a lively exchange with artist colleagues through the symposia?
Yes, from the very beginning. These sculpture symposia were also attended by Japanese artists. It cost them their last penny, and they came with just their tools and without their being able to speak our language. Many of them came from eastern countries. We always had to sign everything for them and get hold of necessaries, even postage stamps, when they wanted to send a letter home.

Did you look after that?
Karl looked after scraping the money together. I only had to see to it that he didn't always take away everything from us personally, because I was responsible for making sure that our household had enough money. But Karl organised the money for the symposia together with friends. He was very good at motivating friends. Today it would no longer be possible for twelve to fourteen sculptor colleagues who didn't know each other previously, to work full of enthusiasm on the huge blocks and simply place them in the landscape for free. There was a lot of passion behind it. We can get in the car afterwards, because some of these stones are now standing nearby.

Have all the sculptors been at your place?
Yes. We always had an open house for art and for artists. Makoto Fujiwara, for instance, lived with us for a whole year in a municipality building studio of ninety square metres. I had a large room in it where I painted; we lived and slept in it, and brought up two children. Next to our studio there was a small room where Makoto lived. He had a small car, a Renault R4, and was so cultivated that he stored his entire luggage in this car because we didn't have any free shelves. He

only deposited his toothbrushes with us. He was an ideal guest. When he sensed that Karl and I needed to quarrel, he quickly vanished quietly and came back again later. That's the only way to put up with a long-term guest in a small living space. Frequently, of course, the artists from Prague, Budapest or Bucharest were also there, with whom we discussed until late into the night. We refused to accept political borders. And every now and again complete strangers would appear on our doorstep saying they were friends of a friend, and all of them ate with us and stayed overnight. Because our dear Czechs

came so often, suddenly the cry, 'Are the Czechs here again?' would issue from the children's room. The children then had to vacate their room, share their toys, and sometimes they even gave away things very dear to them for the artists' children at home which, of course, wasn't always easy for them. But the many languages of art, the mood of a new dawn in the 1960s, to have experienced the symposia – for them, too, it was a lasting experience, as I know today.

How did you communicate?
More or less with a mish-mash of German and English. With the colleagues from the East there were countless touching conversations about the difficult problems there. A story about Miloslav Chlupáč occurs to me: one day a long train came from Czechoslovakia full of artists who were travelling from Prague to the Venice Biennale. They had to change train stations in Vienna. And then Milos headed off and suddenly appeared in the Galerie im Griechenbeisl. He simply said, 'Here's my address, I really want to go to St. Margarethen some time'. And then he was already off again so that the group didn't get the idea that someone was slipping off; after all, his family was waiting for him at home. We then

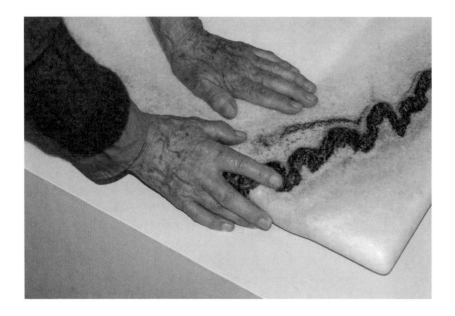

visited him in Prague to find out what he was doing. There, in his wife's villa, he had two very small rooms because the house had been confiscated and the front rooms were all occupied by Party people. In 1963, Chlupáč then came to us in St. Margarethen for the symposium.

Do you have records or photos from this period?
Not so many. In 1969 we travelled to Japan for three months for a very important symposium. It was there that Karl bought a camera and photographed a lot

from then on. Not so much people, but stones, of course, and lots of cranes on which stones were hanging. But from the time before that, there are only a few photos. We still didn't have our own camera. That's the way it was at the time. I remember our first record player, how fantastic that was with the music. Many things only came later.

How did the children change your life?
Totally. To bring up the children was an enormous task. My husband, of course, came first. To make sure that you didn't lose him; that you kept everything together. That was very strenuous for me. And after that came the children. It was only later that painting became the most important thing for me. I've always regarded it as a kind of calling for myself, but it wasn't the case initially that it could take first place in my life.

What journeys did you undertake together? You've mentioned Japan.
Well, we've never made journeys just for the sake of travelling, but we always visited sculptors and looked at what kind of colleagues they had, how they worked, and whether we could invite them to Margarethen. That news always spread immediately in those circles. We were almost always in quarries. And there's something quite different when you're on an island in Japan where there are only quarry workers and fishermen, rather than when you're travelling as a tourist. Of course, we also saw Kyoto and other cities, and also monasteries.

Were you able to take the children with you back then?
Yes, if it could be arranged somehow. In 1961 we spent a whole year with the children in Berlin. They weren't at school yet. After the Wall was built there was the so-called Wall Symposium in the grounds of the Reichstag which Karl organised together with colleagues. When school started, we often came back late or we simply had to remain at home. And during our three-month's stay in Israel, the children lived with my parents.

Which encounters with artists or colleagues have been important for you?
For me personally – that's very difficult to say. Since Karl didn't like being in the foreground at all, often other painter colleagues persuaded him to make an exhibition together. And then I was very soon left to one side and was only 'Karl's wife'. I simply always took on a variety of roles. I was the wife, mother, hostess for the sculptors and the organiser for Karl. It wasn't easy to accept that, but with time I did learn to. There are several artists who were important for me, Mark Rothko, for instance. And I value the painting of Gotthard Graubner. A few sculptor colleagues, in turn, have appreciated my work. Karl and I have also often exhibited together.

You said that you esteemed Rothko very highly. Were you able to visit him in America?

No, unfortunately. But I can tell you an anecdote about him: the Galerie im Griechenbeisl in Vienna had made sure that small stones by Karl were shown in an issue of the journal, *Das Kunstwerk*. Shortly thereafter, a letter from the Staempfli Gallery in New York arrived asking whether the stones were for sale. That was a really big event! So three or four stones were sent to America. Mr Hirshhorn from the Hirshhorn Museum in Washington came into the gallery by chance while the stones were being unpacked and immediately bought all of them. And then Mr Staempfli thought that was good business and organised an exhibition at his gallery in New York to which Karl travelled together with the art dealer, Christa Hauer, from the Galerie im Griechenbeisl, and there he met Rothko. I wasn't there because of the costs and because we had the children to look after. There was a cloudburst and Karl had taken shelter in a gateway where he stood facing a man who had also sought shelter from the rain. 'You're Rothko!' he exclaimed. Rothko said that he'd seen Karl's exhibition and liked it very much. Karl then visited Rothko in his studio. The gallery in Vienna wanted to organise a Rothko exhibition which, however, came to nothing. About two years later, Rothko committed suicide. Unbelievable!

We've seen photos of your trip to Romania.

Yes. In 1968 the Russians marched into Czechoslovakia. At the time, we were in Vermont. Karl had this exhibition at Staempfli's in New York and thought, since he was already there, he also wanted to bring together a sculpture symposium in the United States. In Vermont there are marble and granite quarries. So we were invited with colleagues, 'Mr Prantl, come along with the whole group,' and so we travelled over, about twelve of us. That was a great time! Enormous stones and enormous cranes! All wishes were able to be fulfilled. And then this invasion of Czechoslovakia happened, and we were paralysed because here in freedom we were able to work on the stones, and there, the tanks were rolling in. A year later, in 1969, the idea arose that at Easter they should hold the general meeting of our association at Brâncuşi's *Table of Silence* in Romania. The Czechs and the Poles could also travel there again. And then we arrived in a lot of small cars, like a car rally converging on Romania. That journey was very important for us.

Were your children also with you?

Yes. Everyone who could, brought their family along. For the journey I'd taken a hundred coloured eggs, a large loaf of bread and salt in a huge basket that was checked at the border, since they thought that we'd hidden something under-neath. When we arrived at the hotel in Tîrgu Jiu we were told that there was a

whole bus coming from Bucharest with Romanian sculptors. We were very glad about that. We then all met in this Communist hotel and sat at one table; there was an extra table next to us with the Romanians. You could immediately recognise who was a minder and who was a sculptor. There were at least as many minders present as there were artists. Slowly, the two tables intermingled and contacts came about. It was wonderful. Some of them then went to the West. We had a film team with us. The film director, Robert Dornhelm, who'd made the film, *War and Peace*, in 2007, had Romanian roots. He'd become famous, worked for Austrian national television ORF, and was also there because he could speak Romanian, and he filmed our meeting. Karl gave an incredibly aggressive speech: 'Why are we allowed to come here and they're not allowed to leave? Brâncuşi went by foot to Paris.' The next day in the hotel there was then an outrageous bill. Nobody could pay it, so we did, and all our money was gone. We wanted to go home again straight away, but the others proposed that we travel to the Maramureş. When we made this lovely excursion there, to an area on the border to today's Ukraine with still quite traditional villages and wooden churches, we noticed that we'd been followed the whole time by a car and were continually being observed.

How many symposia have you organised in total?
It's no longer possible to say. There are about fifty large stones of Karl's standing on squares throughout the world, and now there are the legal questions as to who will look after them and to whom the stones really belong. That is often very far from clear. In Margarethen in particular this problem has been posed urgently because the land there is owned by Prince Esterházy or the present private foundation, and they claim that they own everything because it's all located on their land. In the meantime it's become completely kitschy there. And therefore we've brought the sculptures that were standing too densely and were particularly in jeopardy here into this landscape. Without fuss, without television, without anything. One day they were simply gone. A lawyer told us that by now it was barred by law. Earlier on, we would have had to pay the lessee of the quarry the price of the stone on taking it away. But today that obviously no longer applies.

And the other stones that are still standing there – have they passed into the keeping of Esterházy or the foundation?
The whole time we've treated it in such a way that each sculptor owns the work he has made, but that when he transports it off somewhere, he has to pay the price of the stone. That was our agreement. Now you no longer have to pay the price of the stone because that's barred by law. And last year we resolved that the sculptures belong to the Association Symposium of European Sculptors,

and that's simply we ourselves. We asked ourselves whether we should now expand the association, or whether it should consist only of those who really do something. That's always only very few of us, and it also changes.

If there were more Friends of the Association, then of course there would also be a little bit of money available!
You have to keep on working and motivating, and that costs something, too. We've always put everything into the work and haven't spent any money on public relations. The colleagues' living together was quite important, but this kind of marketing was never feasible. We also never learned to do that, and when we do try it, we do it badly. Others have to take that on, and in this area we've had some bad experiences. There are options to improve the situation; especially your commitment helps. Here in the locality everybody is quite naive, including the present mayor. And not only he thinks that, since they make the landscape available, marketing in their sense would also be in our interest. With the former mayor, Irene Izmenyi, the idea was realised of transplanting eighteen symposium sculptures in the free border landscape of the old Austro-Hungarian monarchy from St. Margarethen here to Pöttsching. The farmers sold the few square metres of land required to set up the sculptures to the municipality which, for its part, has undertaken contractually to mow around the sculptures and take care of them. The sculptures are on loan from the Association.

And you are now investing your entire energies there?
Every now and again. I've been saying for ten or fifteen years that I don't want to hear about the symposium any more. Our own workload here is already so incredibly heavy. Our daughter, Katharina, is now assisting, but ultimately I always have to be involved and prevent things from happening here and there.

That requires a lot of energy.
Yes, to be sure, but the symposium is our life. A year ago, a Japanese art historian was here who's writing her doctorate about symposia. She was quite amazed at how many there've been already; she knew only of the symposia in Japan and China. An institute should be established immediately that gathers the appropriate data worldwide so that interested persons can get the information. At our place upstairs there are drawers full of photos and press reports which I'd already ordered once. But Karl, now that he's no longer working, goes upstairs and pulls everything out again.

Back to your stones once more: what will happen to them when you're no longer here?

That's a big, big question. Karl, of course, imagines a wonderful garden into which everything is integrated and which you can visit. Not exactly a museum, but somehow a museum nevertheless – an ideal plan. Our children will do it. Both of them have artistic vocations and are very interested. We've already given them a couple of stones to sell.

It must be hard to have to give up the stones.

If beautiful places that are also appropriate could be found, that'd be a good thing. Several plans, however, have already come to grief through the obstinacy of architects or the authorities. Upstairs Karl has a red granite sculpture the size of the table ready. Our son, Sebastian, is of the opinion that this stone belongs in the vestibule of the Greek-Orthodox Church in Vienna. The idea's a good idea, because the people with Greek roots from Vienna meet there and talk with one another before and after the church service. The colour would also be completely right. But that will never happen, because, among other things, we don't have any contact there. This over-estimation of architecture and design is very bad for art. Lifestyle plays such a strong role today, including in the media, and they're very hostile to art. But that, too, will pass. After all, art can do a lot more.

From the very beginning,
I was always there – seven days
a week and at least eight hours a day

Ute Mack

Ute Mack has been married to Heinz Mack since 1985.
We met in Mönchengladbach in June 2010 and updated
the recorded interview in June 2012.

Mrs Mack, do you feel like a genuine Rhinelander?
No, I don't feel like a genuine Rhinelander in the sense of what is usually ascribed to Rhinelanders in terms of temperament and qualities. I'm the only one from my family to have been born in Rheydt, which is today part of Mönchengladbach. My mother comes from East Prussia and my father from Silesia, so both of them were refugees. After the war they met in northern Germany. Part of my family lives there, and my brother was born there. My father then got a job in Düsseldorf; that was easier to do in the Rhineland at the time, and so my parents moved here. My place of birth therefore already has a special significance when I look at how the paths and fates of my family have run. In the meantime, I've really taken root here. But my mentality, I believe, is more northern German or East Prussian-Silesian.

How many brothers and sisters do you have?
I've a brother who's ten years older. So, to some extent, I feel as if I grew up as an only child, especially because he left home at the age of nineteen, when I was nine years old. He went to Berlin to avoid military service. So I was on my own at home. But we maintain good contact despite the separation in distance.

What did your father do for a living?
He was a skilled worker in a large metal-working factory in Düsseldorf. Originally he wanted to become an opera singer and even took lessons. But then the family came along that had to be fed, and so his vocational wish became a life-long hobby. He always sang; I just remember him singing in his spare time. He even died on stage – that was what he wanted: to die during a stage performance. And this wish of his was fulfilled. He had a stroke on stage and never woke up again.

In other words, that means your life was full of music, rather than art or literature?
Yes, music was definitely dominant in my childhood. We were always making music at home. My brother learned to play the piano as a child, was in a band by the age of fifteen and still makes music and composes today on the side. He worked as a prison director in the big prison Moabit in Berlin. Since 2007 he's been head of the prison hospital. I also had piano lessons, but only for a few years.

Did your mother work too?
She worked for a savings bank here in Mönchengladbach.

And did you go to school here?
Yes, and after that I studied social education and also worked in that field. After a few years, however, I resolved to follow a new path and gave notice without really knowing what would come of it. I call this 'my first life'.

What did you want to become as a young girl?
Let's say what I didn't want to become: under no circumstances did I want to work in an office, and that is precisely what I do today, every day.

Did you have the desire to get to know an artist and even marry him?
No, I didn't think about it much at the time. At a certain point I did want to get to know Heinz Mack, but that had a lead-up. I didn't want to marry him, but I did want to introduce myself to him in order to get a job. I'd already given up social education and was working temporarily for a friend in his market-research firm in Düsseldorf. This friend came to me one day very upset and told me that one of his co-business managers had left the firm overnight and had taken not only furniture, but also some staff along with him. He asked me for help because at the time I didn't have anything to do. I really wanted some time for myself to reflect, but he urged me to come to Düsseldorf and work as a receptionist. I didn't have any idea about how to do that since my professional back-

ground was in social education. Telephone switchboards, telefax and office communication were all completely unknown to me, as was also the entire area of market research in general. But I did him the favour. It was like leaping into ice-cold water. For almost a year I worked there and went through a decisive experience, namely, that you can do almost anything if you really want to. When the work started to get boring, I gave notice, which was very much regretted by my best female friend whom I had got to know there.

Some of my friends at the time were working in the field of art, and so I often liked going to exhibitions. There I heard by accident that Heinz Mack was working on a catalogue raisonné of his sculptures and that students were helping him in the evenings and at the weekend. I wanted to get involved in this project. I made an effort to get an interview, and that was how I met Heinz Mack.

That was the next question I wanted to ask.
That was our first meeting. And then it went on further – there was another interview and yet another. We always talked very easily with each other, but I

didn't get a job. And so a few weeks passed by. He was always very taken with our conversations, but it never became concrete. That's rather typical for Heinz Mack. Sometimes he's somehow undecided. Then the whole thing was rudely interrupted by a catastrophic fire in his house, and I said to myself, that was that. Of course, I rang up and asked whether he needed help. I tried to keep up the contact. All that happened in September 1984. And contrary to my expectations, he rang up again in December. I gathered my courage and said, 'Mr Mack, you now have to decide. During the many conversations I had the impression that you need help. I'm prepared to commit myself to you and work full-time, but now I need a clear agreement, because I, too, have to plan my future'. A day later he told me that I could start on 1 January. And then I really started in the chaos caused by the fire, and this job developed into something a bit more.

In the meantime you're your husband's manager, as we know. What did your activities consist of at the beginning?
I started work 27 years ago, and the development was, naturally, a process. At first I had to learn about a new field of work since I'd entered it from the side, so to speak. Apart from that, there was no office at all, only an old *Erika* typewriter in a carry-case. A long-term workshop worker who was about to retire was already thinking of other things, and at the time a typist came once a week, typed a few letters for the artist, but then stopped coming altogether. Everything that had survived the fire was in a bad state, packed in boxes and crates. There was no order. For every copy of a letter I had to go into town. I remember agitated discussions about the first photocopier. In short, the start was difficult. The situation now can't be compared with it at all. Today I have a very well organised office and staff.
From the very beginning, I was always there – seven days a week and at least eight hours a day. So really everything has gone over my desk from time immemorial: telephone calls and correspondence, contacts with art dealers and museums, preparations for exhibitions, work on catalogues and the archive, catalogues raisonnés and much more.
From the very beginning I was firmly resolved to do everything for Heinz Mack so that he could look positively into the future after this terrible fire.

Does your husband let you work independently?
In the beginning I had the impression that he involved himself too much with things that he as an artist really didn't need to do, and which others could do for him. But initially it was difficult to get him to do that, because letting go and handing over is also a process of developing trust. That took some time. Heinz Mack's inclination to interfere regularly with work-processes was very great at first. For instance, around 1990 I was working on a small book about works situ-

ated in public space, and he'd continually interfere – unnecessarily. That was the point when it became apparent to me that things couldn't go on this way. I sought a word with him and made it clear that either I would finish the book, or he would. If you work so closely together, drawing limits is, of course, not always easy. Today I work completely autonomously because he has complete trust in my actions.

But of course I also know precisely which matters I have to and want to speak about with Heinz Mack, and where my limits are. I try to be objective. Mack says

I'm his best critic, and that's probably true. And I think I've succeeded in putting him in a situation where he can pursue his artistic work with maximum freedom.

How did you proceed?
At first I put my energies into acquiring a new storehouse and staff. I can say that the idea of doing this came from me at the time. His studio, which we'll see later, the so-called 'glass studio', was completely packed after the fire with everything that had been saved. So he couldn't work there. The workshop didn't have enough space; the older staff member also worked there and Heinz Mack didn't want someone looking over his shoulder during the artistic process. So the most urgent task was to improve the storage situation so that the 'glass studio' could be made available to the artist again as soon as possible.
When the construction of the storehouse materialised in 1988, of course Heinz Mack was excited and had completed the plans for the building. Anybody who knows him knows how he gets stuck into it once the work starts, and how he is full of enormous creative power and energy. To the present day we haven't regretted the decision in favour of this storehouse. The same also holds true, by the way, for our residence on Ibiza that came about later. After the fire, Heinz Mack was, of course, very down psychologically. The first catalogue raisonné for prints was supposed to be produced, and here at Huppertzhof there was no peace and quiet at all; the place was a huge building site. One day he said, 'Mrs Kottwitz, let's take the *Erika* and everything we need for the book, retreat for a week to Ibiza, rent a house and work there in peace and quiet'. I found that delightful. So I sat there with the *Erika* underneath the lemon tree and thought I was in another world. To work this way is a perfect dream.
Then something happened which I hadn't planned at all: beneath the starry night sky of Ibiza, far away at the back of beyond, drinking a glass of wine together, we came closer personally. After our return, this mixing of work and private life caused me problems. It wasn't clear to me whether it would work out, and I was also afraid of losing my job. But then an angel came: I became pregnant. Happily, to my surprise, and although the situation was complicated, Heinz very soon committed himself, with all the consequences and even, some- what conservatively, insisted on our getting married. I was relieved because I knew then that everything could continue.
He always says that nothing better could have happened, although, strictly speaking, he no longer wanted to marry after two shipwrecked marriages and several dramas with women.

Did you have dreams at the time?
Dreams? Yes, I've had this absolutely deep feeling of conviction only twice in my life that what's happening at the moment is precisely the right thing for me,

a very deep certainty that you can't describe in words. I believe that this happens very rarely, if at all. Shortly after I'd met Heinz Mack for the first time, I had a dream that gave me the firm conviction that I'd always remain with him. I related this dream to a friend who likes to dabble in such New Age things. He said that the symbols in my dream were fateful. Since then I had the feeling that I'd be with Heinz Mack until he was old and grey and died. I've really always felt that, but I was careful not to tell anybody because I didn't want to be regarded as weird.

Up until today, this dream has been fulfilled, and, looking back on my life, I wouldn't want to change anything at all. The same holds true as it did back then: I believe that it is through fate that I belong here to Heinz Mack.

That's really wonderful. To turn to a completely different subject: do you receive many visitors?

Mainly working visits when, for instance, it's a matter of exhibition projects. The calendar is often overfull. By the way, we only have one calendar in order to avoid clashes of dates and appointments, which often happened previously.

Do artists or museum people also come to your place?

Fairly rarely. Otto Piene and Günther Uecker, of course, have been here, and Soto has also been a guest. When Heinz was still a member of the Academy of Arts in Berlin (he resigned shortly after the fall of the Berlin Wall), his colleagues from the faculty of sculpture also came to him. I'd have to think once again in peace and quiet about which artists have been here over the years. Of the

museum people, up until today only a few have been interested in the artist's studio. We notice that. I don't know what kind of inhibiting threshold is there. But twice a year we like to invite quite officially guests from the most diverse occupations and walks of life, who otherwise would perhaps never meet. After dinner – we call this 'according to the custom of the house' – we go upstairs under the roof. There we have a music room with a large grand piano, since my husband plays the piano very well. The master of the house himself performs a

short musical programme, and after that we try to find a common topic on which everybody discusses with one another. We and our guests find it stimulating that in this way more intensive encounters and deeper conversations come about. Often it then gets later than planned. A good sign! We like that very much.

Are there records of these visits?
Yes. By now I've a box with calendars from the last 27 years in which I've always entered what happened when and where, and when which working visit took place, and I also have guest books so as not to forget all those who've been guests at our place.

How has your daughter, Valeria, changed your life?

She's really a gift. I'm a proud mother, and my husband loves her more than anything else. Through the fact that he became a father once again later in life, at the age of 56, he has a special perspective and access to her.

After the fire, and until Valeria was six months old, we'd lived in an old villa in the city, but continued to work here at Huppertzhof. In December 1986 we then moved to the reconstructed residence. That was a great advantage because then it was always possible to have contact with our child at short notice. I didn't give up my work; during the day, a child carer looked after Valeria.

I believe that our daughter has learned to appreciate art and music in a natural way. For this reason she's also taken up studies that go in an artistic direction. She's very interested in all sorts of subjects, helps us wherever she can, and always wants to know everything precisely. It's conceivable that later on she'll take care of her father's oeuvre. That's a very auspicious prospect.

But what has changed in your life? You have two poles: your child and your husband, as well as your work and the house. Apropos house: I've just seen these wonderful tiles; were they there before?

After the fire, the house was rebuilt over a period of two-and-a-half years. Following all the misfortune through the fire, afterwards we had the opportunity to make some improvements. And so these tiles came about. We like the folklore motifs, with folk art from Hungary and Romania. Stimulated by this, on our 'honeymoon' in the holiday house where we stayed, we lay on the floor and painted ornamental forms according to which later on the tiles were fired.

Regarding your other question, I believe that I assumed a mediating, diplomatic position to foster and balance the father-daughter relationship, especially during the period that's difficult for all young people growing up. There were moments when the two would have had terrible rows if I had not tried to explain their positions. But I'm sure such things also happen in other families. It's a complex topic. Mediating and conciliating at work and at home, in this way opposite poles can come closer together.

What journeys have you undertaken with your husband?

Primarily working trips where, for instance, exhibitions of his works were opened somewhere in the world. From 1985 until today there have already been more than 150 exhibitions near and far.

Our visits to Morocco and Oman were inspiring. At the beginning of the 1990s, Heinz wanted to do photographic experiments in the desert once again. And so we travelled to Oman with a kind of mixed bag into which he had packed all kinds of materials that he wanted to place in the desert sand to photograph them. In this way, an exciting series of photos taken in the Omani desert came about.

Where were you in Morocco?
Mainly in Marrakesh and environs. But we also travelled into the mountains. We would have also liked to see the other royal cities, but unfortunately didn't have the time. As often as possible, we like travelling to our finca on Ibiza. That's a true refuge where you can find yourself again and come to rest, even though we also work there. But the Mediterranean atmosphere is different. Heinz Mack can paint and draw wonderfully there. Summer on Ibiza is the highlight of the year for me.

Which encounters with other artists have been especially important for you?
I now don't see myself in a position to restrict that to individuals. That's also difficult because on the whole we come into contact with very many people every day. There are bright spots every now and again that make us happy when we meet amiable and interesting people. And then life, as well as work, goes on. Sometimes we very much regret not having been able to cultivate and maintain our contacts intensively because of the new challenges that continually await us.

Back to your work once more: presumably you're responsible also for the entire organisation, for loan contracts, insurance, transportation – or do you have someone who takes care of these tasks for you?
I don't put this completely into other people's hands. I think I can better conceive and plan when I have an overview. If I didn't, some things wouldn't work like they do at the moment. But I gladly accept help. I already mentioned that staff do this.

What wishes do you have at the moment?
At present I'm still working through the year 2011. Heinz Mack turned eighty, and I believe that was a particularly challenging year that, frankly, sometimes took me to the limits of my powers. Four large museum exhibitions took place, for instance, at the Bundeskunsthalle in Bonn. On top of this there were nine new gallery exhibitions from New York via London to Hong Kong, each with a catalogue. And then worldwide the various art fairs, all of which I need to have a look at. In addition, the large book, *Heinz Mack – Leben und Werk*, appeared that I gave to my husband for his eightieth birthday, documenting the most important phases of his life. The biographical background is treated far too briefly in the usual catalogues. With another large book that also appeared in 2011, dealing with painting from the last twenty years, I was fortunately helped by an art historian with whom I've already gladly carried out several projects.
So I was really occupied from early in the morning until late in the evening with everything concerning our minicosmos here. And that, of course, detracts from

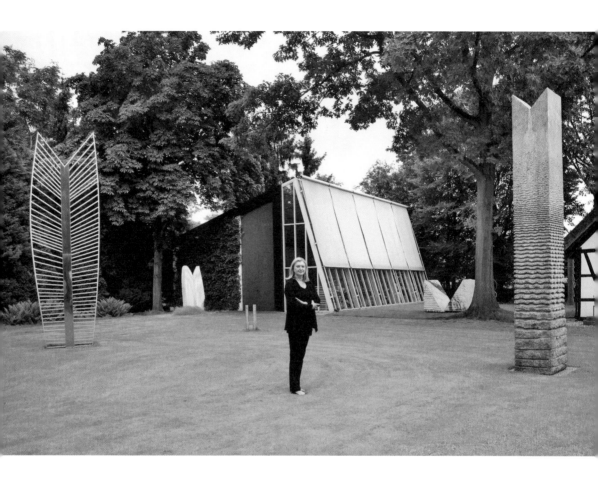

my own, very personal matters. My circle of close friends is small. The time remaining for myself is short. I've also reduced my hobbies which I used to cultivate, for instance, my classical singing lessons, because I had to decide. But I'm still a member of a service club, ZONTA International, and support their charitable activities, committing myself to projects as far as time allows.

My wish now is that my working life, and thus also my private life, might normalise a bit and, of course, I very much wish for myself that, despite all the bustle, we can still retreat to Ibiza every now and then for a short break. But on the whole, I put my private, personal wishes on the back burner because I love my work. In the meantime, it's become a life's mission.

At my age you can speak
of dreams only with difficulty

Vlasta Prachatická

Vlasta Prachatická, artist, has been married
to the sculptor, Stanislav Kolíbal, since 1953.
We met in Prague in January 2011.

*Mrs Prachatická, in contrast to your husband, you work figuratively and are
known for your portrait-busts. Do you also consider other subjects?*
No, from the start I concentrated on the human face.

*What do you take as the basis when creating your portraits? Do you use
photos or drawings?*
If the persons concerned are still living, they come to me. If they're no longer
alive, then I use photos. I always need shots from different angles. At first I form
the head in plaster, and then it's cast in bronze by specialists here in Prague.
During this work process I hold back a bit and only check the surface. Since the
bronzes have frequently been lost, or rather stolen, because of their material
value, however, today a new material is often used in which the plaster core is
enveloped. Through patination, an effect similar to bronze is achieved. I could
also work with marble, but that would be too strenuous physically.

Do you work in your own studio?
No. Earlier on, I sometimes worked in my husband's studio, but otherwise I
always worked here at home. The head of the poet, Rainer Maria Rilke, that you
see there on the pedestal, is my most recent, and I hope, not my last work. At
the moment I have major problems with my eyes.

Whom do you want to portray next?

Really, most of all I'd like to portray Rilke once more, but in a somewhat differ-
ent way. There was even a commission, but then the matter became a bit
complicated. The work was supposed to be mounted on a building that stands
on the location of the house in which Rilke was born. The new British owners
unfortunately didn't agree, however. At the moment it's not quite clear how to
solve this problem. There's a former Piarist grammar school here in the city centre
that Rilke attended; that could possibly be a good location for my portrait. [This
Rilke portrait was unveiled in the city centre of Prague not far from Rilke's birth-
place, which no longer exists, in December 2011.]

How did you come to produce your works? Were they commissioned?
Sometimes I took part in competitions, for instance, in one for the portrait of the composer, Bohuslav Martinů. Many other artists had also entered, including some who weren't specialised in portrait art. The specialist jury then decided in my favour. But at other times, I've simply portrayed people for my own pleasure.

In comparison to your husband's art, yours was relatively conservative, and you presumably had fewer difficulties in official places than he did.
Yes, my situation was completely different because I created works wholly different from his. Through the fact that I occupy myself exclusively with portraits, my works were mostly accepted by the socialist regime. My art didn't correspond to the usual socialist-realist view, but it was tolerated. Therefore I was also permitted to take part in competitions which I often also won.
The situation of my husband, Stanislav, was worse because he was frequently criticised, along with his art, at particular times. This started even during his

studies and continued in the 1950s and 60s. Only in 1967 and 1969 was he able to exhibit independently in Prague; after that, however, he wasn't allowed to show his works in Czechoslovakia for almost twenty years. From 1973 until 1980, this prohibition also applied to exhibitions abroad. Despite that, thanks to his friends' efforts, a few exhibitions took place there which, however, Stanislav couldn't visit or see. These political restrictions also affected the fate of our daughter, Markéta. She was not allowed to study graphic art at college, even

though she'd successfully passed the entrance exams. By the way, she was awarded the main prize in Bologna in 1984 for her illustrations of Lewis Carroll's *Alice in Wonderland*.

Only after 1980 did Stanislav's situation improve somewhat insofar as he was allowed at least to exhibit abroad. In this way, from 1985 on, his works came into foreign museums and collections, including yours.

Were you able to earn a living with your art?
No, that would never have been sufficient. I didn't earn enough for us to live on, and with my husband's art alone it wasn't possible either. Therefore I also worked as a book illustrator, specialising in children's books and novels. That was really our main source of income.

I know that you've also been awarded prizes for your works.
Yes, a few even during my studies at the art academy. Later on, official competitions offered opportunities to take part, but only when it was a matter of portraying important persons. It was then a matter of either a plaque with a portrait, or placing a portrait in a public space such as the foyer of the National Theatre in Prague. For my two portraits of the composers, Bohuslav Martinů and J. B. Foerster, I won first prize each time. Perhaps even today you'll find them in their original places. I had less luck, however, with my work portraying Jan Masaryk, the son of the first president of Czechoslovakia, T. G. Masaryk, and later Foreign Minister: here, too, I was awarded first prize, but this portrait was then no longer mounted, as planned, in the foyer of the Ministry for Foreign Affairs because, after the Soviet occupation of Czechoslovakia in August 1968, the political situation changed dramatically.

In recent years I've regularly taken part in exhibitions of the Society of Portrait Sculptors in London. In 2007, this society awarded me its annual prize, the Freakley Prize, and in 2009 the Jean Masson Davidson Medal.

Of course I'm interested in how you got to know your husband. But before that, please tell us something about your childhood and your family. Where were you born?
I was born in Staré Smrkovice, a small village about a hundred kilometres from Prague, so small that there wasn't even a church. Our home there is still standing. I had a brother who, however, died when he was still a child. That was a great trauma for the entire family. My mother died in 1987.

What do you think: did the landscape there influence you in any way?
Perhaps it influenced me in a certain way later when I was choosing my future career. It's an area with a lot of sandstone and lots of quarries from which the

stone is extracted. Therefore in Hořice, a town nearby, a school for aspiring masons and sculptors was established. I attended this school, so you could say that the landscape affected my future life from the start.

Do you come from an artistic or musical family?
No, not at all.

What occupation did your father have?
My father owned a tile factory and agricultural land. My mother helped him to run the factory and the farm. There was a lot of very good clay here that I was able to use for my work, and that also contributed to my decision to become a sculptor.
After the Communists took power in 1948, everything was nationalised, and our property, as well as that of our neighbours became the Agricultural Co-operative. My father then worked there as a stoker in the sawmill and my mother worked in pig-fattening.

To which of the two did you have the closer relationship?
More to my mother, because my father was more of a pragmatic person, whereas my mother was a very empathetic, sensitive woman. She had great understanding for the fact that I liked to draw and encouraged me in my love of art. In this way she possibly influenced me indirectly.

And did you go to school in the neighbourhood?
In the first years, I attended the school in the neighbouring village, and then I went to the Art School for Masons and Sculptors in Hořice. I was so glad that there I was able to prepare myself for my further artistic career and didn't have to go to grammar school.

What dreams did you have as a young girl?
That's hard to say. In any case, I was blissful that I was able to develop my talents in Hořice because my real dream was to follow an artistic career. I had a teacher there who was a former student of the Prague Academy of Arts. He supported me very much and then suggested that I apply to the art academy a year before completing school. Anything else would've been lost time for me, he said back then. And I followed his advice all too gladly.

Did you have the desire to get to know an artist?
No; that's the way it happened, but it was never my desire.

How did you meet Stanislav Kolíbal?
We met at a concert. Our relationship then lasted more than a year, but we couldn't marry because there wasn't a flat or a studio available anywhere. At the time there was a great housing shortage. Therefore, for better or worse, I lived at first with my girlfriend in a former shop in which I could also pursue my work. I'd already finished my studies at the academy, and Stanislav had continued his in stage design at the theatre academy.

But one day we heard of a studio whose tenant had just died, and we made an effort to get the allocation. This was decided not only by the district's allocation commission, but also by the commission of the artists' association which in the meantime had accepted us as candidates for membership. After the studio was assigned to us, we could finally marry in January 1953. We spent nine years in this studio. Our two children were born there which, however, initially impeded our work somewhat. But hopes for a flat were small. One evening we met acquaintances who had declined participating in the construction of terrace houses shortly before. It concerned a project by teachers in the philosophical faculty at Charles University. I don't know how long we would have remained without a flat if there hadn't been this coincidence. Construction took two years, and we've been living here since then. That's fifty years now.

How have the children changed your life?

As I said, the children lived with us in the studio. When they were very small, they claimed more of my attention than I would have liked at the time. But when I look back, I can't really say that not enough time remained for me to work or that I'd felt totally occupied by them.

Did you undertake journeys?

At first you weren't allowed to leave the country at all; the borders were closed. After 1966 you could then leave once every four years. This was preceded by a difficult procedure because you first had to make an application at the bank for foreign currency, and when you had obtained approval, you had to take care of documents and clarify many formalities. Our first trip at the end of the 1960s was to Egypt. There we visited the museums – a magnificent experience for me. Equally fascinating was Italy with its many art treasures, but that was only later.

Your husband travelled to America early on for an exhibition?

Yes; he exhibited there, but wasn't allowed to travel over. In 1967 he took part in the exhibition, *Sculpture from Twenty Nations*, at the Guggenheim Museum in New York. Only in the 1980s were trips to the United States approved for him.

Were you able to support your husband in his work?

By virtue of the fact that we were both artists and worked together in a studio, we've basically mutually helped and influenced each other.

Were there exchanges with other artists?

Yes, we had contact with many artists from our student days; we had many connections. Mostly they were my husband's friends who created an unconventional art, far removed from the official line.

Did collectors or museum people come to your place?

At that time there were no collectors at all, because the regime prohibited private property. But some art historians were very open-minded, and there were people every now and then who were personally interested in this art. I remember that in 1966 Thomas Messer, director of the Guggenheim Museum in New York at the time, visited us. He was born in Bratislava. That was such an unusual visit that I remember it well. I also recall the composer, Luigi Nono, Ryszard Stanisławski, the director of the museum in Łódz, and Italian friends such as the art historian and critic, Paolo Fossati and other artists from Rome. Unfortunately I didn't make any notes at the time, and there also aren't any photos.

What was your relationship with the other artists?

Well, we were integrated into a group of acquaintances and friends with whom we worked together. We all had the same attitude towards the regime, although we had differing artistic aims. As a portraitist I followed the classical line, whereas friends created modern art. They had another way of expressing themselves. The collaboration with Kolíbal went very harmoniously; each of the two of us was able to take their own path. I gladly accepted his criticisms, and I hope he also gladly accepted mine.

What dreams or wishes do you have for the future?

At my age you can speak of dreams only with difficulty. To be 82 – that's a ripe old age for dreams. I prefer dreaming about the past.

List of illustrations

88 Elizabeth Goldring-Piene with the *Seeing Machine* and her *Eye Robot* at a rehearsal for the new theatre production with Robert Wilson, *My New Friend Su: The Moon's Other Side*, Wilson's Watermill Center, Water Mill, NY

91 Elizabeth and Otto Piene at the Galerie Walter Storms, Munich, 2010; in the background works by Otto Piene: *Japanese*, 1974 and *Mud Moon*, 1981/85

93 Elizabeth Goldring-Piene before the works *Aschen*, 1999/2001, *Indian Summer*, 1999/2002 and *Aufwärts Rot*, 1997, by Otto Piene

96 Elizabeth Goldring-Piene before the work *Japanese*, 1974, by Otto Piene

98 Otto Piene, *Sky Art*, Siena, 2004

103 Essila Paraiso with her work *Venere di Milo*, 1976

106 Website *vietatonline* by Essila Paraiso

111 Franziska Megert before her work *Bonus* from the cycle *Benchmarks*

113 Franziska Megert in her studio in Düsseldorf; on the right one of her video works

114, 115 Franziska and Christian Megert in the studio, Düsseldorf 2010

116 View of exhibition *Franziska Megert – Jeu de Lumière*, 2011, at the CentrePasquArt Biel, Switzerland; on the left the installation *Time Addiction* (Computeranimation), 2007

117 View of exhibition *Artcontainer*, 2012, Steffisburg, Switzerland, with the work *Benchmark Out Performer* (130 × 130 cm) in the ship container

119 View of exhibition *Franziska Megert – Jeu de Lumière* 2011 at the CentrePasquArt Biel, Switzerland; in the foreground the sculpture *HOMMeAGE* (Computeranimation), 1996, in the background the installation *Time Reflections By Reflecting Time*, (Computeranimation), 2009

123 Franziska Megert before her work *Yellow Allocation* from the cycle *Benchmarks*

126 Hermann Bartels

128–132 Vacation shots

134 Hermann Bartels

137, 153 Hannelore Ditz with works by Arnulf Rainer

140 Hannelore Ditz and Arnulf Rainer with their daughter, Clara, in Arnulf Rainer's studio, 2011

151 Hannelore Ditz with her daughter, Clara, in Arnulf Rainer's archive

155 Karin Girke in August 2011 in Baden-Baden before the work *bewegt*, 1959, by Raimund Girke

159 Raimund Girke's studio, Cologne, 5 October 1990

160 Raimund Girke in his studio, Cologne, 22 June 1997

161 Karin and Raimund Girke, Düsseldorf, 12 May 1994

163 Raimund Girke in the studio with his works, Cologne, 14 October 1998

171 Kitty Kemr before a cushion picture by Gotthard Graubner

173–176 Kitty Kemr and Gotthard Graubner in the studio

185 Léonore Verheyen and Anna Lenz in Heffen, 2012

186 Jef Verheyen in his studio in Hoogstraat, Antwerp, 1964/65

187 top Dani Franque in 'Atelier 14', Antwerp, around 1954/55

187 bottom Ceramics by Dani Franque and Jef Verheyen, 1954/55

189 Jef Verheyen, *Espace en 3 temps* (triptych), 1976/77

190 Dani and Jef Verheyen at the opening of *Kreislauf der Farbe*, Düsseldorf, 1973

191 Dani Franque in the garden in Les Talons, France, around 1989

193 Marie-Madeleine Opalka in her home in Venice

194 View of the estate in Le Bois Mauclair, France

Photo credits

All photographs by Roswitha Pross, Munich, except:

Archive Edith Talman, Ueberstorf, Switzerland: p. 80

Archive Gertrud Bartels, Erkrath: pp. 126, 128, 129, 130, 131, 132, 134

Archive Graubner, Neuss: p. 176

Archive Mack, Mönchengladbach: pp. 274, 275

Roberto Battistini: pp. 219, 223

David Bordes: pp. 224, 229, 232

Carsten Clüsserath, Saarbrücken: pp. 42, 45

Michael Dannenmann, Düsseldorf: p. 175

Goldring Archive, Groton: Stephanie Lin: p. 87; photographer unknown: p. 88

Gerhard von Graevenitz, Amsterdam: p. 19

Gerhard Heisler, Saarbrücken: p. 34

Kay Kaul, Düsseldorf: p. 119

Willi Kemp, Düsseldorf: pp. 159, 160, 161, 163

Rotraut Klein-Moquay Archives, Paris: photographer unknown: pp. 230, 234; Joe Schildhorn: p. 237

Anna Lenz, Tyrol: pp. 27, 70, 75, 98, 115, 137, 146, 189, 197, 201, 203, 214, 259

Urmila Lo Grigat, Dachau: pp. 20, 22

Franziska Megert, Düsseldorf: pp. 116, 117

Ulrike Schmitt, Nuremberg: back flap (portrait Roswitha Pross)

Philipp Schönborn, Munich: p. 231

Verheyen Archive, Heffen: Leon Francq: p. 187; Andrea Heirman: p. 191; Marc Poirier dit Caulier: p. 186; photographer unknown: p. 190

Gordana Vidovic, Saarbrücken: p. 36

Credits copyright

Published by

Hirmer Verlag GmbH
Nymphenburger Strasse 84
80636 Munich
Germany

Editor
Anna Lenz

Concept and realisation
Anna Lenz, Roswitha Pross, Ulrike Honisch and Ulrike Schmitt

English translations
Michael Eldred

Editing
Ulrike Honisch

Copy-editing
Ulrike Honisch, Ulrike Schmitt

Corrections
Jane Michael

Design and typesetting
WIGEL, Munich

Lithography
Reproline Genceller, Munich

Project management Hirmer
Rainer Arnold

Printed and bound by
Friedrich Pustet KG

Paper
Munken Lynx 130 g/m^2

Font
Avenir

Printed in Germany

Bibliographic information of the Deutsche Nationalbibliothek
The Deutsche Nationalbibliothek holds a record of this publication
in the Deutsche Nationalbibliografie; detailed bibliographic
data are available on the internet at URL http://www.dnb.de
© 2013 Hirmer Verlag GmbH, Munich

ISBN 978-3-7774-2149-0

www.hirmerpublishers.com